₩₩₩₩₩₩₩₩₩₩₩₩ <7 W9-ANC-299

CALLIGRAPHY BIBLE

A COMPLETE GUIDE TO MORE THAN 100 ESSENTIAL PROJECTS AND TECHNIQUES

CALLIGRAPHY BIBLE

A COMPLETE GUIDE TO MORE THAN 100 ESSENTIAL PROJECTS AND TECHNIQUES

MARYANNE GREBENSTEIN

Consulting Editor

Compilation copyright © 2012 by Quantum Publishing Ltd

All rights reserved.

Published in the United States by Watson-Guptill Publications, an imprint of the Crown Publishing Group, a division on Random House, Inc., New York. www.crownpublishing.com

WATSON-GUPTILL is a registered trademark and the WG and Horse designs are registered trademarks of Random House, Inc.

This compilation is comprised of material previously published in THE COMPLETE CALLIGRAPHER, copyright © 1993 by Quintet Publishing Limited, CALLIGRAPHY SCHOOL, copyright © 1994 by Quarto Publishing Inc., THE ENCYLOPEDIA OF CALLIGRAPHY ILLUMINATION, copyright © 2005 by Quarto Publishing plc, and THE CALLIGRAPHER'S COMPANION, copyright © 2007 by Quarto Inc. All published by arrangement with Quantum Publishing Ltd.

> Quantum Publishing Ltd 6 Blundell Street London N7 9BH

Library of Congress Cataloging-in-Publication Data

Grebenstein, Maryanne Calligraphy bible p.cm. ISBN 978-0-8230-9934-4 2011928848

Editor: Anna Southgate Managing Editor: Julie Brooke Project Editor: Samantha Warrington Assistant Editor: Jo Morley Designer: Jeremy Tilston Production Manager: Rohana Yusof Publisher: Sarah Bloxham US Jacket Designer: La Tricia Watford Consultant Editor: Maryanne Grebenstein

Printed in Singapore by Star Standard Industries Pte Ltd

First American Edition

Contents

INTRODUCTION

GETTING STARTED

Basic kit Preparation Ruling lines Holding the pen Making a mark Getting it right Looking at letters Looking at numbers

ALPHABET WORKBOOK

The alphabets The variations Using the workbook Alphabet 1: Roman capitals Alphabet 2: Uncials Alphabet 3: Half-uncials Alphabet 4: Carolingian Alphabet 5: Versals Alphabet 5: Versals Alphabet 6: Gothic Alphabet 7: Bâtarde Alphabet 8: Italic Alphabet 9: Copperplate Alphabet 10: Foundational

6	DESIGN & COLOR	13
	Which script?	14
10	Margins	14
12	Layout basics	14
16	Cutting and pasting	14
18	Texture techniques	15
20	Alphabetical designs	15
22	Interpreting the text	15
26	The principles of color	15
28	Choosing and mixing color	15
30	Writing with color	16
	Colored backgrounds	16
32		
34	DECORATIVE DETAIL	16
35	Flourishing	16
36	Ornament	17
38	Borders	17
46	Illumination	17
54	Designing an illuminated letter	17
62	Applying gold	18
74	Flat gilding	18
82	Raised gilding with PVA	18
94	Raised gilding with gesso	18
106		
118		
130		

38	PROJECTS	188
40	Letterhead	190
44	Wedding invitation	193
46	Poetry broadsheet	196
48	Poster	199
50	Concertina book	202
52	Decorative border	205
54	Celtic angular knotwork "A"	208
56	Celtic inspiration	210
58	Romanesque "N"	212
60	Romanesque inspiration	214
62	Renaissance "F"	216
	Renaissance inspiration	218
66	Arts and Crafts "T"	220
68	Arts and Crafts inspiration	222
70	Modern letter "H"	224
73	Modern inspiration	226
76		
78	GALLERY	228
80	Calligraphic scripts	230
82	Design & color	236
84	Decorative detail	240
86	Project inspiration	244
	Resources	250
	Glossary	252
	Index	254

Introduction

THE WORD *CALLIGRAPHY* STEMS FROM THE GREEK WORDS *KALLOS* AND *GRAPHE*, WHICH LITERALLY MEAN "BEAUTIFUL WRITING." THE ART HAS ROOTS THAT STRETCH BACK INTO THE MISTS OF TIME, YET THE TECHNIQUES, TOOLS, MATERIALS, AND SOME OF THE LETTERFORMS HAVE REMAINED LITTLE CHANGED OVER THE CENTURIES.

This book is concerned both with the working methods of practicing calligraphers and with what they want their calligraphy to "perform" as a result of these "methods." In the Western world, we expect to see lettering running from left to right and from top to bottom in straight lines of varying lengths. However, the calligrapher has wonderful opportunities to break free from the traditional mold and make letters perform visually as well as intellectually.

The modern student of calligraphy should turn to historical models for an understanding of letterforms as they were used by earlier professionals. Before the invention of printing, calligraphy was vitally important as one of the few means of storing and transmitting the written word. For centuries, scribes produced books by hand and we have much to learn from the methods they employed.

Print is primarily for reading, not purely for its decorative effect. The vast amounts of written material to which we are exposed every day make us switch off our sensitivity to lettering. Newspapers filled with sensationalism, information on every packaged product, road signs, shop signs, and street names all bombard us. The act of reading has become an everyday skill that most of us take for granted.

A piece of skillfully crafted calligraphy encourages us really to "see" what we are reading by making the words beautiful to look at. Much of its impact relies on producing a rhythmic texture in the writing. Yet this beauty is not necessarily peaceful. Tensions can also be used to disturb us: a variety of letterforms can be used in different styles and sizes or arranged in varying orientations. Seen in this light, calligraphy is a powerful tool for communicating the written word in the modern world.

CALLIGRAPHY TODAY

The revival of interest in calligraphy in the Western world really began with the work of Edward Johnston (1872–1944). Johnston studied at the British Museum in London where he analyzed how old manuscripts had been written, the tools that were used and the different angles of the pens. He created the foundational hand we use today (see pages 130–137) and taught many students who went on to become highly skilled calligraphers.

There is now a more liberal approach to design and letterform. Working within the vast advertising empires has allowed the more innovative and creative calligraphers to push back the boundaries. Calligraphy is now being developed into an art form and is a platform for making challenging statements, creating feelings about the language of words and letters, and expressing poignant poetry and prose. With the introduction of the color camera, four-color printing, color photocopying and computers, there are hundreds of ways to present new letterforms. The world of graphics and advertising relies on the color sciences and the "feel and expression" of words, rather than just information. New images, concepts and shapes increase interest and excitement, communicate ideas, and sell products. Computerized lettering can be stretched, turned, made heavier, faded in and out; it can be enlarged and reduced and made to create mood, express action or insinuate feeling.

Today, the skilled calligrapher is continually adding new vitality to letterforms. The production of beautiful formal manuscripts and the commercial world of graphics both rely on the interpretation and feel of words, and the myriad possibilities of new shapes and images are endless.

THE ALPHABET

The history of the alphabet began over 20,000 years ago with the painted pictures created in caves, and evolving slowly to symbols of various forms modified by the social and technical changes that occurred. The Phoenicians created the first alphabet in about 1200 BCE, which in turn was developed in 850 BCE by the Greeks and then the Etruscans who, when they invaded Rome in the seventh century BCE, took their alphabet with them. When the Romans superseded their rule in the third century BCE, they had modified the alphabet to almost what we see today, with the exception of three letters "J," "U," and "W." ("I" and "V" served as dual letters for "J," while "U" and "W" did not exist.)

The Roman alphabet has been in existence for over 2,000 years, yet its visual form has varied, changed by the writing tools employed and the social and economic environment in which it has been written. The best known Roman alphabet, the imperial capital, was used both in stone-carved and brushwritten letters and can still be seen on monuments such as Trajan's column (CE 113). Formal writing on papyrus scrolls for manuscripts, documents, signs, and notices were in the form of rustics written with a brush or reed. Romans also used a cursive, everyday hand for informal documents and accounts, and for use on wax tablets using a stylus. These different scripts had become standard by the first century CE. Square capitals written as a book hand—a type of script used for transposing literature—on vellum were evident by fourth century CE.

Papyrus scrolls were gradually replaced by the codex (book), and the use of animal skin was developed. As parchment and vellum became the standard material in Western countries for books, the use of the quill pen, usually goose, became more widespread. Letter shapes became rounder because of the way this tool marked the material and the speed of writing. These types of letter are known as uncials.

UNCIALS AND HALF-UNCIALS

Uncials (see pages 46–53) appeared in the fourth century CE and became the main Roman book hand until the eighth century CE, and for headings until the twelfth century. During this

time, there were many variations written throughout Europe, including the later used half-uncial (see pages 54–61). These letters were capitals, although "D," "F," "G," "H," "K," "L," and "P" show the first suggestion toward the ascenders and descenders used in the minuscule (lowercase letters). Britain developed its own style of writing, which was influenced by the monks who came over from Ireland. As book production increased, writing became faster and less formal, ascenders and descenders became longer, producing a hand we call insular half-uncial, which was used in the *Book of Kells*.

CAROLINGIAN MINUSCULE

Charlemagne, King of the Franks, CE 768–814, and crowned Emperor of Rome in 800, governed a vast area of land stretching from Italy and Spain in the south throughout Germany and Europe. For Western civilization, this was the beginning of a great cultural revival. Charlemagne was Christian, literate, and a great lover of books and classical learning. He issued a decree to form all liturgical books throughout his kingdom and invited many educated men to his court to fulfill this task. He appointed Alcuin (CE 735-804) Head of the Cathedral Schools of York to become Master of the Court School of Aachen. The script used at the court of Charlemagne was Carolingian (see pages 62–73) or Caroline minuscule (lowercase), an elegant hand developed from the half-uncial, but with a slight forward slope which was used far into the eleventh century. A hierarchy of scripts during this standardization of books developed. Titles were in Roman capitals, opening lines in uncials or half-uncials, with additional lines often in rustics, but the main area of text was in Carolingian minuscule. Capital letters that appeared within the text were generally uncial.

VERSALS

The earliest books consisted of continuous writing in capital letters with few spaces in the text. Later, larger capitals were used to emphasize headings and beginnings of verses. The shapes and proportions were based on Roman inscriptional capitals, and they were drawn quickly and skillfully with the pen. These letters became known as versals (see pages 74–81) and the finest examples date from the ninth and tenth centuries. Versals from this time were often colored in red and blue as in the Winchester Bible.

BEGINNINGS OF GOTHIC

During the eleventh and twelfth centuries, the written letter became more compressed and the decoration more elaborate, with illuminated and historiated initial letters within the text. The artists for these books traveled the continent, moving from monastery to monastery as the work required.

There was a great demand for books not only by the Church, but also by the laity and universities. By the thirteenth century, craft workshops had become established in cities such as Paris, Bologna, Oxford, and York, employing professional scribes. The letter shapes became more compressed in response to the fashionable architectural and artistic styles of the day and the need to economize on the materials used in book production.

GOTHIC OR "BLACK LETTER"

The gothic or "black letter" (see pages 82–93) emerged with great variations throughout Europe. Northern Europe used quadrata, a textural angular hand with "diamond"-shaped feet. In England the scribes were busy using a compressed Gothic with "flat feet," Gothic prescissus, constructed by either turning the pen at the end of the letter stroke or filling it in with the corner of the pen. Gothic (textura) became very compressed, creating a heavy texture on the page. It was slow to write and difficult to read. The letters were based on the angular compressed "o" shape, with identical close spacing within and outside each letter.

During this time a more cursive Gothic, called bâtarde, (see pages 94–105) was being used in France and in Germany. This was called fraktur, a cursive Gothic, but written upright and with the heaviness and rigid feel of textura.

Southern Europe, Italy, and Spain disliked the heavy Northern European Gothic and used a rounder, more open form, called rotunda.

ITALIC

During the Italian Renaissance, CE 1400–1500, there was a rebirth of interest in classical learning, which inspired the Italians to rediscover the Caroline minuscule. From this they created the humanist script and the beginnings of italic letterforms (see pages 106–117).

Following the invention of the printing press, printers had many styles of lettering from which they could choose. Many printed books were in Gothic, but in Italy they became more interested in the classical Roman, Caroline, and humanistic hands. These are the basis of our modern typefaces, and many still carry their names, such as palatino and bodini. Italian scribes revived the Roman square capitals (see pages 38–45), and many manuscripts written in Italy after 1450 contained pages with these elegant letterforms, some of which were executed by the Paduan scribe, Bartolomeo San Vito, who developed his own inimitable style.

Italic was the descendant of humanist script. It was written with more speed to produce a slight slant and fewer pen lifts, which resulted in an elegant, flowing letter. Modern variations of the italic script are endless.

COPPERPLATE

After the Renaissance, writing with an edged pen diminished and was superseded by copperplate (see pages 118–127), which was done with a pointed quill. From the seventeenth to the nineteenth century, copperplate was widely used in both industry and commerce.

FOUNDATIONAL

As we come to the end of the twentieth century, one hundred years since Edward Johnston created foundational hand (see pages 130–137), it seems inconceivable that the alphabet will change its present form, yet history dictates that this is inevitable. Possibilities for new shapes, new ideas, and images are endless, making calligraphy and working with letters continuously exciting and stimulating.

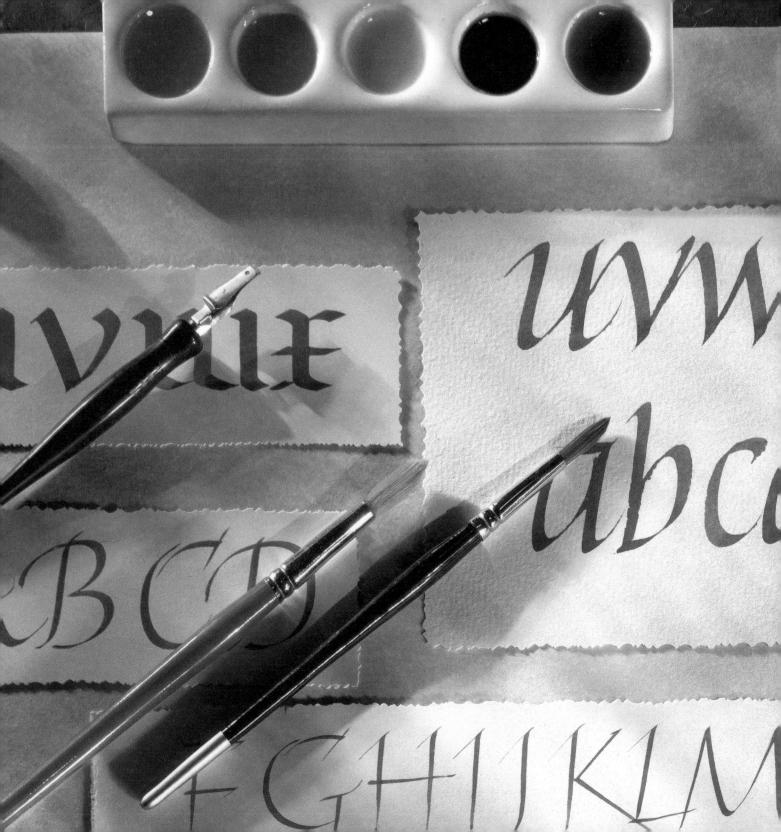

Getting Started

With an overview of the materials required for a wide variety of techniques, and advice on how best to prepare your workspace, this section is an invaluable resource for newcomers to the art of calligraphy. Here, you will find instruction on how to rule the paper for calligraphic texts, how to hold a pen, and, most importantly, how to make your first marks. Follow the step-by-step demonstrations to practice the various pen angles required for the scripts featured in the Alphabet Workbook section that follows, and familiarize yourself with the basic characteristics that are common to individual letters and numbers. **GETTING STARTED**

Basic kit

WHEN STARTING CALLIGRAPHY, THE IMMEDIATE ESSENTIALS ARE A BOARD, A DIP PEN, PAPER, AND NON-WATERPROOF INK. HOWEVER, BEFORE LONG, YOU MAY WISH TO OBTAIN SOME ADDITIONAL EQUIPMENT, SUCH AS PENCILS; AN ERASER; A T-SQUARE (FOR EASY LINE DRAWING), DIFFERENT PEN NIBS, AND COLORED PAINTS OR INKS.

TOOLS AND EQUIPMENT

There is a tremendous range of materials and implements available to the calligrapher. Start with the essentials, and build up your equipment gradually as you become more proficient and develop specific interests.

FOR CALLIGRAPHY

The most common items used for calligraphy can be bought in stationery stores, but try artists' suppliers and craft stores for more specialized equipment.

- 1. Masking tape to secure paper but can be lifted easily.
- 2. Gum sandarac, finely ground resin dusted onto paper or skin to increase writing sharpness: a) in crystal form b) finely ground and kept in a jar or in a bag.
- **3.** Triangle (30, 45 and 60 degrees). Useful for measuring pen angles and drawing verticals and horizontals.
- 4. Protractors for measuring pen angles or letter slant (italic).
- 5. T-square for drawing parallel writing lines.
- **6.** Repositionable glue stick, non-permanent glue or rubber cement, and spreader to use for layouts.
- 7. Pencils (2H and HB).
- 8. Ruler for measuring and line drawing.
- 9. Metal ruler to use when cutting paper.
- 10. Craft knife for cutting paper.

- 11. Calligraphy inks, non-waterproof.
- 12. Scissors.
- Calligraphy fountain pen with square-edge nib. Good for beginners.
- 14. Dip pen holders with various nibs. (Rounded barrels are more comfortable.)
 - a) Osmiroid square-edged nib b) scroll nibsc) mapping nibs d) Rexel square-edged nibs with separate reservoirs e) speedball nibs
- 15. Elbow nib for copperplate writing.
- 16. Copperplate nib holder for straight nib.
- 17. Pen holders with nibs.
- 18. Automatic pens for large-scale writing.
- 19. Watercolor paint in pans and half pans.
- 20. Watercolor paint in tubes for painting and washes.
- 21. Designers' gouache, opaque watercolor excellent for writing in color.
- 22. Palette for mixing paint.
- 23. Brushes, sable or sable/synthetic mix for painting.
- 24. Pencil sharpener.
- 25. Eraser.

Optional items: compass, ruling pen, cutting mat, and sketchbook.

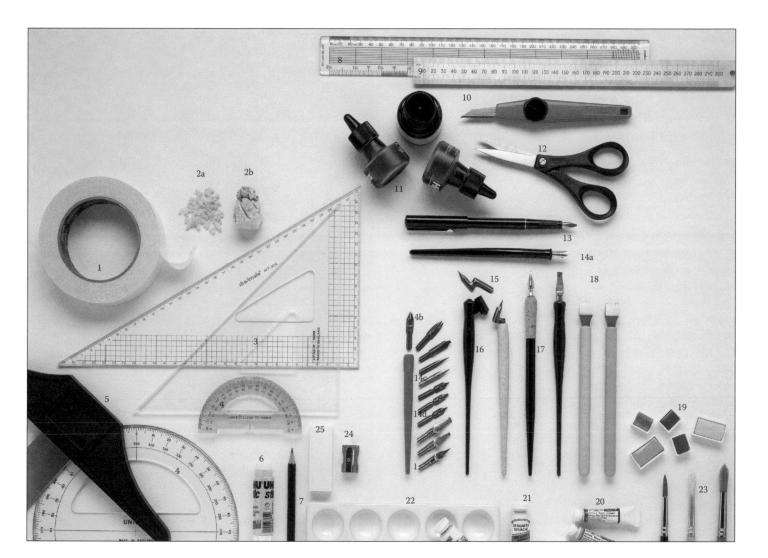

CARING FOR YOUR EQUIPMENT

Properly cared for, your equipment should last a long time:

- Nibs and reservoirs should be removed, washed, and dried carefully after use.
- Brushes can be rinsed in cold water, repointed, and stored

brush side up in a jar. When mixing paint, use cheap nylon or old brushes to prevent wear on your best brushes.

• All equipment should be kept clean and stored well for best results and longer use.

BASIC KIT

GETTING STARTED

GILDING

A basic gilding kit is shown here. In addition, you will need a small piece of silk for brushing away excess gold fragments.

- 1. Glass muller, traditionally used for grinding either ingredients for gesso or pigments for paint.
- 2. Glass slab on which to grind ingredients with a muller above. Both items are difficult to obtain and expensive to buy. We recommend you use a pestle and mortar, bought specially for grinding these materials only. Do not use for anything else, as some ingredients are toxic.
- **3.** Scalpel with changeable blades. A pointed blade (shown) for trimming paper. A curved blade for trimming away excess gold and scraping surfaces.
- 4. Agate burnisher for polishing gold.
- **5.** Paint brushes. Smaller brushes for painting or manipulating gold. Large fluffy brush for dusting away gold particles.
- 6. Glass eye dropper for measuring drops of distilled water.
- 7. Gesso made into small, dry cakes ready to use. Add two drops of distilled water.
- 8. PVA (polyvinyl acetate), a glue for gilding.
- 9. Acrylic gloss medium, synthetic glue for gilding.
- **10.** Gilding medium (pink) manufactured for use in illumination. Works well applied with a brush on larger gilded areas. Use an old brush.
- 11. Precious metal for gilding.
- **12.** Loose-leaf gold. Usually 23¹/₄-carat gold is best, bought in books of 25 leaves.
- **13.** Glassine or drafting vellum paper for use when gilding to protect the gold initially when first burnishing.

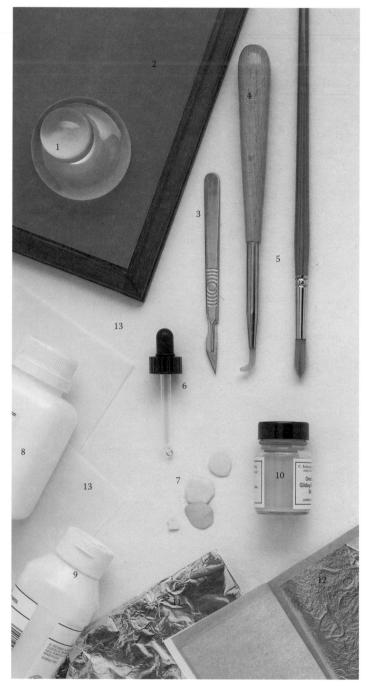

PAPERS

There is a vast range of textured, smooth, or colored paper from which to choose. Paperweight is measured in grams per square meter (gsm). The smaller the number, the lighter or thinner the paper will be. The number relates to the weight of a ream or pack of paper, which is 500 sheets. Therefore, 190gsm will be thinner than 300gsm. The surface textures of high-quality watercolor papers are described as hot pressed—smooth surface; or cold pressed—slightly textured surface; rough very textured surface.

Try out your first marks and experiments on different papers and keep notes for future reference. This will help you learn the individual qualities of each. When buying expensive paper, handle it with care and, where possible, carry it looped rather than rolled, or it may become damaged. Store it flat.

TYPES OF PAPER

- Handmade papers. These will need to be purchased from artsupply stores. There is a good choice of textures and qualities available, depending on the natural fibers used in their manufacture. Their use can add great interest and variety to the written page, and they are delightful as covers for small books and 3-D objects.
- 2. Manufactured paper. Stocked in most art-supply stores. These papers are generally cheaper and made from wood pulp or a mixture of wood pulp and cotton or linen. This paper is made in a long roll and cut into sheets, and is produced in white, cream, and various colors.
- **3.** Tracing, or layout paper is slightly transparent and has a smooth surface, which is most suitable for writing practice. It is used for overlays and cut-and-paste in designing work.
- 4. Pastel paper. Good-quality pastel paper is invaluable to the calligrapher. An extensive selection of color, tone, and texture is available, and it usually offers a smooth or a textured reverse side on which to write.
- 5. Vellum and parchment. Prepared animal skin. Today vellum usually refers to the finer skins such as calf. Parchment is generally made from sheepskin.

DIFFERENT SURFACES

When choosing paper for work, pleasing effects can be made by using different surfaces.

- Writing on hot-pressed paper produces fine, smooth pen work and is suitable for the more delicate pieces.
- Interesting, slightly textured pen lines are made on cold-pressed paper.
- An exciting textural feel is produced on rough paper, though this is only suitable for use with a larger nib.

Preparation

THE IDEAL WORKING CONDITIONS FOR MAKING GOOD CALLIGRAPHY ARE GOOD LIGHT, WHETHER DAYLIGHT OR FROM DIRECTED ARTIFICIAL LIGHT, A COMFORTABLE SEAT AT THE RIGHT HEIGHT AT A TABLE, A SLOPED BOARD WITH A PADDED WRITING SURFACE, AND SPACE TO ONE SIDE FOR YOUR EQUIPMENT.

PREPARING A WORKSPACE

You will no doubt be sitting at a desk for long periods of time, so you need to be sure you are comfortable and in the optimal position for producing good work. Try to sit so that the available light will not cast any shadows over the area where you are writing. If you are right-handed, the light needs to come from the left. Position the light source from the right if you are left-handed. Here are a few additional points to consider when arranging your working environment.

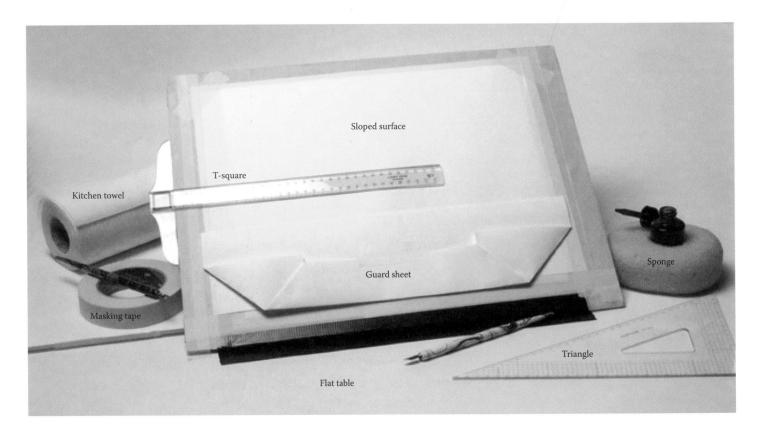

DESK

It is perfectly possible to write calligraphy on a flat table, but a sloped surface is better for posture and for controlling the ink flow from a dip pen. Prop a sheet of plywood—24 x 18 inches (60 x 45.5cm)—against some books on the table. Pad the writing surface for comfort and smooth writing, using eight sheets of ironed newspaper covered with white cartridge or blotting paper. Attach it all to the work surface with masking tape.

GUARD SHEET

Protect your writing paper from the oils in your hand—which can make the paper slippery—and from drips of ink, using a guard sheet. This is simply a strip of paper that covers the part of the surface where your hand rests as you work. Either attach a wide strip across the board using tape or keep it loose under your hand.

AVOIDING AND RESOLVING SPILLS

To avoid spills, pour a working quantity of ink into a smaller jar or a film canister. Fit this pot into a piece of sponge by cutting a hole with scissors, or secure it to the table with masking tape (*see below*). Position the ink on the side of your writing hand, so that you don't have to reach over the paper to refill. Keep some kitchen towels or tissues close by to clean up any spills of paint or ink, and to dry nibs.

USEFUL TOOLS

A T-square is valuable for ruling parallel lines and a triangle for checking pen angles. Protractors are also useful for checking pen angles.

TAKE OCCASIONAL RESTS

When working on a piece, get up occasionally to stretch your legs and relax neck muscles.

Get up and walk around after concentrated work, flex your hand to ease any tension, and gaze into the distance to rest your eyes.

PREPARING YOUR TOOLS

Try out new dip pens on scrap paper to get a feel for the nib, since different brands will vary. You may find that you need to take a few extra steps to get the nibs ready for flowing calligraphy.

NEW NIBS

If new nibs are coated with a varnish or machine oil that resists the ink, try the "flame treatment" (*see below*). Hold the underside of the nib over the flame of a lighted match for no more than four seconds, then plunge the nib into water (hear it sizzle). The nib tip should now stay coated with ink when dipped; if not, repeat the process, but don't overheat the metal.

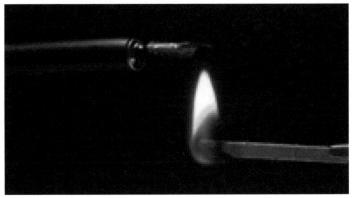

Ruling lines

IN ORDER TO ACHIEVE SUCCESSFUL AND CONSISTENT RESULTS YOU NEED TO RULE ACCURATE LINES WITHIN WHICH YOU WRITE. TO PRACTICE DRAWING LINES, TAKE A SHEET OF LAYOUT PAPER, A SHARP PENCIL, AND A GOOD PLASTIC RULER WITH CLEAR MARKINGS. DRAW A SINGLE HORIZONTAL LINE—THIS WILL ACT AS A BASELINE, OR WRITING LINE—AND FOLLOW THE ADVICE ON X-HEIGHT AND LINE SPACING BELOW.

THE X-HEIGHT

The distance between the baseline and top line—the lines between which the letters fit without their ascenders or descenders—is known as the "x-height" and depends on the size of your nib. Each of the alphabets the book will feature (see pages 34–137) offers a scale alongside the "A" indicating how many nib-widths are needed. Hold your pen sideways and make squares in steps or ladders up the page from the baseline. Try this several times if your pen blobs or if you overlap. Once you are sure it is accurate, take this measurement as your model for ruling lines.

LINE SPACING

Ruling a whole page of lines that are all the same distance apart is the easiest option. In this instance, write on every third line. This leaves a two x-height interline gap, which is usually enough to accommodate ascenders and descenders. When writing mainly lowercase, gauge the height of ascenders and occasional capitals by eye, to avoid ruling extra lines that will confuse your work. You should only add an extra line for capitals if a whole word or more is to be written completely in capitals. Note that ascenders are marginally higher than capitals in many alphabets.

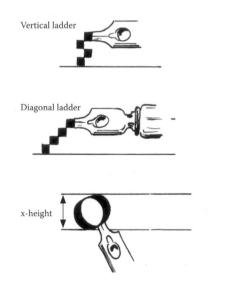

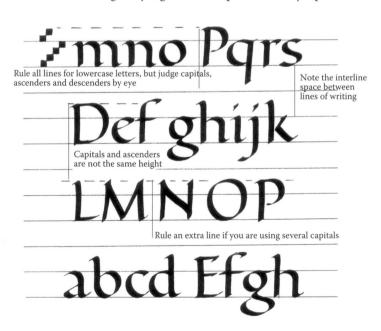

RULING THE PAGE

When you are practicing on thin paper, you could rule one set of lines (heavily) and keep it underneath, to save time. For finished work on thicker paper, and for very narrow lines, you will need to rule lines on the actual writing page.

You will need

Ruler Compass T-square 2H pencil

1 Measure accurately how far apart your lines should be; generally you are measuring "nib-widths."

2 If you would like all of your lines to be exactly the same distance apart, use a compass for greater accuracy.

3 Simply walk the compass down the side of the page. Alternatively you can mark the measurements with a ruler.

4 When you have marked the measurements on both sides of the page, join them with clear sharp lines using a ruler.

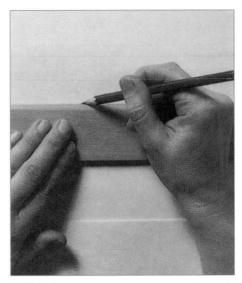

5 If you have a T-square, you need only mark down one side of the paper, secure it to the board to keep it from moving, and use the T-square held firmly with its edge against the board as you rule lines across.

Holding the pen

IT IS IMPORTANT TO ESTABLISH A WAY OF HOLDING THE PEN THAT ALLOWS A FIRM AND STEADY GRIP WHILE YOU WORK, BUT THAT ALSO ENABLES YOU EASILY TO CHANGE THE PEN ANGLE WHEN NEEDED. MOST RIGHT-HANDED CALLIGRAPHERS REST THE PEN ON THE FIRST JOINT OF THE MIDDLE FINGER AND USE THE THUMB AND FOREFINGER TO GUIDE THE PEN AND MAINTAIN ITS ANGLE.

GETTING THE RIGHT PEN ANGLE

Pen angle problems are more marked in the early stages of learning. A flatter angle to the writing line is more natural than a steep one, so you will need to check the angle constantly at first.

Establish an angle of 40 to 60 degrees between your pen and board for best results. Here, at right, you can see how the heel of the hand rests on the board to ensure stability.

CHANGING PEN ANGLE

The simplest way of altering nib angle without disrupting your writing effort is to roll the pen between your thumb and forefinger without altering the position of your hand. In the

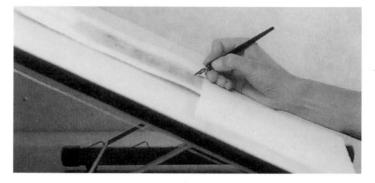

illustrations you will see how the angle of the penholder held in your hand moves in a 90 degree arc as you change the angle of the nib from 0 degrees through 45 degrees to 90 degrees.

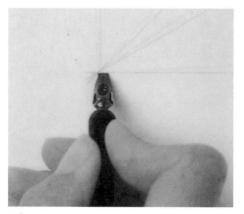

0 degrees

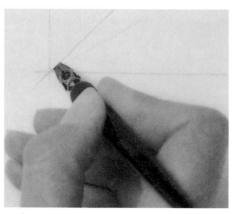

45 degrees

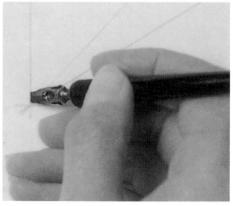

90 degrees

HINTS FOR LEFT-HANDERS

For most scripts the strokes are pull rather than push strokes —that is, the pen is pulled across the paper instead of being pushed. These standard stroke directions are aimed at righthanders, who form the majority of the population. In order to follow the correct stroke direction, left-handed calligraphers cannot simply use a mirror image of the right-handed writing positions but have to adopt alternative positions for their hands and arms.

Left-handed calligraphers have discovered many ways of overcoming this difficulty, but for beginners the underarm position is considered most effective. This position enables strokes to be the same as for right-handers, and the work can be viewed from a regular perspective. Penholder and nib are aligned in a similar way to the right-handed pen—an obvious advantage when learning from a right-handed teacher or right-handed examples. However, this position may not suit all left-handed calligraphers. You may need to experiment with different methods to find the solution that is best for you.

A more general difficulty encountered by left-handers is achieving and maintaining a steep-enough pen angle to the paper. Some people solve this by turning the paper up to the left, but this may disturb the writing of verticals and constant slants. Oblique nibs can help left-handers to achieve accurate angles.

UNDERARM POSITION FOR LEFT-HANDERS

At the wrist, turn the left hand as far as possible to the left in order to place the nib on the paper at the correct angle. It may help to slant your paper down to the right. Encourage free arm movement by placing the paper slightly to the left of your body and writing from this position. It helps if you work on an extrawide board with a guard sheet across the full width, so that you can move your work to the left as you write.

ALTERNATIVE LEFT-HAND POSITIONS

If for any reason the underarm position does not suit you, try one of these alternatives.

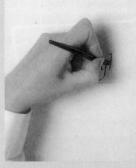

1 Hook position: Place your hand above the writing line in a "hook" position by flexing the wrist downward. Then, after placing the nib on the paper at the desired angle, move the nib in the direction of the stroke. It may help to slant the paper slightly to the left.

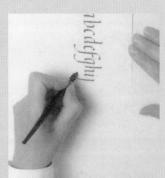

2 Vertical position: In this method the paper is placed at 90 degrees to the horizontal and you work from top to bottom instead of from left to right. This enables you to render strokes as a righthander, but the unusual angle may make it difficult to judge the letterforms as you work.

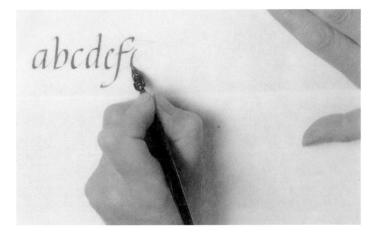

Making a mark

WHEN YOU BEGIN TO WRITE CALLIGRAPHY, ONE OF THE FIRST QUESTIONS THAT ARISES IS HOW TO ENCOURAGE OR HOW TO CONTROL THE INK FLOW. GENTLE PRESSURE ON THE NIB, AND SMALL, PULLING STROKES ON A SPARE PIECE OF PAPER WILL USUALLY GET THE INK FLOW STARTED. IF NOT, THERE ARE SEVERAL MEASURES YOU CAN TAKE (SEE GETTING IT RIGHT, PAGES 26–27).

GETTING A FEEL FOR THE NIB

Try a few strokes to get the feel of the nib. Keep the pen in complete contact with the paper to avoid writing with ragged edges. Press hard so that you get the nib to spread apart and reveal greater contrast between the thick and thin strokes. If the pressure is too light, your strokes may be hesitant, slightly ragged, or waisted.

Practice holding the pen at a constant angle to achieve thick and thin strokes. Try the exercises illustrated on the following pages to develop your skills in producing consistent strokes at accurate angles. Use a protractor to help you establish the pen angles on your practice sheet.

EVEN AND UNEVEN PRESSURE ON THE NIB

A clean-edged stroke depends on both edges of the nib being in contact with the paper. A ragged edge along one side of the stroke may indicate that the nib has not been aligned correctly on the paper.

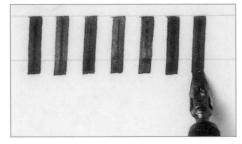

1 Rule lines ½in (1cm) apart and practice downward vertical strokes with the nib held horizontally (at 0 degrees) to the writing line.

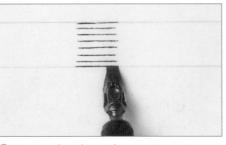

Incorrect

2 Keeping the nib at 0 degrees, try writing some horizontal strokes between your writing lines from left to right.

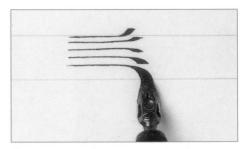

3 Make further horizontal strokes, but now practice pushing them up and then pulling down at the ends.

PRACTICING HEIGHT AND SPACING

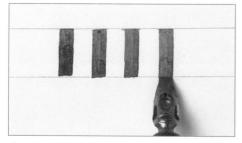

1 With lines ruled as before, practice parallel downstrokes. Concentrate on making them the exact height of the writing lines.

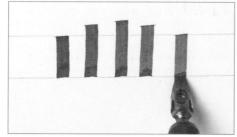

2 Starting with a stroke at the height of the writing lines, draw parallel strokes progressively taller, then progressively smaller, as shown.

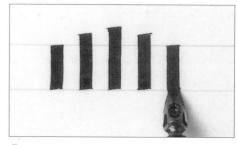

3 Repeat stage 2, but this time, concentrate on spacing the strokes as evenly as possible.

PRACTICING PEN ANGLES

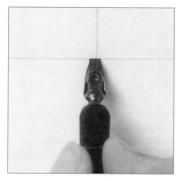

0 degrees: establish the angle

0 degrees: downward vertical pull

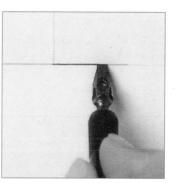

0 degrees: left-to-right horizontal

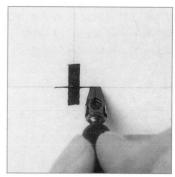

0 degrees: vertical and horizontal

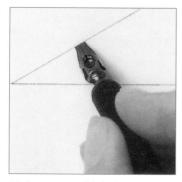

30 degrees: establish the angle

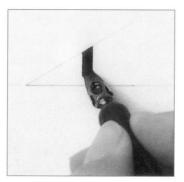

30 degrees: downward vertical pull 30 degrees: left-to-right horizontal

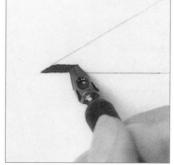

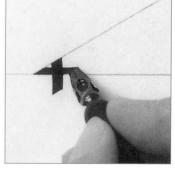

30 degrees: vertical and horizontal

GETTING STARTED

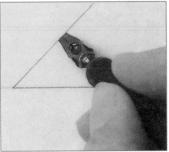

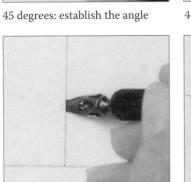

90 degrees: establish the angle

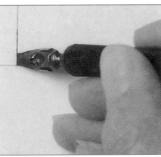

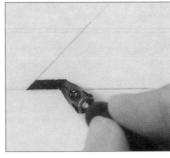

45 degrees: downward vertical pull 45 degrees: left-to-right horizontal

90 degrees: downward vertical pull 90 degrees: left-to-right horizontal

45 degrees: vertical and horizontal

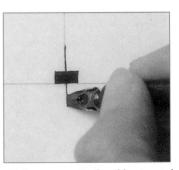

90 degrees: vertical and horizontal

MULTIPLE STROKE PRACTICE

1 Vertical strokes: practice parallel vertical strokes between your writing lines at pen angles of 30 and 45 degrees. Try to keep the strokes evenly spaced, approximately 1 nib-width apart.

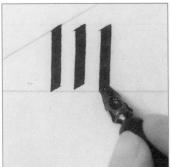

30 degrees

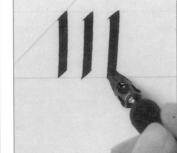

45 degrees

(2) Horizontal strokes: try some parallel horizontal strokes at 30 and 45 degree pen angles. The strokes should be evenly spaced, approximately 1 nib-width apart.

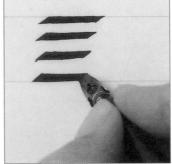

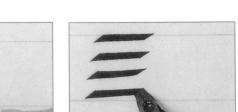

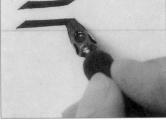

45 degrees

3 Left-to-right diagonals: practice parallel diagonals between your writing lines at 30 and 45 degrees. As before, try to ensure even spacing based on 1 nib-width.

4 Right-to-left diagonals: note how diagonals drawn from right to left produce a much thinner stroke. Practice these with a pen angle of 30 and then 45 degrees. Concentrate on achieving parallel strokes at consistent angles.

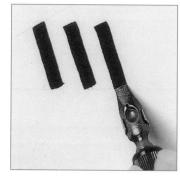

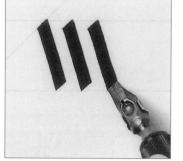

30 degrees

45 degrees

30 degrees

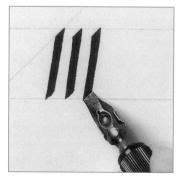

45 degrees

PRACTICING CURVED STROKES

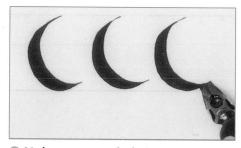

1 30-degree counterclockwise curve: practice arcs based on half an "O."

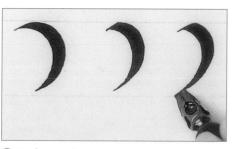

2 30-degree clockwise curve: practice arcs in the opposite direction.

3 Circular "O" form: use both strokes to complete the letter.

3 Oval "O" form: use both strokes to complete the letter.

1 45-degree counterclockwise curve: practice arcs based on half an oval "O."

2 45-degree clockwise curve: practice arcs in the opposite direction.

Getting it right

TO PRODUCE THE CRISP, SHARP, THICK, AND THIN STROKES THAT CHARACTERIZE GOOD CALLIGRAPHY, YOU NEED TO FIND A PEN, INK, AND PAPER THAT ARE ALL COMPATIBLE AND PRACTICE REGULARLY TO ACCUSTOM YOUR HAND AND EYE TO MAKING REPEATED, REGULAR MOVEMENTS. MOST PENS WILL WRITE ON A VARIETY OF PAPERS WITH MANY DIFFERENT INKS AND PAINTS, BUT YOU MAY ENCOUNTER SOME COMMON DIFFICULTIES WHEN STARTING OUT.

PROBLEMS WITH THE RESERVOIR

1 The reservoir should be loose enough to slip on and off without force, but not so loose that it falls off and drops into your ink.

2 Check tightness by slipping the reservoir off and on again, holding it by the wings.

If the reservoir is too tight, pull the two side wings apart slightly—it is made of brass and will not break.

Take the reservoir off again and check the pointed end; it may have moved out of position following previous maneuvers. Bend it inward.

5 When you replace the reservoir, the point will be bent too far over the nib, but it is supposed to be like this.

(6) As you pull it down onto the nib, the point will be sprung against the underside of the nib so it will stay touching the nib to allow it to feed ink to the slit. Adjust it further down if the pen discharges too much ink.

GETTING IT RIGHT

SLIPPERY PAPER

Powdered gum sandarac applied to the paper through a porous bag makes the surface more resistant to ink; if it is rubbed rather than dusted, it will roughen the surface slightly, which may help if the paper is slippery.

TOO MUCH INK

Dipping the pen in ink is potentially a blotchy disaster; always wipe the top on the edge of the bottle, or feed the pen with a brush.

INK BLEEDING

Some papers are too absorbent for some inks, resulting in ink bleeding into the surface and giving a line feathery edges.

OLD NIB

Compare old and new nibs—nibs wear out and result in a lack of crispness in the writing.

QUICK TROUBLESHOOTING GUIDE

WHAT'S HAPPENING	LIKELY PROBLEM	SOLUTION
The pen won't write	It may have traces of machine oil from manufacture, which will resist ink, or it may have a coat of varnish if it is the kind vulnerable to rust.	Wash it in hot soapy water and try again.
	The ink may be restricted from flowing if the nib has a too-tight slip-on reservoir.	Gently bend the wings out and slip it back on.
	The reservoir may not be feeding the ink to the slit in the nib.	Reposition the point of the reservoir so it is in direct contact with the underside of the nib, close to the end.
The pen slips across the paper	The surface is too smooth, shiny, or greasy for the pen to get enough grip.	Change the paper, or rub the surface with gum sandarac.
	The pen may be blunt.	Try another nib.
The marks are blotchy	The ink may be too thick.	Dilute it or change it—check if it is waterproof by trying to smudge it when it is dry, waterproof inks are often quite thick
	There may be too much ink all over your nib.	Shake or wipe off the excess each time you dip.
	The pen may be discharging too much ink because you are writing flat.	Adjust your surface so you are writing on a slope about 45 degrees.
	The nib may be blunt.	Try a new nib.
The ink bleeds into the paper	The paper may not be sufficiently sized to resist ink.	Change it or try a dusting of gum sandarac, which is water-repellent.
	The ink may include chemicals designed to keep it from clogging the pen, and these may be encouraging it to seep into the paper.	Try a different ink or designers' gouache mixed to inky consistency.

Looking at letters

IN ORDER TO PRODUCE BEAUTIFUL CALLIGRAPHY, YOU MUST FIRST USE YOUR EYES. OBSERVE HOW LETTERS IN ANY ALPHABET ARE DESIGNED ESSENTIALLY AS A MATCHING SET. THIS MAY BE OBVIOUS AS FAR AS THE LETTER WEIGHT AND THE STYLE OF SERIFS (THE TICKS OR CURVES OR SLABS AT THE ENDS OF LETTERS) ARE CONCERNED.

BASIC CRITERIA

Look carefully to notice an alphabet's particular characteristics. For example, observe how the widths of letters are in proportion, how the capitals generally conform to geometric principles, and how lowercase letters depend on their arch structures to create their overall character.

CAPITAL LETTERS

These were first designed by the Romans 2,000 years ago. Their forms are based on a circle within a square. The most important principle to remember is their relative widths; it might be helpful to memorize these or at least to copy them in their width groups so as to appreciate how they differ (*see right*).

LOOKING AT WIDTHS

Roman capitals showing relative widths. 1. Circular: note how round "C," "G," and "D" are. 2. Wide: approximately four-fifths of the square. 3. Half width: some protrude at the bottom. 4. "M" just bursts out of the square. "W" is much wider.

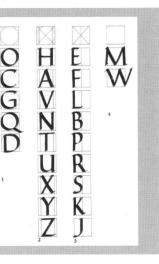

CHECKING WIDTHS

One way to check the width of letters is to use a scrap of paper with the width measurements marked along the edge. Hold it up to the completed letters to get an idea of how you are managing. This will be more helpful than writing on graph paper, as you may become dependent on the lines.

SERIFS

One feature that affects the character of any alphabet is the kind of endings, called serifs, at the beginning and end of strokes. They are generally hooks or ticks, made as part of the stroke, or thin or thick lines or slabs added as extra strokes. It is an important part of your study to notice which kind have been used in any particular example, and to be consistent when you use them.

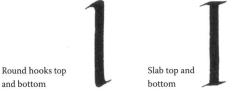

Diagonal line top and bottom

LOOKING AT LETTERS

LOWERCASE LETTERS

"Lowercase" is really a term from the days of hand typesetting when the printer kept the minuscule letters in a separate tray underneath the capitals; it has come into common usage as referring to the small letters.

Lowercase letters conform to regular shapes, but in most alphabets there are more letters with curves than there are in the capitals, and they are nearly all the same width. They differ in another way from capitals in having some letters protruding above or below the main writing lines. These are called ascenders and descenders, and help to characterize the letterforms and distinguish them from the capitals.

THE MATCHING SET

The letters in the lowercase alphabet make a matching set by being based on the shape and slope of "o" and "i"; in this case, foundational hand, based on a circular "o" and an upright "i." Notice how other alphabets conform; oval, sloped "o"s and uprights are common in italic alphabets, for example, and all the letters are narrow and sloped to match.

aokow xoz nmhuv bdpqog fbvsj

Foundational hand lowercase letters: Lowercase (minuscule) letters follow the profile of their "o," note even on the bottom of "t," "l," "i," diagonals follow its width.

How letterforms have changed through the ages (from left to right): Roman, flat uncial, angled-pen uncial, half-uncial, English Carolingian (later revived as foundational), Gothic, French bâtarde, italic.

ARCHES

Another important feature of any style of lowercase alphabet is the way the arches are formed. In an upright, circular one, the arches are joined very high up, with a separate stroke of the pen. By contrast, an italic arch is made quite differently, usually without lifting the pen from the previous downstroke, making it grow out of the first stroke like a branch.

SPACING LOWERCASE LETTERS

Look for even balance between and within letters. Some can cause awkward combinations and may need to be squeezed closely together to even out the spaces. Turning the page upside down can help you to spot open spaces and dense areas.

USEFUL TERMS

No matter what letterform you work with, you will surely come across the following terms:

x-height, also known as body height, refers to the gap between the lines in which the "o" or "x" might fit.

Counter refers to the shape inside the letter.

Ascender refers to the part of the letter that extends above the x-height.

Descender refers to the ascender's counterpart, the part of the letter that extends below the writing line.

Interline space refers to the gap between x-heights, sometimes governed by the ascender/descender lengths to avoid clashing.

Serif refers to the little hook at the entry and exit strokes of many letters.

Looking at numbers

THE ROMANS USED LETTERS TO WRITE NUMBERS—A SYSTEM THAT IS STILL SEEN IN CERTAIN FORMAL CONTEXTS. FOLLOWING THE INVENTION OF THE PRINTING PRESS IN THE FIFTEENTH CENTURY, HOWEVER, PRINTERS MORE COMMONLY USED ARABIC NUMBERS IN ORDER TO ESTABLISH AN EFFICIENT SYSTEM FOR KEEPING PRINTED BOOK PAGES IN ORDER. WITHIN TIME, CALLIGRAPHERS "ROMANIZED" THESE SYMBOLS, TOO.

Pi, by John Nielson. This dynamic design shows the decorative use of numbers. The numerals are written in contrasting weights and sizes in ink.

STYLE

Numerals in calligraphy usually match the style of the script being used. So, for example, Carolingian numbers are written with a pen angle of 30 degrees, while Italic numbers are written with a pen angle of 45 degrees. This means that numbers can be vertical and based on a circle, or compressed and slanting. However, the number "0" is always slightly compressed to distinguish it from the letter "O." Compressed numerals suit a script of similar style, such as italic, but vertical numbers can also be used with slanting letters for effect.

SPACING

When writing numerals, bear in mind that spacing should be generous for the wider, circle-based numbers and slightly closer for compressed numerals. Watch out for uneven or overly close spacing, which can cause numerals to lose their elegance.

HEIGHT

Modern numbers are written at the same height as the capitals of the chosen script, aligning both at the top and the bottom. With old-style numerals, the "1," "2," and "0" are the x-height of the script's lowercase letters; the remaining numbers descend and ascend below and above the lowercase x-height.

14TH AUGUST 1956

Vertical lined figures

14 th August 1956

Vertical old style

14 TH AUGUST 1956

Slanting lined (compressed)

14th August 1956

Slanting old style (compressed)

The examples shown demonstrate the different qualities of the main numeral styles using in different scripts. Note the different spacing requirements of the various examples shown.

With enough practice, you can master a wide range of calligraphic scripts over time. This workbook presents each of ten popular alphabet styles, complete with full instruction on making the strokes that make up the letters from "A" to "Z." A number of these alphabets—Roman capitals, uncial, half-uncial, versal, and foundational are single case only (upper or lower). The rest—Carolingian, Gothic, bâtarde, italic, and copperplate have both upper and lowercase forms to try. For each set, you will find a handful of variations to experiment with, as well as lined pages in which to practice the letterforms while starting out. This is a very satisfying way to make positive progress in the art of calligraphy.

ALPHABET WORKBOOK

The alphabets

THE ALPHABETS IN THIS SECTION OFFER AN ENORMOUS RANGE OF STYLES. IF YOU FLIP THROUGH THE PAGES YOU WILL SEE THAT THERE IS AN ALPHABET FOR JUST ABOUT EVERY OCCASION. SOME ARE MORE COMPLICATED THAN OTHERS AND REQUIRE BOTH SKILL AND EXPERIENCE WITH THE PEN.

The alphabets in this section of the book are divided into ten sets, each starting with an exciting alphabetical design related to the scripts covered. Choose one of the main alphabets, and study it carefully. Read the instructions and take note of any special features that are mentioned, most importantly, the number of nib-widths and the pen angle.

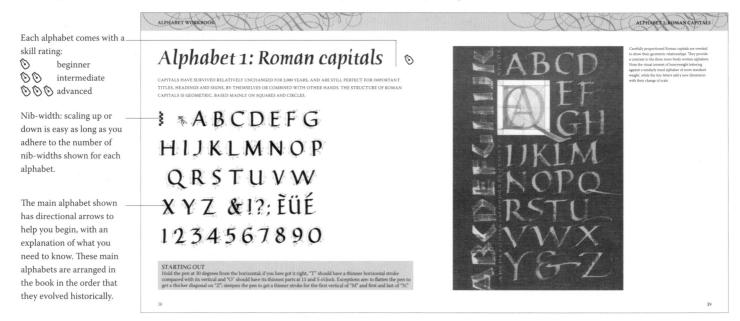

Other characteristics to be mindful of are:

- Is it upright or sloped?
- Is it round, or oval, or spaced closely together?
- How prominent are any ascenders and descenders?
- Are the arches of lowercase letters joined high up or down low?
- What are the serifs like?

The variations

THESE ARE SMALLER, IN ORDER TO FIT THEM ALL IN, BUT YOU SHOULD FIRST LEARN TO WRITE THEM WITH A PEN THE SAME SIZE AS FOR THE MAIN ALPHABET. NO DIRECTIONAL ARROWS ARE PROVIDED. THIS IS BECAUSE YOU SHOULDN'T NEED THEM ONCE YOU ARE FAMILIAR WITH THE MAIN VERSION.

> Each variation includes pen angle diagrams and an overlay of some letters to indicate how this

ALPHABET WORKBOOK	HOAND	LARA	ROMAN CAPITALS VARIATIONS	2
ROMAN CAPITALS: VARIATIONS				
RENAISSANCE A lighter-weight version of eight nib-widths, with thin serifs and nome Renaissance styling. Note the "Y" formation and the top lead-in serifs on "R," $T_{\rm F}$ and "R."	SABCDEFGHIJKLMN OPQRSTUVWXYZ &I?;ÈÜÉ 🚓 🌇 AHOP	SANS SERIF There are no serifs on this one, but it is still a standard seven nib-widths. Instead of serifs, apply subtle pressure at the beginning and end of each stroke.	ŧABCDEFGHIJKLMN OPQRSTUVWXYZ β&1?:ÈÜÉ ≝ ≲ AHOP	
HEAVYWEIGHT This is more freely written, at only five nib-widths. Make sure rou do not sacrifice good letterforms when attempting to loosen up in this way.	ABCDEFGHIJKLMN OPQRSTUVWXYZ &1?;ĚŰĚ 🛛 AHOP	RUSTICS Thick horizontals and thin verticals characterize this style. All horizontals slope downhill and bottom serifs look as if they are on tiptoes.	IABCDEFGHIJKLMNOPARST VVWXYZ61??EŬÉ KHOP	Look closely at the overlay of the letters
SLOPED STANDARD This version is seven nib-widths height and is sloped, not to be confused with an italic, which would be compressed in width.	ÌABCDEFGHIJKLMN OPQRSTUVWXYZ B&I?;ÈÜÉ ≝⊊ AHOP	PRESSURE AND RELEASE. You need some experience to do this version justice, as its beauty lies in its subtleties. Press at beginning and end of each stroke.	I ABCDEFGHIJKLMN OPQRSTUVWXYZ 8&?!!ÉŮĚ ≊K AHKOPP	"AHOP"/"ahop." They a to help you compare the variation with its paren
HEAVY AND CHUNKY Five nib-widths with slab serifs, the serifs at the ends of examples 'C'' and 'E' are made of downward strokes still at 10 degrees.	ABCDEFGHIJKLMN OPQRSTUVWXYZ &1?: ĚŰÉ 🏤 AHOP	NEULAND This heavyweight style uses thick strokes only, which means holding the pen vertically and horizontally to avoid any thins.	SABCDEFGHIJKLMN OPQRSTUVWXYZ &I?;ÈÜÉ_∞E_ AHOP	alphabet.
LIGHTWEIGHT This lightweight style can show up any besitation. Use a small sib, and be careful when blending the joins between strokes.	IABCDEFGHIJKLMN OPQRSTUVWXYZ &!?;EÜÉ ≝ Ж, АНОР	FLOURISHED FLOURISHED None rulb-widthu gives this style a lightness needed to complement the flowing extensions. Make the sweeping strokes as part of the letter.	IABCDETGHIJKUM NOPORSTUVWXYZ BEI?: ÉÜÉ 😹 AHOP	
10			41	

between the red and the black letters.

two alphabets make.

THE VARIATIONS

ahop/AHOP

In lowercase, the letters "ahop" demonstrate an ascender and descender, an arched letter, and the "o," which governs the width and shape of the others. For capitals, "AHOP" gives a selection of width letters, including the all-important "O," plus diagonals, curves, uprights, and a crossbar.

Using the workbook

HAVE FUN SELECTING THE ALPHABET TO SUIT YOUR NEEDS. WHEN YOU HAVE CHOSEN, TAKE TIME TO STUDY ITS SUBTLETIES AND PRACTICE FREQUENTLY AND CRITICALLY UNTIL YOUR COPY LOOKS LIKE THE EXAMPLE. ONCE THE WORKBOOK PAGES ARE COMPLETE, PRACTICE RULING YOUR OWN PAGES TO CONTINUE.

GETTING STARTED

This workbook takes you through the alphabets in chronological order from the earliest to the most recent. Use the guide on each opener page to see how easy the letterfoms are to master. You may wish to start with the more basic, straightforward styles before moving on to the more complex ones. You need a pen of the right width—most of the alphabets here are done using a 2.5mm-wide nib. Hold your nib against the nib-width ladder given with each alphabet to check the size. For versals, a much narrower nib is needed, and for copperplate you need a totally

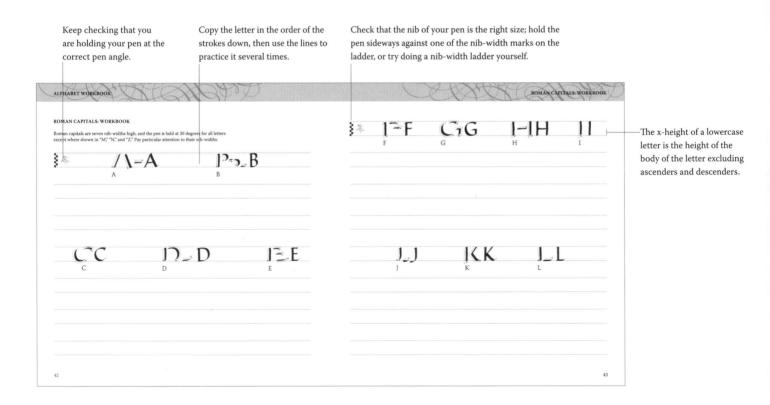

different, flexible pointed nib. The alphabets are broken down into strokes in sequence, and lines are provided underneath for you to try the letter several times. Watch your pen angle as you do so. Note that the x-height of a lowercase letter is the height of the body of the letter, excluding ascenders and descenders.

Copy each letter carefully, at the correct height and pen angle, following the directional arrows. Move on to another

RULING LINES

All the alphabets provided give an indication of how many nib-widths high to allow when ruling lines (see pages 18–19). Then you need to know how far apart each line of text should be when writing more than one line:

• Standard interline spacing; use for text where most will be in lowercase with occasional capitals. Xx Anbnendne Xx nfnGnhninj Xx knlmnoPnq Xx Rnsntnunv

- Reduced interline spacing, one lowercase x-height apart; makes a dense texture. Best for stacked single words, more would be hard to read.
- Increased interline spacing: makes a lighter texture but beware, as lines of text can appear to float away.
- Anbnendnen
 fngnHninjnk
 nlnmnonpN
 Qnrnsntnuv
- x Bnendnenfngn x.hnínjnKnlnmo x Pngnrnsntnunv

letter after three or four tries. Practice until you are able to write the script without constant reference to the model. When you are familiar with the formation of the letters in your chosen alphabet, write words and sentences on scrap paper to discover any awkward combinations. When you are fully confident writing that alphabet in the large size, you can try smaller pens; remember to check your nib-widths carefully.

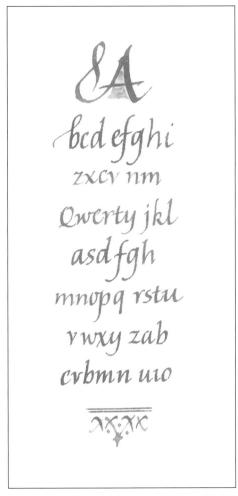

A traditional, balanced arrangement using standard interline spacing.

Alphabet 1: Roman capitals

CAPITALS HAVE SURVIVED RELATIVELY UNCHANGED FOR 2,000 YEARS, AND ARE STILL PERFECT FOR IMPORTANT TITLES, HEADINGS AND SIGNS, BY THEMSELVES OR COMBINED WITH OTHER HANDS. THE STRUCTURE OF ROMAN CAPITALS IS GEOMETRIC, BASED MAINLY ON SQUARES AND CIRCLES.

 $\mathbb{E} = \mathbb{E} \left\{ \mathbb{E} \right\} = \mathbb{E} \left\{ \mathbb{E} \left\{ \mathbb{E} \right\} = \mathbb{E} \left\{ \mathbb{E} \right\} = \mathbb{E} \left\{ \mathbb{E} \left\{ \mathbb{E} \right\} = \mathbb{E} \left\{ \mathbb{E} \right\} = \mathbb{E} \left\{ \mathbb{E} \left\{ \mathbb{E} \left\{ \mathbb{E} \right\} = \mathbb{E} \left\{ \mathbb{E} \left\{ \mathbb{E} \left\{ \mathbb{E} \right\} = \mathbb{E} \left\{ \mathbb{E} \left\{ \mathbb{E} \left\{ \mathbb{E} \left\{ \mathbb{E} \right\} = \mathbb{E} \left\{ \mathbb{E$ $|H|^{2} |I| |J|^{2} |K|^{2} |L|^{2} |M|^{2} |N|^{2} |P|^{2}$ Q R^2 T^2 U^2 V^2 V^4 XYZ &!?: ÈÜÉ 1234567890

STARTING OUT

Hold the pen at 30 degrees from the horizontal; if you have got it right, "T" should have a thinner horizontal stroke compared with its vertical and "O" should have its thinnest parts at 11 and 5 o'clock. Exceptions are: to flatten the pen to get a thicker diagonal on "Z"; steepen the pen to get a thinner stroke for the first vertical of "M" and first and last of "N."

ALPHABET 1: ROMAN CAPITALS

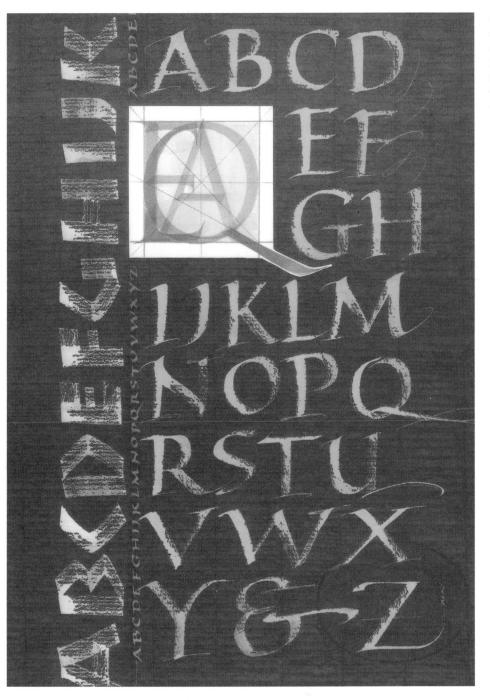

Carefully proportioned Roman capitals are overlaid to show their geometric relationships. They provide a contrast to the three more freely written alphabets. Note the visual interest of heavyweight lettering against a similarly sized alphabet of more standard weight, while the tiny letters add a new dimension with their change of scale.

ROMAN CAPITALS: VARIATIONS

RENAISSANCE

A lighter-weight version of eight nib-widths, with thin serifs and some Renaissance styling. Note the "Y" formation and the top lead-in serifs on "B," "F," and "R."

HEAVYWEIGHT

This is more freely written, at only five nib-widths. Make sure you do not sacrifice good letterforms when attempting to loosen up in this way.

SLOPED STANDARD

This version is seven nib-widths height and is sloped, not to be confused with an italic, which would be compressed in width.

HEAVY AND CHUNKY

Five nib-widths with slab serifs; the serifs at the ends of examples "C" and "E" are made of downward strokes still at 30 degrees.

LIGHTWEIGHT

This lightweight style can show up any hesitation. Use a small nib, and be careful when blending the joins between strokes.

#ABCDEFGHIJKLMN
OPQRSTUVWXYZ
&!?;ÈŰÉ ⅔ AHOP

ABCDEFGHIJKLMN OPQRSTUVWXYZ &!?;ĒÜĒ 2014 AHOP

\$ABCDEFGHIJKLMN
OPQRSTUVWXYZ
B&:?;ÈÜÉ ⅔ AHOP

ABCDEFGHIJKLMN
OPQRSTUVWXYZ
& ?; ÈÜÉ ⅔ AHOP

IABCDEFGHIJKLMN OPQRSTUVWXYZ &!?;ÈÜÉ <u>▲</u> AHOP

SANS SERIF

There are no serifs on this one, but it is still a standard seven nib-widths. Instead of serifs, apply subtle pressure at the beginning and end of each stroke.

RUSTICS

Thick horizontals and thin verticals characterize this style. All horizontals slope downhill and bottom serifs look as if they are on tiptoes.

PRESSURE AND RELEASE

You need some experience to do this version justice, as its beauty lies in its subtleties. Press at beginning and end of each stroke.

NEULAND

This heavyweight style uses thick strokes only, which means holding the pen vertically and horizontally to avoid any thins.

FLOURISHED

Nine nib-widths gives this style a lightness needed to complement the flowing extensions. Make the sweeping strokes as part of the letter. #ABCDEFGHIJKLMN
OPQRSTUVWXYZ
B&!?;ÈÜÉ ⅔ AHOP

IABCDEFGHIJKLMNOPORST VVWXYZ6!?;ÈŸÉ 70 AHOP

ABCDEFGHIJKLMN OPQRSTUVWXYZ B&?!;ÉŰÈ
AHOPP

\$ABCDEFGHIJKLMN OPQRSTUVWXYZ &!?;ÈÜÉ___90 ← AHOP

RECDEFGHIJKLM NOPQRSTUVWXYZ B&!?;ÈÜÉ [™] 32000 AJHOPP

ROMAN CAPITALS: WORKBOOK

Roman capitals are seven nib-widths high, and the pen is held at 30 degrees for all letters except where shown in "M," "N," and "Z." Pay particular attention to their nib-widths.

30%	∖ =A] ∋ =∋	<i>_</i> B
А		В	
CC	\mathbf{D}	J D	IE E
С	D		E
	7		
4			

ALPHABET WORKBOOK $\frac{3}{6} \frac{1}{2} \frac{1}$ O_{0} Э P SIS 17-1R CLQ. R S Q

Alphabet 2: Uncials

UNCIALS APPEARED IN THE FOURTH CENTURY AND REMAINED AN IMPORTANT BOOKHAND UNTIL THE EIGHTH CENTURY; IN THE SEVENTH TO NINTH CENTURIES, MORE COMPLEX VERSIONS EVOLVED, WITH A FLATTER PEN ANGLE AND COMPLEX PEN MANIPULATION. THE STYLE IS DEVELOPED FROM ROMAN CAPITALS, BUT WITH A SHALLOWER PEN ANGLE AND ONLY FOUR NIB-WIDTHS HIGH. IT IS STURDY AND ROUND, WITH SOME GREEK-LOOKING LETTERS, SUCH AS "A" AND "M." USE UNCIALS FOR MODERN AND HISTORIC WORK WHERE A LESS FORMAL EFFECT IS DESIRED.

 $\frac{1}{2} = \frac{1}{2} \frac{$ $\frac{1}{2} \frac{1}{2} \frac{1}$ $\frac{1}{10} \sum_{n=1}^{\infty} \frac{1}{2} \int \frac{1}{10} \int$ $|\mathbf{D}^2| \mathbf{e}^2 | \mathbf{A}^2 | \mathbf$

STARTING OUT

Hold the pen at about 25 degrees and check that you are keeping all the letters wide enough. Note how the stroke order of "A" is different from a Roman capital version, and this shows how it has evolved through haste into a shape that foretells its lowercase descendants (compare it with the "A" in Carolingian on pages 62–73).

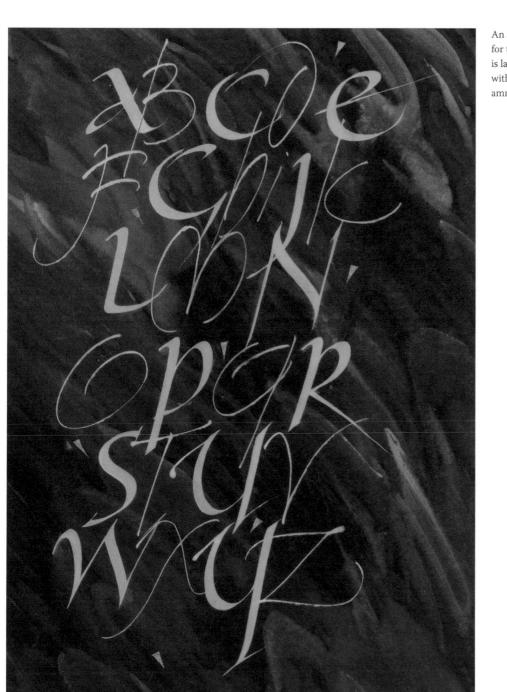

An automatic pen and a ruling pen give contrast for this lively design; the color wash background is laid with plaka, left to dry, then written over with gouaches. Finally, gold leaf is laid onto gum ammoniac. Calligraphy by Gaynor Goffe.

UNCIALS: VARIATIONS

LIGHTWEIGHT, COMPRESSED

This variation is a freer, oval interpretation at six nib-widths and at a comfortable 30 degrees; note the forward slope.

HEAVYWEIGHT

Only two and a half nib-widths high makes this very dense; it is upright with open, rounded shapes and shallow pen angle.

LIGHTWEIGHT, FREE

Try this variation when you have complete fluency in the hand, as it needs to be written with more speed, but take care to retain the letterforms.

STANDARD, COMPRESSED

This is four nib-widths but more oval than the standard and with a slight forward slope; note the "e" ligature.

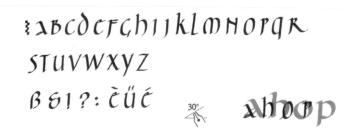

TABCOCECHIJKLON OPGRSTUVWXYZ B61?; čűć

* abop

ixbcdepghijklonн opgrstuvwxyz в €1?;èüé ^m ahop

VERY LIGHTWEIGHT

Twelve nib-widths of a thin pen gives this an outline appearance; try not to get the wobbles! Keep it upright and rounded.

IABCDEFCHIJKLMN OPGRSTUVWXYZ BE!?;ÈŰÉ **≈ ahop**

EXPANDED

This version is only three nib-widths high but spread out laterally, which makes it look more lightweight and slightly sloped—try writing this quickly.

ABCDEFGHIJKLMH OPGRSTUVWXYZ BE1?; èűé

% altopp

VERY COMPRESSED

This looks much denser than the variation above, even though it has more nib-widths, owing to the tight lateral compression. It is slightly sloped.

SQUARE

This achieves a more ancient look with a completely flat pen angle; the serifs on "C," "E," "F" etc., are made by twisting the pen onto one edge, which makes it look much heavier because of the tight compression.

\$ABCDEFGDIJkLMNOPGRSTU
VWXYZ
B 51?; ÈŰÉ
ADOPP

>ABCDEFGDIJKLMN NOPGRSTUVWXYZ B61?:èüé _____ Abop

UNCIALS: WORKBOOK

Uncials are four nib-widths high, and written at a comfortable angle of 25 degrees. Make gentle curved serifs and keep any protrusions (ascenders and descenders) minimal.

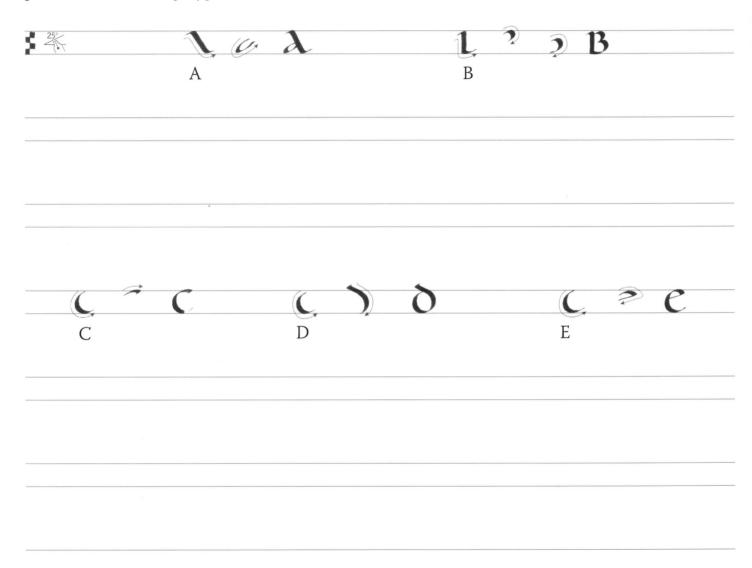

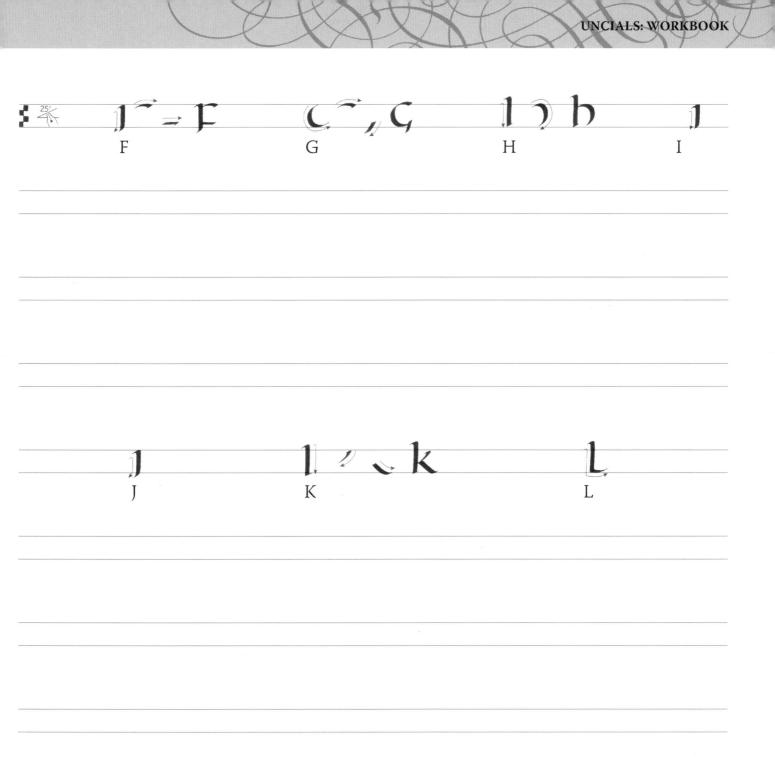

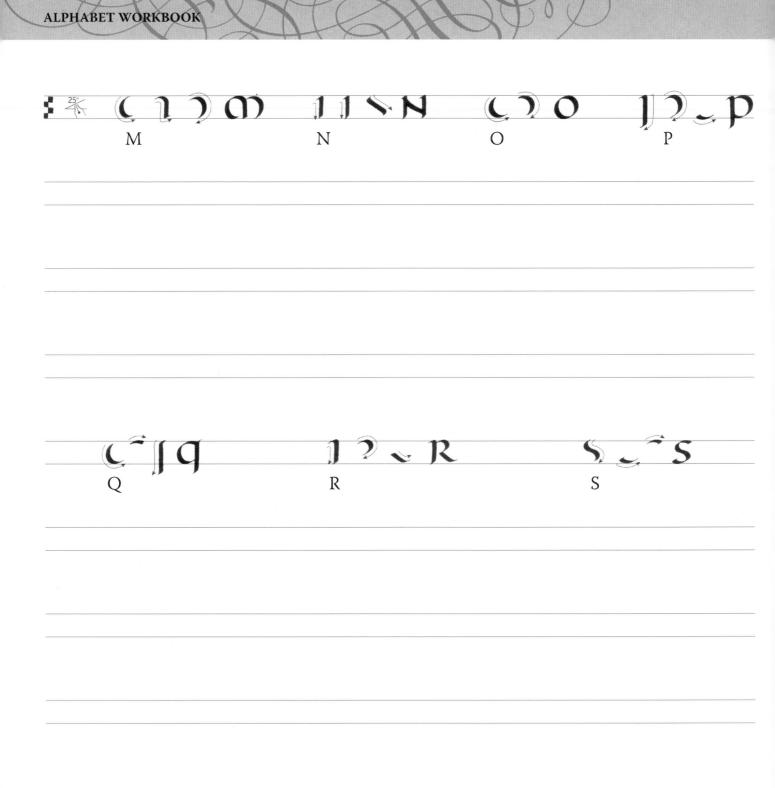

Alphabet 3: Half-uncials

THIS STYLE EVOLVED ALONGSIDE UNCIALS BETWEEN THE SEVENTH AND ELEVENTH CENTURIES. SOME VERSIONS HAVE QUITE PRONOUNCED ASCENDERS AND DESCENDERS, SHOWING THE FIRST SIGN OF A LOWERCASE DEVELOPMENT. IT IS A VERY CURVY ALPHABET THAT STANDS ON ITS OWN AS A COMPLETE ALPHABET. USE THIS HAND BY ITSELF, OR WITH VERSALS OR ROMAN CAPITALS, FOR FORMAL OR INFORMAL OCCASIONS.

hijkenvop **ARSCUVUX** YZB&!?:ěüé 123456 7890

STARTING OUT

Hold the pen very flat (only 5–15 degrees) to make thick verticals and thin tops and bottoms of curved letters. The wedge-shaped serifs add weight to compensate for that thinness; make them as a separate curved stroke and blend carefully into the stem. Keep the ascenders, if any, shallow.

ALPHABET 3: HALF-UNCIALS

The rounded nature of this hand lends itself to a compact design, inviting play with color in the shapes between letters. Automatic pen on textured watercolor paper in designers' gouaches, with patches of gold leaf. Calligraphy by Mary Noble.

ALPHABET WORKBOOK

HALF-UNCIALS: VARIATIONS

NO WEDGES

A freer version with a more comfortable pen angle and curved serifs. Notice how the curve on "H," "M," "R," and "P" branches from the main stem.

COMPRESSED, TALL

This Anglo-Saxon style looks more lowercase. Make the main strokes at 5 degrees, but twist the pen gently for the thin branching joints.

ANGLO-SAXON

Another form of Anglo-Saxon, this time with soft wedges on some serifs. Two "R"s are shown, the third "r" is actually an ancient form of "S"!

EXPANDED, SLOPING

This is still four nib-widths but is spread out to give it an informal effect. Make the branching arches on "H," "K," "M," "P," and "R" with no pen lifts.

sabcdefghijklmn opqrstuvшхyyz ß&!?;èüé

ahop

stuvwxyzß& ** ** ahop

sabedeerzhijklmno pgnrystuvwxyzßet !?:eüe ** ** ** ahop

sabcderghijklm nopqrstuvux yzBB

ahop

SHALLOW, HEAVYWEIGHT

This version is at three nib-widths and with the wedge serifs. The wedges of "D" and "T" require some pen manipulation.

adcdergghijklm Nopqrstuvuxyz β&!?;èüé

LIGHTWEIGHT

This version is at six nib-widths, with curved serifs and high branching arches. Keep the letters open and matching in widths.

sabcdergghijklm Nopqrstuvwxyyz B&!?;èüé ahop

sabcddefshijklm Nopqrstuvuxyz B&!?;èüé # ahop

sabcderghijklmwopq rstuvuxyzB&!?;eüé

3% ahop

OVAL

At five nib-widths, this is slightly compressed into an elegant oval. The wedges are understated—blend them in smoothly. Keep the pen at a consistent 15 degrees.

COMPRESSED, SLOPED

This is the same weight as above, but more compressed and with a definite slope. Note the rounded high branches on "H," "K," "M," "P," and "R."

HALF-UNCIALS: WORKBOOK

Keep a flat pen angle for these letters, so that you get thick sides and thin tops and bottoms. Blend the wedged serifs into the letter.

5° 15°			25	25"8		
	а		b			
CC		0°O		C P=€		
С		d		е		
,						

Alphabet 4: Carolingian

CAROLINGIAN WAS A NINTH TO TENTH CENTURY STANDARD BOOKHAND, PLEASANT TO READ, THAT EVOLVED IN THE COURT OF KING CHARLEMAGNE. IT HAS A ROUNDED LETTER STRUCTURE, BASED ON AN EXTENDED "O" SHAPE. THE INTERLINEAR SPACE IS LARGE (ALMOST THREE TIMES X-HEIGHT OF LETTER), GIVING AN OPEN, FLOWING LETTERFORM ACROSS THE PAGE. THE MODERN CAPITALS HERE ARE SLOPED ROMAN CAPITALS WRITTEN AT A HEIGHT OF SIX NIB-WIDTHS. CAROLINGIAN IS STILL USED AS A BOOKHAND TODAY.

} * abcdefghíjkl mnopqitituy xyz B&!?; ēue ABCDĒFGHIJK LMNQPQRSTU VWXYZ

0123456789

STARTING OUT

Hold the pen at a constant 30-degree pen angle.

Use the springing arches at the top of "B," "D," "P," and "R" as a reference for minuscule arches.

ALPHABET 4: CAROLINGIAN

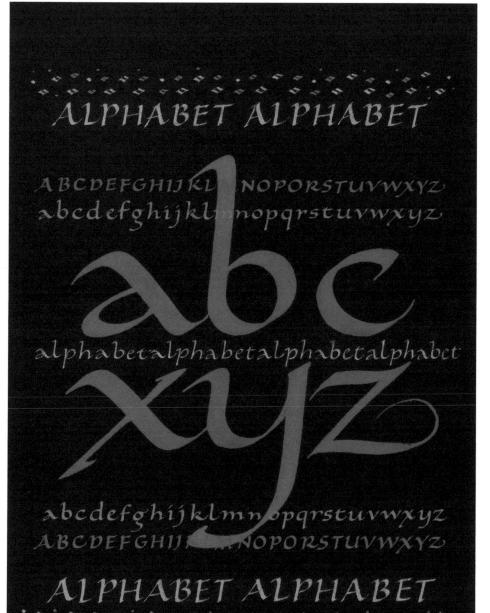

0 * 0 D

A simple, alphabetical design in which the emphasis is on letter and color harmony. It is written in gouache on black pastel paper. The capitals at the top and bottom are worked in gold gouache to create contrast. Calligraphy by Janet Mehigan.

ALPHABET WORKBOOK

CAROLINGIAN: VARIATIONS

CAROLINGIAN BOOKHAND

Early ninth-century minuscule. The pen angle is 30 degrees at nib-widths x-height and sloped. Make the "club" terminals of the ascenders with an upward, then downward movement on the stroke.

TALL AND ELEGANT

These rounded minuscules have ascenders and descenders twice the x-height with large, wedged serifs and high arches. The line spacing gives a spacious, elongated look.

MODERN FORMAL

Small, hook serifs. The ascenders and descenders are the same nib-width height as the x-height (a three to three ratio). This version is rounded and similar to foundational, but with springing arches.

SHALLOW, SLAB SERIFS

Write at three nib-widths with a flattened pen angle of 20 degrees to create this more "chunky" look. This version gives a strong linear quality across the page.

}abcdefghijklmnop rseuvwxyz B&!?;ēüé n shop

abedefghíjklmnopq rstuvwxyz B&!?ěűé **Ahop**

LIGHTWEIGHT WITH "CLUB" SERIF

Write this version using a small nib. The letterforms are based on an extended "o" to gives a delicate, open feel with an emphasis on the heavier ascenders.

HEAVYWEIGHT

Two and a half nib-widths with small serifs. Note the slight inward pull on the last strokes of "h," "m," and "n." Be watchful of good inside letter shapes (counters).

EXPANDED

This version is based on an extended "o." It is wide, with low springing arches and generous serifs.

EXPANDED: FLOURISHED

A more freely written version of the above, at three nib-widths x-height. It has wide, open letters, flowing descenders and generous serifs, so creating vitality within the letterform.

rstuvwxyz Bl?;ēűé&

CAROLINGIAN LOWERCASE: WORKBOOK

Written with an x-height of three nib-widths, ascenders and descenders are four nibwidths. Keep a constant pen angle of 30 degrees. Note springing arches on "b," "h," "k," "m," "n," "p," and "r." Round shapes are based on an extended circle.

	C A		12	6
a			b	
		a 1	d	
<u>с</u> ² с	d			<u>с</u> 2 е

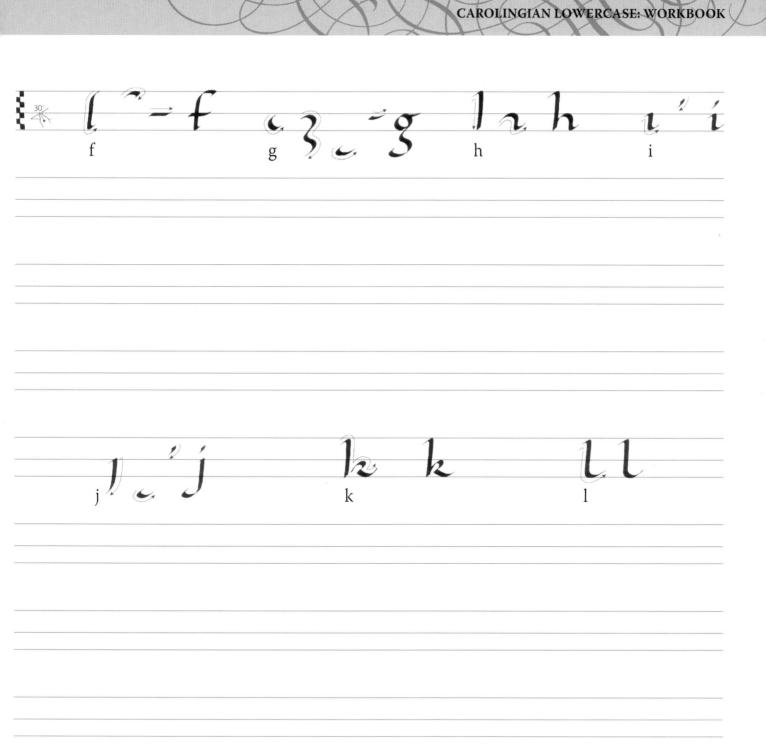

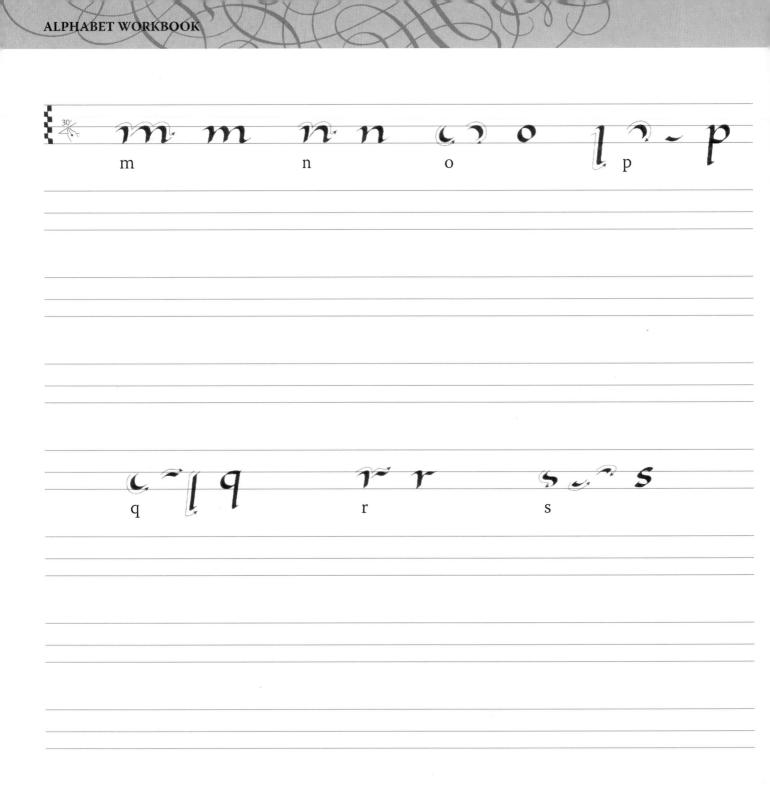

30° 1/L 11 t t 1 11 W t u V W FIZZ **X** / X VJ y х Z

CAROLINGIAN LOWERCASE: WORKBOOK

CAROLINGIAN CAPITALS: WORKBOOK

Carolingian minuscules are historically used with uncial or versal capitals. Modern Carolingian capitals are modified Roman capitals, written as six nib-widths high with a slant of five to ten degrees. Rounded with springing arches on "B," "D," "P," and "R."

30	A	=A	13 B	B	
C C	C	1,) D	D	E	- = E

30	$\int_{F}^{F} = f$	G	~ 7 (; 1] H	[= H	11 I
	J J]	1 & K	K	1 1	

CAROLINGIAN CAPITALS: WORKBOOK

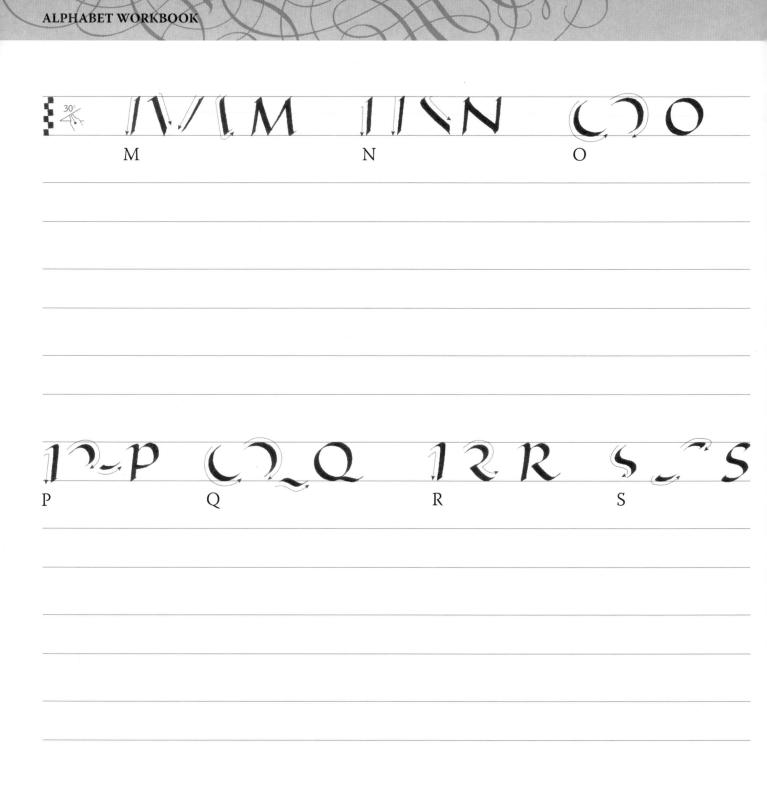

			XX	YX1	HX	XM	LS: WORKBOOK
30°	T	Ul.	U	v //	\mathcal{V}_{\perp}	w	// W
	// ^				1	7	7
X	// /		Y			Z	Ζ

Alphabet 5: Versals

VERSALS CLOSELY FOLLOW THE CLASSICAL ROMAN CAPITALS. IN BOTH HISTORICAL AND MODERN FORMS, THE LETTER STRUCTURES ARE MADE WITH COMPOUND PEN STROKES. THE FINEST EXAMPLES ARE IN NINTH TO TENTH CENTURY MANUSCRIPTS, USED AS HEADINGS OR TO DENOTE BEGINNINGS OF VERSES, USUALLY IN RED OR BLUE. ON HEAVIER FORMS THE LETTERS CAN BE OUTLINED WITH THE PEN AND PAINTED WITH COLOR.

 $= 1 \begin{bmatrix} 2 \\ 4 \end{bmatrix} \begin{bmatrix} 2 \\ 1 \end{bmatrix} \begin{bmatrix} 2 \\ 5 \end{bmatrix} \begin{bmatrix} 2 \\ 5 \end{bmatrix} \begin{bmatrix} 2 \\ 4 \end{bmatrix} \begin{bmatrix} 2 \\ 4 \end{bmatrix} \begin{bmatrix} 2 \\ 5 \end{bmatrix} \begin{bmatrix} 2 \\ 4 \end{bmatrix} \begin{bmatrix} 2 \\ 4 \end{bmatrix} \begin{bmatrix} 2 \\ 5 \end{bmatrix} \begin{bmatrix} 2 \\ 6 \end{bmatrix} \begin{bmatrix} 2 \\ 5 \end{bmatrix} \begin{bmatrix} 2 \\ 6 \end{bmatrix}$ $\mathbf{\hat{Y}}_{6}^{*} = \mathbf{Z}_{5}^{*} + \mathbf{\hat{E}}_{7}^{*} + \mathbf{\hat{E}}_{7}^{$

1234567890

STARTING OUT

Use three strokes of the pen held horizontally (0 degrees) to make the letter stem. Make curved areas using three strokes, but with the pen held at a slight angle. Give the stems a slight "waist" for elegance.

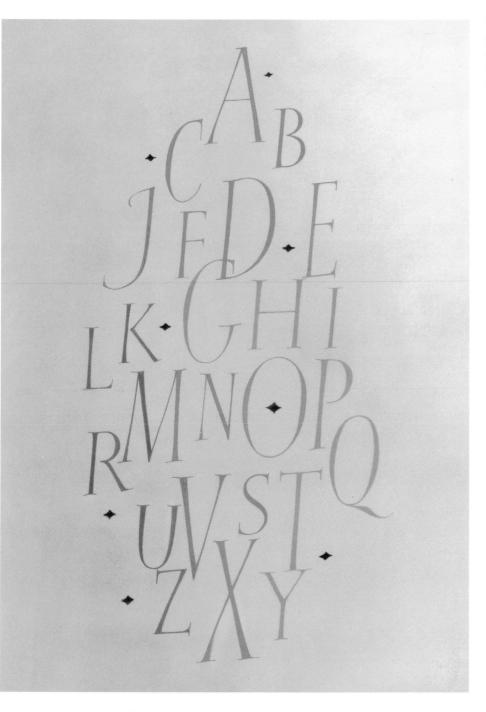

These elegant letters were pen drawn in red and yellow gouache, on a background wash of colored acrylic ink, which gives a sealed surface on which to write. Diamonds are gold transfer on raised PVA. Calligraphy by Janet Mehigan.

VERSALS: VARIATIONS

LIGHTWEIGHT, COMPRESSED

Draw this version using three pen strokes of a small nib at 24 nib-widths height. Add hairline serifs. Note the compressed shape of "D," "C," "G," "O," and "Q."

SANS SERIF

The lack of serifs on this example gives a modern look. Construct the stems with slightly curving outer strokes and fill in with the third pen stroke.

LOMBARDIC

This is based on a twelfth-century versal, used for the beginning of decorative letters and singly. Draw with a small nib and "flood-in" the letter shape with color.

SKELETON VERSALS

Draw using a small pen, at 24 nib-widths letter height. Use only two strokes for downward stems and letter curves.

 $\begin{array}{c} ABCDEFGHIJKLM \\ NOPQRSTUVWXYZ \\ \& !?; EUE \\ \xrightarrow{\circ}{\land} & \circ \in \end{array}$

 $\begin{array}{c} ABCDEFGLJK\\ LONOPORSTUV\\ MXYZ& ?; \ \tilde{E}ÜE\\ \xrightarrow{\kappa} & \checkmark & \Lambda HOP \end{array}$

MABCDEFGHIJKLM OPQRSTUVWXYZ &!?;ÈÜÉ ☆ ☆ ★ AHOP

SLOPED VERSAL (ITALIC)

This version is slightly compressed with an upward lift. It is often drawn with lateral movement, giving it the illusion of dancing on the page.

SLOPED SANS SERIF

There are no serifs on this one, but it is slightly weighted at the tops and bottoms. It looks modern and elegant.

DECORATIVE

Use a small pen for this version, at 24 nib-widths high. Make very thin strokes with exaggerated shapes on the curves. Add extended curved serifs. Draw freely and sloping.

MODERN

This version has slanted and slightly curved upright strokes. Note the slanted 20 degree serifs and their individual formation. MABCDEFGHIJKLMN OPQRSTUVWXYZ &!?; ĚÜÉ $<math>\stackrel{20}{K}$ $\stackrel{20}{K}$ $\stackrel{\infty}{\leftarrow}$ AHOPP

ABCDEFGHIKLOD NOPQRSGAVAIXYZ &!?; ĔÄĔ ²⁶ ∞ € AHOP

ABCDEFGHIJKLM NOPQRSTUVWXYZ &!?;ÈÜÉ ☆ ∞ ← AHOP

VERSALS: WORKBOOK

Versals are compound stroke capitals. Draw two vertical strokes downwards with an angle of 0 degrees. Use the same angle for serifs. Fill the center with a third stroke. The pen angle for serifs on "C," "E," "F," and "L" is 90 degrees and the angle for curves is 20 degrees.

	B B	C C C c
D	F E	= F

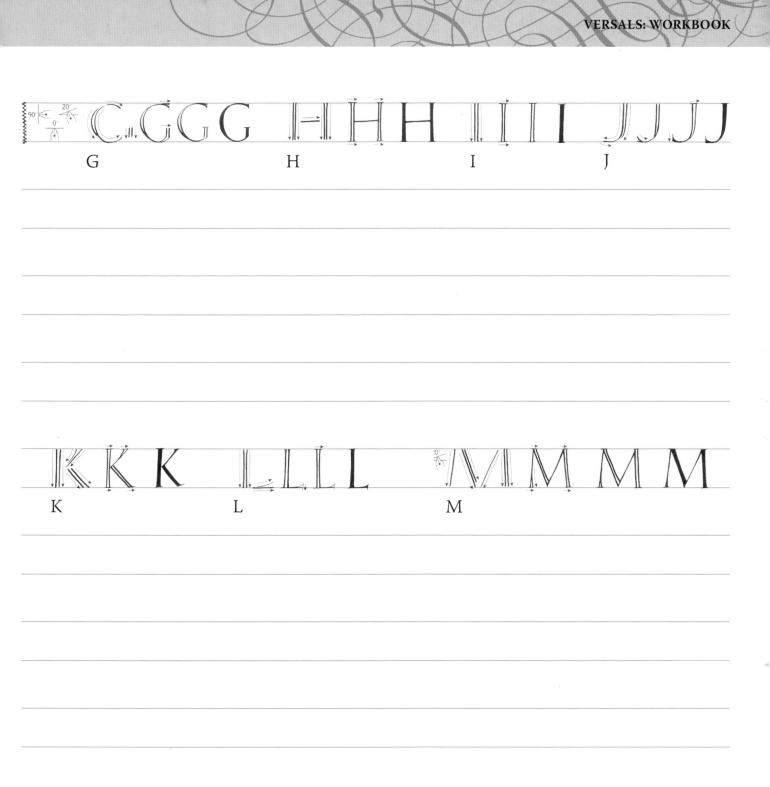

Alphabet 6: Gothic

THIS STYLE EVOLVED FROM THE CAROLINE MINUSCULE, AND BY THE THIRTEENTH CENTURY IT WAS WELL ESTABLISHED AS A PRESTIGIOUS BOOKHAND, CONTINUING IN ITS MANY FORMS UNTIL THE SIXTEENTH CENTURY.

The Gothic style has dense, angular strokes and diamond heads and feet. Written generally at four to five nib-widths x-height, with narrow counters (one to one and half nib-widths), it is very textural and difficult to read. The capitals, unlike the lowercase, are wider and rounder in shape, with the addition of elaborate hairline structures and flattened diamond shapes for decoration, which creates great contrast.

* A B C D E F G B JJRLMAOPQR STUUUXU3 abedefabí í klmn opqrstuowryzp G?!:EUÈ 30123456789

STARTING OUT

Hold the pen at 40 to 45 degrees and create the letters with many pen lifts and manipulated angles.

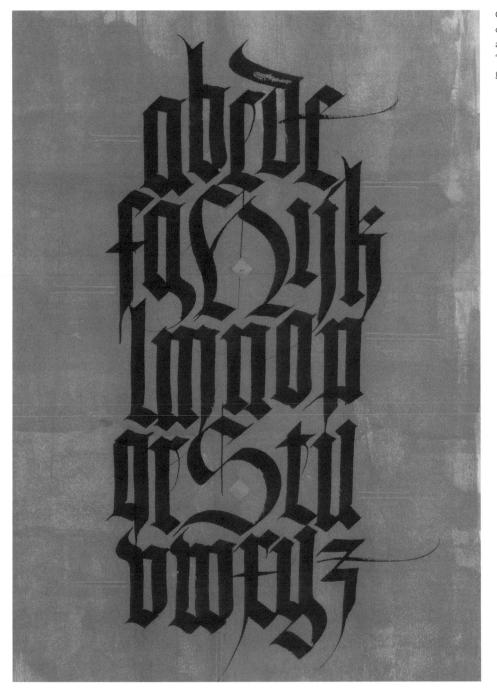

ALPHABET 6: GOTHIC

Gothic alphabet in black Chinese stick ink written on a red rollered background. An innovative contrast and use of space is created by the larger lowercase "h" and "s," with diamond inserts in yellow ocher gouache. Calligraphy by Ian Garrett. ALPHABET WORKBOOK

GOTHIC: VARIATIONS

ROTUNDA

This rounded letterform is based on a fifteenth-century Italian style. This less angular, more open Gothic style is very legible. Note the various pen angles.

ROTUNDA CAPITALS

Nib-widths of five for lowercase, and seven for capitals, makes this a more lightweight letterform than the one above. Try to write fairly freely.

TEXTURA PRESCISSUS

Use a 45 degree pen angle for this script. It is very textural and slow to write. Note some "feet" of letters are flat because of pen manipulation—flatten the pen at base of a letter, or fill the remaining shape with the nib corner.

MODERN QUADRATA

This is from the same historical period (thirteenth century), but less rigid than the letterform above, with "diamond" tops and bottoms. Write at a 45 degree angle and at four nib-widths.

ABCDEFGHIJKL MNOPQRSTUVUI XYZ sabcdefghijklmnop grstuvwxy3ß& # ** ahop

sabcdefghijklmnopq rstuvwxyzB&!?; čijć

🐁 ahop

sabcdefghijklmnopg rstuvwxyzB&!?; éüè % ahop

MODERN GOTHIC

For this simplified version, use pressure at the top of ascender to give definition. Note the direction of the strokes at the tops and bottoms of the bowls and arches.

SHAPED

This is written at an x-height of five nib-widths. It is a variation with many concave vertical strokes, which produces a more dancing texture in the letters.

CONTEMPORARY

A fractured letterform written at an x-height of six nib-widths. It is lightweight with many curved strokes and creates exciting text. It can be used as a display script.

SQUAT

Based on a design by Rudolf Koch. The mix of angles, curves, and verticals, which break part of the way up, produces a lively texture in this densely written variation. 3 a b c d efgh í j klmnopq r s tuv w y 3 8 f?!: éűè % ahop

3 abedefghíjklmnopq rstubwyyz fs?!;éűè % ahop

abcdefghiijklmnopq rstuvweyzße?!;éűè % ahop

2abedefghijklmnopqrst uvwryzßs?!; ćűè

GOTHIC LOWERCASE: WORKBOOK

Gothic lowercase uses an x-height of five nib-widths based on a squared-off oval. Inside letter space (counter) should be one to one and a half nib-widths. The space between letters equals that of the inside, giving a regular texture of black and white. Hold the pen at 40 degrees.

40%	form 1 form 2	1.1.11	a l'it	ļ
	а		b	
	LĨĽ		[?= f	
	c	d	e	

ALPHABET WORKBOOK

GOTHIC CAPITALS: WORKBOOK

Gothic capitals are six nib-widths high. They are short, full, rounded shapes, though angular in construction. Write them with the pen held at 40 degrees. Many variations of Gothic capitals exist.

* 2(= A	1? 2 B	Q°C
A	В	C
17=0	U- E	
D	E	F
	,	

4% 65°6 G	H H	I	
L R.R.			. 222
K	L	M	

GOTHIC CAPITALS: WORKBOOK

ALPHABET WORKBOOK U O272 40° N 0 U Т

		AN	GOTHIC CAP	ITALS: WORKBO
40≪ 2 () U	21	2 1 2) v	2.2." w	1 20
20-	X	2 S 2	3 Z	• 3
X		Ŷ	L	

Alphabet 7: Bâtarde

THIS IS A GOTHIC CURSIVE HAND, A MORE FREELY WRITTEN, EVERYDAY STYLE THAN THE FORMAL GOTHIC HANDS OF THE PREVIOUS PAGES. THIS SECTION CONTAINS SEVERAL VERSIONS OF SOME LETTERS, COPIED FAITHFULLY FROM FRENCH MANUSCRIPTS OF THE THIRTEENTH TO SIXTEENTH CENTURIES. THE LOWERCASE IS ONLY THREE NIB-WIDTHS HIGH, AND HAS SHARPLY POINTED ARCHES. THE CAPITALS TEND TO VARY IN HEIGHT.

abcSefghiJkl m m n n o p q r r s s t Ba!?;eüe ΛBC D Q € F BBJJJKLEMN MOD 10 LOQKSC 11 20 V W W . Y 3 Z

STARTING OUT

Drag the ink along the corner of the nib to make the hairline strokes; twist the pen on the downward stroke of "F" and "p" to get the tapering point. Some strokes may be difficult with a modern nib, as they were invented for the more flexible quill pen.

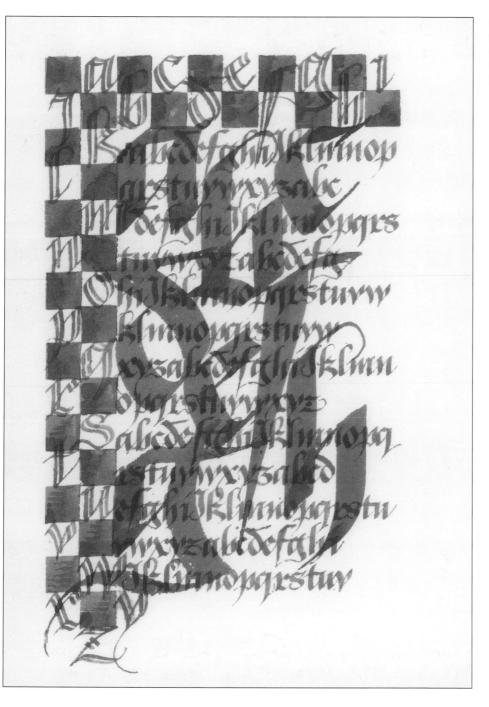

Cream-colored handmade paper sets off this design of green and brown in an interplay of overlays and contrasting sizes. The design emphasizes the more textural effects of this attractive hand. Calligraphy by Juliet Jeffery.

BÂTARDE: VARIATIONS

SIMPLIFIED

There is not so much detail here, as in the main alphabet. The main pen angle is about 37 degrees, but you need to twist the pen to get the hairlines.

SLOPED AND DECORATED

This version has refined ascenders, as well as an elegant "g" form; note the choice of arch shape on "n."

SMOOTHER

A plainer version with smooth arches. Fine hairlines on the ends of ascenders are made by skimming on the edge of the pen.

LIGHTWEIGHT

At five nib-widths this looks quite different; curved tops to ascenders and a plain "y" form; the "f" vertical is given weight with an extra stroke.

*abcdefghijklmnop qrstuvwxyz Bo-!?;Eüé % ahop

rabcdefahijklimnn
opqrstuuvvwxyyz
Bs!?; dié

;abcdefghíjklmno pqrstuvvwxyyz Bol?: eüé 35% 40%

WIDER

A more open form with some rounded features and extra decorative hairlines; note the overlapping top stroke of "g" and the foot of "h."

UPRIGHT

Written slowly and without slope, with a horizontal finish to the ascenders. Pen twists for "f," "g," "v," "w," "x," and "y." Elegant hairline descender for "g."

SWELLING

In this variation, thick strokes are subtly swelled by pen pressure, blended into pen-manipulated thin strokes and very elegant hairline extensions.

LIGHTWEIGHT, POINTED

This version is four nib-widths, compressed and sloped, emphasizing sharp points. Hairlines are pulled back onto the letter; note the top of "g" and bottom of "b." rabcdefghhiijklmm
nopgrrstuvwxyz
Ba!?; ëüé

abcdefghijklmn opqtstuvwxyz Ba!?;ēüé

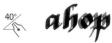

*abcdefghíjkllm
nopqrstuvwxvz
&§!?;?üé
% % ahop

rabedefghíjklmn opquistiveryz Bo!?; ëüé 💥 🛣 ahop

BÂTARDE LOWERCASE: WORKBOOK

Bâtarde involves a lot of pen manipulation, as most strokes require you to twist the nib to change from thick to hairline, usually by dragging the ink in a quick movement by the corner of the nib.

35		a a a a a a a a a a a a a a a a a a a			b b	Ø
		~				
c	Ĩ (c.) ð	5		e

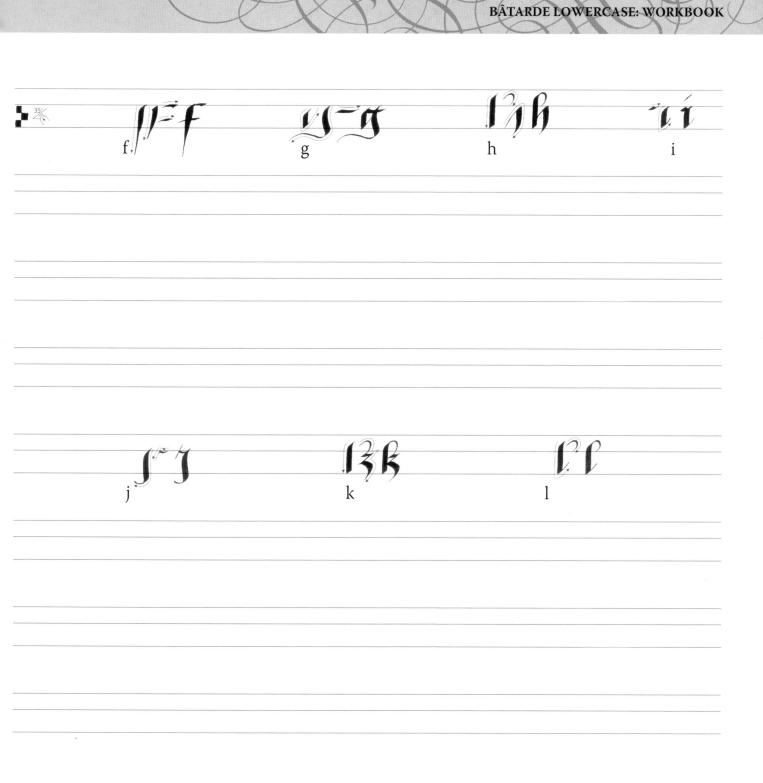

1.1.11 }¾ 1*11Č*111 (,)0 0 p m n 5.8 1.1.1 UJ.J q r S

1-1 VI II 35% 1/ V V t u v W 125 x Ζ y (

BÂTARDE LOWERCASE: WORKBOOK

BÂTARDE CAPITALS: WORKBOOK

Bâtarde capitals vary a lot in height, but on average are $4\frac{1}{2}$ nib-widths. Try to develop a light touch with free movements and pen twists for hairlines.

35%	~/C~ A	V	B	3
C C c			•	$\mathcal{C}^{2} = \mathcal{C}$

k K K	¥ 666 G	
	<u>Го</u> -Б н	BÂTARD
22	I	DE CAPITALS: WORKBOO

3× 11/111 1/11 (00 12-20 0 Ν Р М 1~X (V. Q S R Q

ALPHABET WORKBOOK

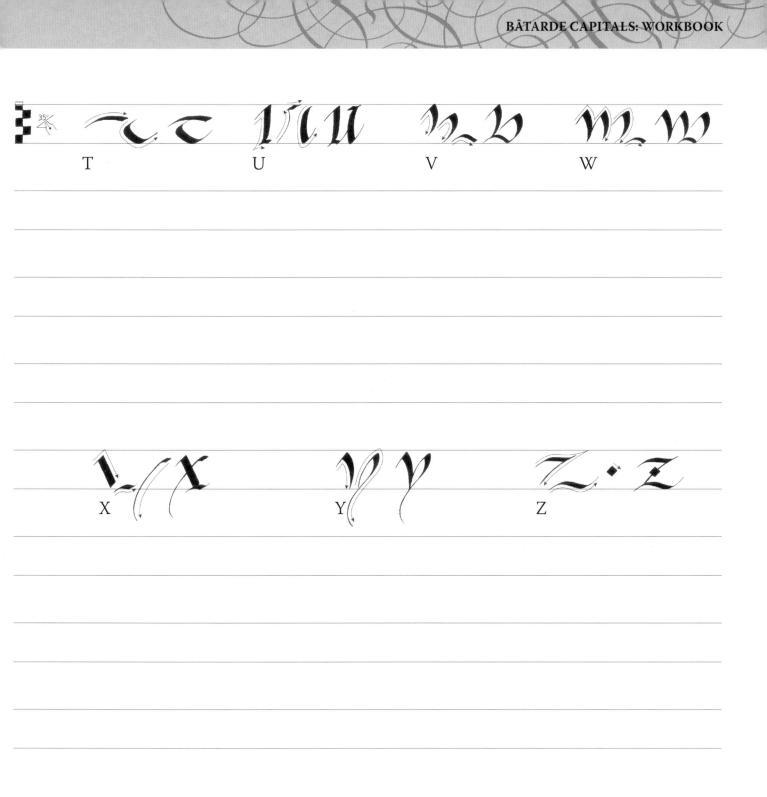

Alphabet 8: Italic

ITALIC EVOLVED IN THE EARLY FIFTEENTH CENTURY DURING THE ITALIAN RENAISSANCE, IN THE FORM OF A CURSIVE HAND DEVELOPED FROM THE HUMANIST MINUSCULES. THE ORIGINS OF BOTH LETTERFORMS LAY IN THE NINTH TO TENTH CENTURY CAROLINGIAN SCRIPTS. ITALIC IS THE MOST VERSATILE LETTERFORM AND CAN BE USED FOR FORMAL SCROLLS AND CERTIFICATES, OR FOR MORE EXPRESSIVE FORMS OF CALLIGRAPHY.

35245 $\vec{a} \cdot \vec{b} \cdot \vec{c} \cdot \vec{d} \cdot \vec{c} \cdot \vec{f} \cdot \vec{g} \cdot \vec{h} \cdot \vec{j} \cdot \vec{k} \cdot \vec{l}$ mnopqrstuvw xyzB&!?; ěűé ABCDEFGH1JK LMNOPQRSTUV WXYZ 1234567890

STARTING OUT

Hold the pen at a 5 degree slant with a pen angle of 35 to 45 degrees. Use minimum pen lifts for each letter.

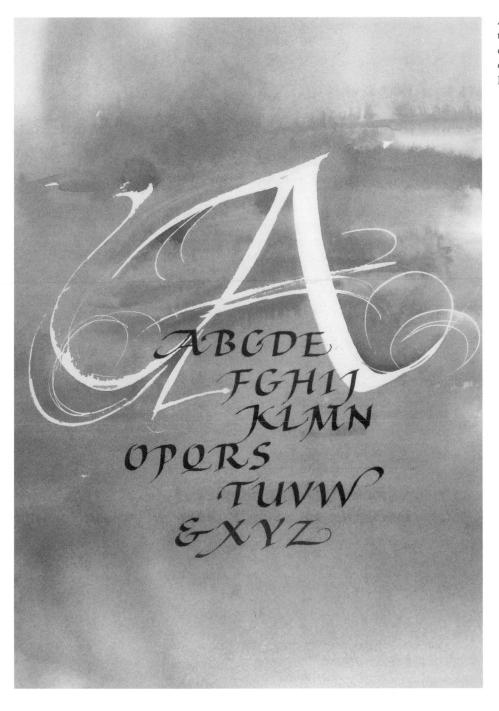

ALPHABET 8: ITALIC

An automatic pen and masking fluid were used for the large letter "A," the fine lines created with the pen corner. The "swash" capitals were written in gouache on an acrylic ink background wash. Calligraphy by Janet Mehigan. ALPHABET WORKBOOK

ITALIC: VARIATIONS

FORMAL

Five nib-widths and sloped. Write at a 45 degree pen angle. Smooth oval arches spring from about two-thirds up the x-height stem. Write slowly.

LIGHTWEIGHT, EXPANDED

Use a pen angle of 30 degrees to produce this rounder, wider letterform. An x-height of eight nib-widths makes it lightweight and spacious. Note the small hook serifs.

COMPRESSED ANGULAR

Written with a steep 45 degree pen angle and very compressed to create dense, pointed letters. The space inside and around letters should correspond to make an even texture.

SHARPENED, EXPANDED

This variation uses an x-height of five nib-widths and 40 degree pen angle. It appears lightweight because of its expansion. Note the low springing arches and pointed, angular letterform. This script has sharp serifs. abcdefghíjklmnopqrstu
vwxyz ß&!?;èüé
Anopp

abrdefghíjklmnopqrstuvwxy
z ß!?; eüé
% a hlupp

\$abcdefghíjklmn
opqrstuvwxyzß!
?; èüé
% ahop

FORMAL, FLOWING

Six nib-widths x-height and a 40 degree pen angle produces this open, oval style. The arched ascenders make the letters look elegant and flowing.

HEAVYWEIGHT

A four nib-width x-height creates a denser letterform. The 30 degree pen angle and expanded letters give a round, squat shape similar to Carolingian.

FLOURISHED

This version has a standard five nib-widths and a 30 degree pen angle. Write with rhythm and confidence. Allow extra space between lines and write using your whole arm. This is fun to try.

"SWASH" CAPITALS

Use the entire arm and write with confidence, sweeping into the letter or out, extending the letters only where it seems natural. Use this script sparingly and thoughtfully.

sabcdefghíjklmnopqr stuvwxyz ß&!?, ēűé

iABCDEFGHIJKLM NOPQRSTUVWXYZ B&I?,ÈŰÉ ³⁸€AHOP

ITALIC LOWERCASE: WORKBOOK

Italic lowercase letters are five nib-widths high, written with a pen angle of 40 degrees with springing arches to the letters "b," "h," "k," "m," "n," "p," and "r." Write with a slant of five to ten degrees from the upright.

×.	С. ² Ц. С. а		10=b b	
C. c	C	<i>C. - 1</i> , d	d	€. 2 € e

ALPHABET WORKBOOK × mm n n() \cap p m n 0 1 U 5. 5 S q r

ITALIC LOWERCASE: WORKBOOK 40% ULU 1/1./ W 1 11 t V W u VJ 1 / X y х

ITALIC CAPITALS: WORKBOOK

Here the italic capitals are written at seven nib-widths with a pen angle of 40 degrees. They are based on compressed Roman capitals with a slant that ranges from 5 to 10 degrees. Note the small hook serifs.

40%. A	$=A$ P_{B}	¬ B
C ² C c		1 = = E E
		•

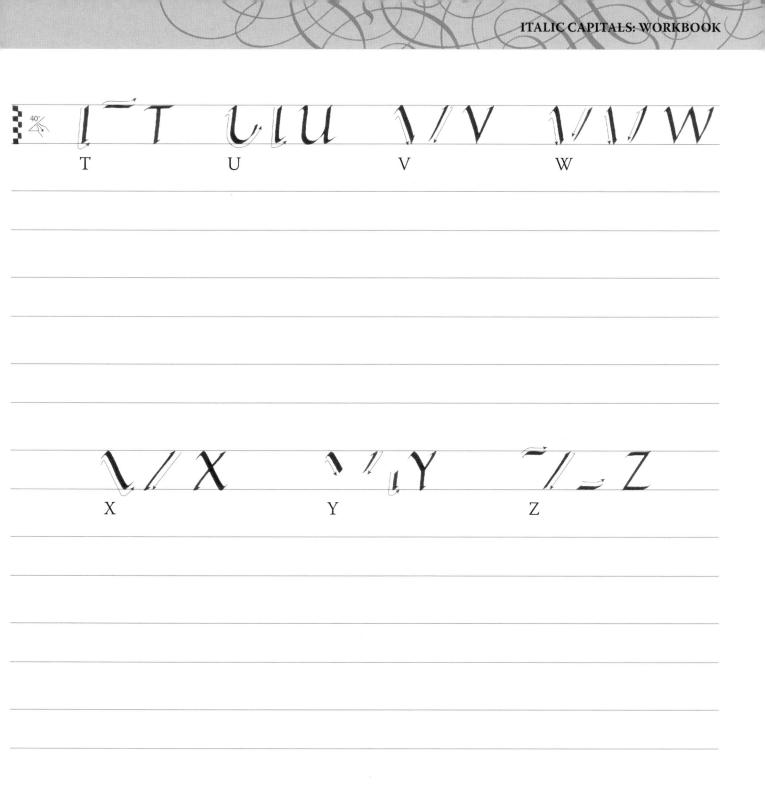

Alphabet 9: Copperplate

COPPERPLATE, ALSO KNOWN AS ENGLISH ROUND HAND, HAS AN OVAL SHAPE WITH A STEEP SLOPE AND A FLOURISHED STYLE THAT HAS BEEN DEVELOPED FROM ITALIC AS AN ENGRAVER'S SCRIPT FROM THE SEVENTEENTH CENTURY. THE ASCENDERS AND DESCENDERS ARE TWICE THE X-HEIGHT OF THE LOWERCASE LETTERS, AND THE CAPITALS COME ABOUT THE SAME HEIGHT AS ASCENDERS. USE COPPERPLATE FOR FORMAL OCCASIONS AND FOR PROJECTS THAT ALLOW ITS DECORATIVE ASPECT TO BE FLAUNTED.

INUVOWA: abodeffghijklmno Æ sæ LO. 2ª £! &: "? BEA OEE() 0123456789

STARTING OUT

You hold the special flexible pen totally differently from the broad-edged kind. Turn the paper and your hand so the pen is directly in line (parallel) with the steep 55 degree writing slope. Pull down towards you while applying pressure for downward strokes and use very light pressure for the upward strokes so you do not dig into the paper.

The complexity of this design becomes increasingly apparent as you follow some of the decorative outer flourishes and find where they originate. Careful planning and skilled penmanship have resulted in beautiful artwork. Calligraphy by Frederick Marns. ALPHABET WORKBOOK

COPPERPLATE: VARIATIONS

STRONG DOTS

The capitals have a pronounced dot at the left-hand edge of their flourish. Modest flourishes keep this version of the script comparatively simple.

Aa Bb Cc Dd Ee Ff Gg Hh Ji Jj Kk Ll Mm Nn Oo Pp Lg Rr Is It Un Vv Ww Xx Yy Iz Bg!!; éüé

HEAVYWEIGHT

This version is the trickiest; the weight is achieved by a double line and filling in! The weight allows "B" and "D" to have one joined flourish without distorting the letters.

Aa Bb Cc Dd Ee Ff Gg Hh Ii Jj K k Ll Mm Nn Oo Pp Qq Rr Ss It Uu Vv Mw Xx Yy Iz B& !!; èüé

MEDIUMWEIGHT

For this version, make two strokes for the heavy lines if you cannot achieve it with pressure. Flourishes on capitals are short self-contained curls. The points of "M" and "N" are looped.

Aa Bb Cc Dd Ee Ff Gg Hh Ii Jj K k Ll Mm Nn Oo Pp Qq Rr Ss It Uu Vv Ww Kx Yy Zz & & !!; èü é

WIDER

This version is slightly more open laterally, and of a standard weight. The flourishes in the capitals are more open; the dots are small but make a nice pattern.

Aa Bb Cc Dd Ee Ff Gg Mh Ii Lj K k Ll Mm Nn Oo Pp QqRr Is It Uu Vv Ww Xx Yy Zz B g.!?; è ü é

COPPERPLATE LOWERCASE: WORKBOOK

Turn the workbook until the slopes of the letters are vertical and the writing line goes uphill. Hold the special pointed nib vertical, making light upward strokes, and pressing for downward strokes.

1 a a b а C 1. :C; e d С е

COPPERPLATE LOWERCASE: WORKBOOK

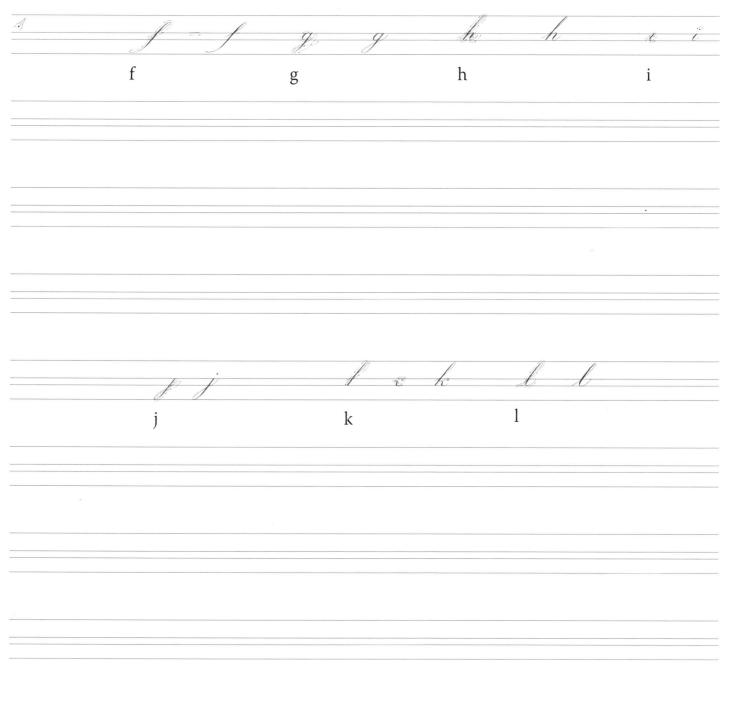

ALPHABET WORKBOOK

13 W W W O h m 0 р n inf nje. no 1 q r S

COPPERPLATE LOWERCASE: WORKBOOK

1 1-H U V HO U t u V W Y X Ζ Х у

COPPERPLATE CAPITALS: WORKBOOK

Turn the workbook until the slopes of the letters are vertical (and the writing line goes uphill). Hold the special pointed nib vertical, making light upward strokes and pressing for downward strokes.

A cA cA	S B	C Q	R Ø) D
A	В	С	D	
E E		F	Ċ	G
Е	F		G	

COPPERPLATE CAPITALS: WORKBOOK Ì A. I. F.C 1. C.J C. O Н Ι L'K M.M 0 Κ L М

ALPHABET WORKBOOK Ó.c 1. -0 Р Q Ν . Q.J. \sim 5 Ċ 3 2 S R Т

COPPERPLATE CAPITALS: WORKBOOK 1. U V W $\frac{2}{2}$ Y Y Ce 1 Х Y Ζ

Alphabet 10: Foundational

FOUNDATIONAL HAND WAS DEVISED BY EDWARD JOHNSTON (1872–1944), BASED ON HIS STUDIES OF NINTH AND TENTH CENTURY MANUSCRIPTS, IN PARTICULAR THE RAMSEY PSALTER (HARLEY MS 2904, BRITISH LIBRARY), A CAROLINGIAN SCRIPT. THE MODERN FOUNDATIONAL HAND IS SLIGHTLY DIFFERENT FROM THE ORIGINAL MANUSCRIPT. WHILE WE USE CLASSICAL ROMAN CAPITALS WITH THIS SCRIPT, THE CAPITALS WOULD HAVE BEEN UNCIAL OR VERSALS IN THE TENTH CENTURY.

 $= \underbrace{\mathbf{A}}_{\mathbf{A}} \cdot \underbrace{\mathbf{B}}_{\mathbf{A}} \cdot \widehat{\mathbf{C}} \cdot \underbrace{\mathbf{D}}_{\mathbf{A}} \cdot \underbrace{\mathbf{F}}_{\mathbf{A}} \cdot \widehat{\mathbf{F}}_{\mathbf{A}} \cdot \underbrace{\mathbf{F}}_{\mathbf{A}} \cdot \underbrace{\mathbf{F}}_$ RSTUXXXZ abcdefight lmnopqrstuv WXYZBE?!;EŰE \$012345 6789

STARTING OUT

Write upright at four nib-widths x-height, with a constant pen angle of 30 degrees (except diagonals). Form the letters using frequent pen lifts, beginning and ending with small serifs. This gives the script its formal characteristics.

Well-proportioned and executed lowercase foundational alphabet with controlled hairline extensions to "e," "g," "j," and "s." Written with an automatic pen and red ink on red ink background washes giving it vibrancy. Calligraphy by Ian Garrett.

ALPHABET WORKBOOK

FOUNDATIONAL: VARIATIONS

HEAVYWEIGHT

Write at an x-height of three nib-widths with wedge serifs for a slightly stronger look. Note the high, firm arches of "h," "m," and "n."

LIGHTWEIGHT

Five nib-widths x-height and slab serifs throughout give this variation elegance rather than strength.

HEAVYWEIGHT

This version is only two nib-widths x-height, with letters stretched laterally to preserve internal spaces. Note the slab serifs. This gives the letterform a very strong texture.

COMPRESSED

Based on an almost straight-sided "o," this variation of the script has a rhythm of emphasized verticals. Note the small serifs and pen angle changes.

sabcdefghíjklmno pqrstuvwxyzß&?!; éűè

💥 🎋 ahop

wabcdefghijklm
nopqrstuvwxy
zBG?!;éűè

ahop 🖏

COMPRESSED, SLANTING

This has rounded arches and a flattish pen angle of 20 degrees that is characteristic of foundational. The steeper angle refers to the first strokes of "v," "w," "x," and "y."

CNUT CHARTER

This version has compressed sloping letters, springing arches and pen manipulation on many strokes. Based on an early eleventh-century manuscript. Note the inward pull on "u," "h," "m," and "n."

HEAVY COMPRESSED

Strong compression and a somewhat flat pen angle (25 degrees), give this variation a dense texture. Note the use of wide, low capitals to break the pattern.

INFORMAL AND FREELY WRITTEN

A variation at four nib-widths, with manipulated pen angles. There are hairline serifs, several ligatures, and movement (dancing) in the lines of writing.

a b c d e f g h í j g j k k l m n o p q r s tu v w x y z \$8??!;éűè

ahop

\$abcdefghíjklmn
opqrstuvwxyzß
&?!;éűè
¾ ahop

FOUNDATIONAL: WORKBOOK

Foundational letters are four nib-widths high, and the pen is held at 30 degrees for all strokes except thick diagonals of "v," "w," "x," and "y." (use 45 degrees) and diagonal of "z" (0 degrees). Letter arches follow the arc of a circle. Keep bottom serifs small.

30%	J& 3		ləb	
	a		b	
	C ? C	c]=d	(?(2
	C	d	e	

<u>∦111</u> m	11 N n	0 0	p. 1. 2- 1
C1q	1 - T r	s S	<u> </u>

30% 111 11 L V t u W V z = 1 - ZX / Xy y х

FOUNDATIONAL: WORKBOOK

Design & Color

Once you have established a way of working, and have mastered a number of the scripts in the preceding Alphabet Workbook, you can start to create works of your own. Having chosen a text to work with, your main concerns should be finding an appropriate script, deciding on an effective layout, and choosing a color scheme for the piece. This section looks at a number of basic guidelines and techniques that will help you make the right decisions about design and color. There is sound advice on the principles of designing a layout, on different ways of looking at calligraphic scripts, and on the basics of color theory. It will only be a matter of time before these aspects of calligraphy become second nature to you.

Which script?

WITH SO MANY SCRIPTS TO CHOOSE FROM, IT IS DIFFICULT SOMETIMES TO DECIDE WHICH ONE WILL BE APPROPRIATE FOR YOUR NEEDS, ASSUMING YOU HAVE DEVELOPED A GOOD COMMAND OF A NUMBER OF SCRIPTS.

REACHING A DECISION

Personal preference does have a part to play, but think also of the purpose of the piece of work, and the meaning of the words. Gothic, for example, is very decorative, but would be an unwise choice for an urgent notice, as it is difficult to read. While some styles have strong historical associations, they can all be used for modern work; many of the variations shown in the Alphabet Workbook (see pages 32–137) indicate modern renderings.

COMBINING SCRIPT STYLES

It is usually best to confine yourself to one or two related styles in any one piece of work. Several variations of the same style are more likely to unify a piece of work than the same number of unrelated styles. This is largely because of the family resemblances in the way the letters are formed.

For example, several different weights and sizes of italic capitals and lowercase, even if they include blocks of variations in style and line spacing, will look more unified than the same text in a combination of say Gothic, uncial, and copperplate. Classical Roman capitals go with anything, as do versals that are based on them. The most suitable hand to use with an initial depends on its style:

- For Roman capitals, use Carolingian or foundational, or italic, if it is a modern design
- For plain versals, use Carolingian, foundational, or italic
- For an uncial form of versal, use uncial or half-uncial
- For an ornate "Lombardic" style, use Gothic

One rule-breaking example where a combination of letterforms has worked because their relative sizes are carefully balanced; note the unusual placement of the focal point at the bottom. Calligraphy by Timothy Botts

FORMAL PROJECTS

A certificate or formal notice calls for dignified, carefully formed, regular letterforms, giving a fairly static look. Roman capitals, versals, foundational, formal italic (although, not the nearly joined-up variations), or some uncials might be good choices, as are the more restrained versions of copperplate. Decorative elements or a flourished initial letter may be included for visual interest.

HISTORICAL ASSOCIATIONS

Sometimes the words you have chosen to write are linked to a particular country or to a past age, making it appropriate to use the hand associated with that link. Some examples are listed here.

Roman capitals: Classical; timeless quality.

Uncials and half-uncials: These are associated with Ireland, Scotland, and Northern England in the early Christian era. There are narrower half-uncials and an Anglo Saxon form. Carolingian: An elegant hand with French connections. Decorative versals: The 'Lombardic' versions traditionally are used as initial letters only, and go with Gothic text.

Plain versals: These are more like Roman capitals and thus have broader associations.

Gothic: Germany; many German calligraphers still use freeform versions, but the highly decorative kinds have medieval associations.

Bâtarde: Late-medieval French, a more cursive form of Gothic. **Italic:** From the Italian Renaissance. "Humanist" versions have a historic feel, but it has become the most popular hand for present-day use owing to its versatility.

Copperplate: Seventeenth and eighteenth century, the most ornate decorations are associated with Victorian England, which combined them with Gothic forms.

Foundational: A modern interpretation of the tenth century, similar to late Carolingian style. Foundational is mainly used as a formal, contemporary hand.

ABCDEFGHIJKLMN Roman capitals

$\Delta BCOCFGDIJKLMN$

abcdergghijklm

abcdefghíjklmnopqr

A B C D E F G H I J K L M

abcdefghijklmnopg

abedefghijklmnopgrst

abcdefghíjklmn

DESIGN & COLOR

POSTERS

The function of a poster is to catch the eye, and then to give the salient points at a glance. That eliminates many alphabets of a decorative nature, although they may be used for the secondary information. Size and weight are important—you need impact. Space your main title closely and use a bold hand; group other information so that it reads in a logical order. Heavyweight capitals, italic, thick versals, and uncials all catch the eye, and a smaller, less heavy version, or a linked script are good choices for the rest of the text.

was a fresh frosty morning as we set out and it was divided that we should travel by the coast road since my friend and Their like a bit of sceney. The light wind on the Shannon was like a young girl whispering- and any friend whistled happilly while we speciover the tree-lined roadway at twenty five miles an hear. Sites in good order this morning he said, 'and what harm but she has had akard week of it: The down rartied merrity ar dis unexpected compliancer back caone a succession of clanging noises. As we neared Tones she stopped, for no rasson at all. "That's all right, my friend sid, we'll give here arest it. sid as the for wind back. Ten minutes passed and he started her again. All wert

BOOKS

If you have chosen to make a book, choose a hand that looks right in a small size—and one that you can write competently and achieve an even overall texture. The margins and the interline space will be important factors to consider in a book, where every page will look similar. Experiment with widening or narrowing the interline spaces, and giving lots of margin.

The usual scripts associated with writing books, referred to as "book hands," are the easily read lowercase hands such as italic and foundational, but the subject will be the determining factor. An old German story might be appropriate in Gothic and a Scottish folktale may look better in uncial or half-uncial.

An experimental piece exploring letterforms that vary in size as they lock together, depending on the shape of the previous letter and the counter space. Calligrapy by Brian Walker

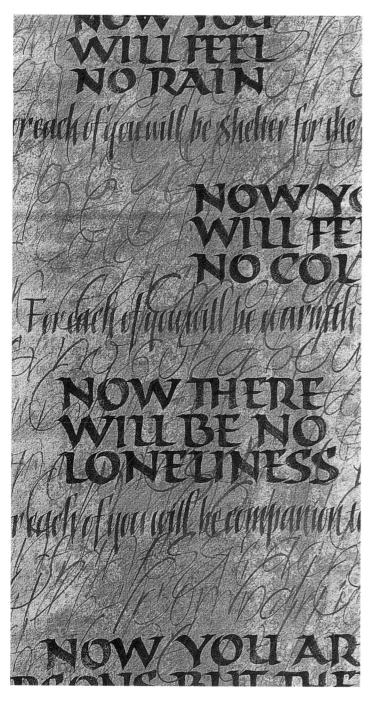

POETRY AND QUOTATIONS

Poems are a favorite subject for calligraphy as they can be interpreted visually with a script that fits the mood and creates the visual effect for the composition. Italic is very adaptable for interpreting texts in this way pointed versions evoke anger or agitation, while soft, expanded versions give gentle effects. Carolingian also has a wide, relaxed appearance, and its tall ascenders demand wide line spacing.

Some of the half-uncials have a lively movement and would suit

cheerful words, as do the more freely written uncials. Copperplate is both controlled and lively, and would suit many situations in place of italic. The bâtarde hands are visually pleasing, decorative, and, in some cases easier to read than the Gothics. If the poem asks for a heavy, solid approach, Gothic can sometimes fit the requirement; executed with a very large pen, the regular heavy strokes interspersed with equal amounts of white can give a very sturdy effect.

GREETING CARDS

Some cards are informal opportunities to play with letterforms, group or repeat words over and over for a pattern effect, make a feature of one letter or a short work, and incorporate decorative borders. The nature of the occasion may suggest the choice of script, but there are no rules. This is a chance to have some fun and experiment with unusual combinations, and to explore the potential of certain hands that intrigue you. If a particular hand excites you but seems inappropriate, try it in a much bigger or smaller size to see if scale makes a difference. **DESIGN & COLOR**

Margins

WHEN YOU USE YOUR WRITING FOR A FINISHED PIECE OF WORK, THE MARGINS YOU CHOOSE MAKE AN IMPORTANT CONTRIBUTION TO THE OVERALL EFFECT. TO SHOW YOUR WRITING IN ITS BEST FORM, YOU NEED TO BALANCE THE TEXT AGAINST THE SPACE AROUND AND WITHIN IT.

GETTING THE PROPORTIONS RIGHT

The amount of space between the lines, between areas of text, and between heading and text helps determine the proportions of the outer margins. Too much space weakens a design, while insufficient space makes it look cramped. Generous margins are generally preferable to narrow ones, because surrounding space gives the text unity. Many designs use the traditionally proportioned margins found in printing and picture framing, and these are easy to calculate. Others may flout convention to achieve a particular effect. Each piece of work has its own requirements. Your ability to assess margins will gradually become intuitive as your experience accumulates.

A general rule to follow is that side margins should be equal, but the bottom margin should be larger than the top, so that the work does not appear to be slipping off the page. If a title or author's name is used, this should be considered as part of the text area when measuring margins.

CALCULATING MARGINS FOR A VERTICAL LAYOUT

For a vertical panel of text, the top margin is gauged by eye and doubled for the bottom margin. A measurement between these two is used for the sides.

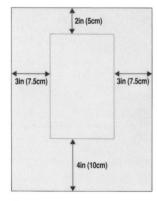

1 The top is 2 inches (5cm), the bottom 4 inches (10cm), the sides 3 inches (7.5cm).

2 lin (5cm) 2 lin (5cm) 2 lin (5cm) 2 lin (5cm) 4 lin (10cm)

2 An equal measurement for top and sides with a deeper bottom margin is sometimes appropriate.

For a horizontal panel of text, the widest space needs to be at the sides.

CALCULATING MARGINS FOR A HORIZONTAL LAYOUT

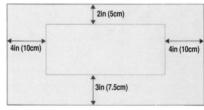

 The measurements are 2 inches (5cm) at the top, 4 inches (10cm) for the sides, 3 inches (7.5cm) for the bottom margin.

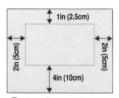

2 An alternative formula. The side margins should always be equal for centered text.

ASSESSING MARGINS USING CARDBOARD STRIPS

Cardboard strips can be used as a framing device to help you determine the most suitable margins for your work. Make a collection of strips in varying sizes from 2 to 4 inches (5 to 10cm) wide: four of each width at different lengths (two long,

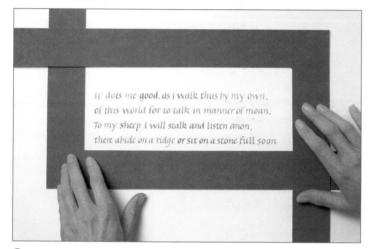

1 Place the strips or L-shaped pieces to make a frame.

two short). L-shaped pieces of cardboard can also be used in the same way. You may be able to obtain scraps from a picture framer, or you could use old mats cut into L-shapes that, together, form an adjustable rectangle.

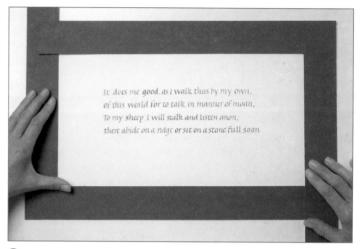

2 Experiment by moving the strips toward, and away from, the edges of the text. Here the text is "lost" within margins that are too wide.

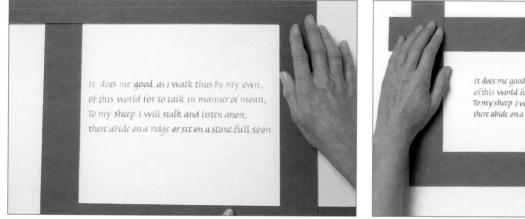

3 Take care not to cramp the text between narrow side margins.

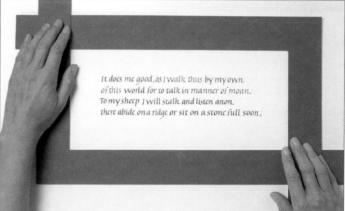

④ When the balance between text and white space looks right, mark the chosen margins with a light pencil point in each corner.

Layout basics

LAYOUT IS THE ARRANGEMENT OF TEXT (AND ANY ILLUSTRATION) ON THE PAGE. THE AIM IS TO BRING TOGETHER THE VISUAL AND TEXTUAL CONTENT OF THE WORK IN A WAY THAT IS ATTRACTIVE, HARMONIOUS, AND LEGIBLE. TO SOME EXTENT, LAYOUT WILL BE DICTATED BY THE PURPOSE OF THE WORK, THE DEGREE OF FORMALITY OR FREEDOM INVOLVED, AND THE MOOD DESIRED.

DECIDING ON A FORMAT

No single format will suit every case. Creative decisions always depend upon individual judgement. This is an exciting area for discovery, but there are formulas and guidelines to help you.

Layouts can have a vertical or horizontal shape, and text may be aligned left, aligned right, justified, centered, or asymmetrical. Deciding which arrangement to choose means considering the overall texture of a piece of work in terms of positive and negative shapes—marks on the page and the spaces between them. Accustom your eye to looking for weak features when planning your layout, and aim for bold, rather than understated contrasts, such as large and small, dark and light, and strong and weak.

The choice of layout also depends on the sense and mood of the text, and the way it is divided into lines. For a poem, line endings need to be kept as the poet wrote them. In interpreting prose, line breaks can be manipulated to enhance the meaning of the text. It is common to have lines of five to nine words in a relatively lengthy text. In short texts, just one or two words per line can provide an interesting layout. Line spacing and the style of script—tall or laterally spread letters—will also affect the shape of the text area. It is useful to begin by making thumbnail sketches—small, quickly delineated inspirational drawings that play with design ideas.

SIZING UP

Many works of calligraphy begin with a thumbnail sketch. To convert this to a full-size layout, draw a diagonal line from the bottom left corner of the thumbnail to the top right of the larger sheet. If the measurement is twice the size of the original, for example, all measurements should double, including the nib size. An alternative method would use a photocopier to enlarge the thumbnail.

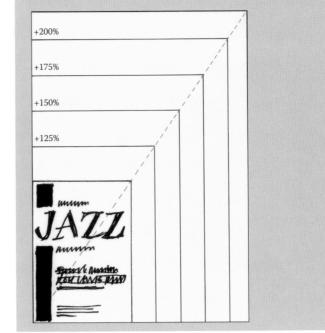

TYPES OF LAYOUT

There are a number of factors that affect your choice of layout:

- Who is the text for?
- Where will the text be displayed?
- How much text is there?
- Are there other components—heading, subheading, author, title, or date, for example?
- Is the text poetry that must retain its line scheme?
- Is the text prose, and where should line breaks come?
- How long are the lines?
- What is the meaning of the text?
- What is the mood of the text—lively, static, formal, or informal?
- Does the text need decoration, and of what kind?

CENTERED

The writing lines are balanced equally on either side of a central line (drawn faintly in pencil for guidance and erased when writing is complete). This symmetrical layout is often useful when balancing long and short lines. A centered layout is most suitable for poetry or short prose pieces.

ALIGNED LEFT

All writing lines begin from a straight, vertical left margin. This gives a strong left edge and a softer right-hand effect. Avoid marked variations in line length and split words. This is a versatile layout, used for both poetry and prose.

ALIGNED RIGHT

The lines are aligned vertically on the right. This layout can be effective in giving tension to a design in a slightly unexpected way. But it takes practice to achieve the necessary accuracy of letter widths and spacing. This layout is often seen in short texts, such as letterheads.

ASYMMETRICAL

This is a layout that does not conform to an established alignment and yet maintains a sense of balance. A key feature is the nonalignment of most or all line beginnings and endings. The informality of the layout lends itself to texts of all kinds where this effect is appropriate.

JUSTIFIED

Both right and left edges are vertically straight. Skill is needed to calculate word spacing to achieve this effect. Justified layouts produce a formal effect that is useful for prose work.

Cutting and pasting

PLANNING A LAYOUT AND MAKING A DRAFT VERSION TO GUIDE YOUR FINAL WORK IS BEST DONE BY THE METHOD KNOWN AS "CUTTING AND PASTING." THIS AVOIDS THE PROCESS OF REPEATEDLY REWRITING A TEXT IN A PARTICULAR FORMAT EACH TIME A PROBLEM ARISES. CUTTING AND PASTING ENABLES YOU TO REASSEMBLE THE TEXT QUICKLY AND ACCURATELY IN NUMEROUS ALTERNATIVE LAYOUTS. IT ALLOWS YOU TO "PLAY" WITH THE TEXT AND DISCOVER A WIDE RANGE OF DIFFERENT APPROACHES.

GETTING STARTED

Begin by writing your text on layout paper. Cut this into lines or words, and place them on a clean sheet of paper large enough to allow the text to be moved around and with adequate surrounding space for the calculation of margins. Move the strips around freely to evaluate different arrangements. It is a good idea to write the text twice so that you can try alternative layouts with the same wording and compare them side by side.

When you have finalized your decisions about overall shape, line length, and spacing, rule writing lines at the chosen height and paste the text in place. You now have a rough paste-up from which to copy your finished work.

To center text during the cut and paste stage of layout planning, fold each cut line of writing in half, so that the first and last letters cover each other. Then align this center fold with the vertical line at the center of your page and glue it down. When writing the final version, take careful measurements from the centered draft layout, marking each line, beginning and ending with a penciled dot. Alternatively, use a photocopy of the centered layout text, cut and fold it line by line and keep it directly above your work for reference while you write the text in its final version.

ASSESSING YOUR LAYOUTS

Having cut and pasted your text into a provisional layout, you need to be able to make a judgement on its merits. Train your eye to look for balance and variety in the distribution of text within your chosen margins.

Top-heavy layout

Third line too long, leaving insufficient left-hand margin

Inaccurate centering

Line lengths too similar; bottom line too short Insufficient bottom margin

CUTTING AND PASTING

CUTTING AND PASTING A LAYOUT

The ideal glue for cut and paste work is rubber cement, which allows you to reposition pieces of text until you are happy with the result.

You will need

Sheet of layout or drawing paper Scissors Ruler Glue, such as rubber cement

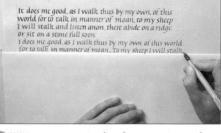

1 Write your text in the chosen script and size. This is italic script, written at four nib-widths x-height.

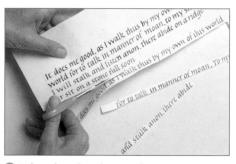

2 When the ink is dry, cut the writing into individual lines using scissors or a craft knife and metal ruler.

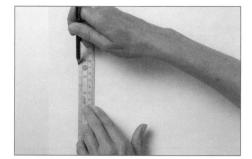

3 Rule a vertical line in pencil on a sheet of layout paper, approximately 2 inches (5cm) from the left-hand edge.

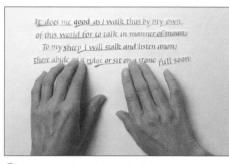

Assemble the strips of writing on the sheet. Move them to various positions across the sheet to observe the effect on shape.

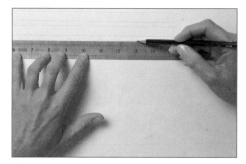

(5) After you decide on the preferred layout, mark and rule the lines on the layout paper.

6 Apply a thin coat of rubber cement along the writing lines.

Position the strips of text and press them into place. Repositioning is possible if necessary while the adhesive is still wet.

8 When the rubber cement is dry, rub away any excess with your fingers to leave a neat and securely glued initial paste-up.

Texture techniques

SOMETIMES WE WANT A MORE DRAMATIC BACKDROP FOR OUR CALLIGRAPHY, AND HERE ARE SOME SIMPLE BUT EFFECTIVE IDEAS. THESE ARE FUN TECHNIQUES THAT NEVER TURN OUT THE SAME TWICE, SO YOU WILL NEED TO RESPOND TO THE TEXTURES YOU PRODUCE WITH APPROPRIATE PLACEMENT OF THE CALLIGRAPHY.

USING CONTRAST

Experienced calligraphers like to explore the greater possibilities that the contrast of weight, size, and style of writing can give a design. Italic and Roman capitals are the best lettering styles for these variations.

SAPIENT	DURAKIIQUE pressidenten malin veras beatum veran malin veras
CALLE CALLE PAUPERU MURITA WOOSTR OCCUPAT MONTH B	manderilans sequences on dearmonger made (help taken count, non-providencion made (help taken count, non-providencion made
Callerpanperum	Has presidenting market the set dearant the
rectus orcupat :	Non providenten andre verse bene andre verse andre verse bene andre verse bene andre verse bene ver
alea reca	har and
ILLA VO	possidention multi
TTA VICCITERN PTL TI (VIDIPAT MOMEN PELLYDIAI MUNERIP.	station possidenten multi

Start off with a selection of text—here italic and Roman capitals encompassing various weights and sizes of letter. This Latin quote becomes random text as paste-ups develop for visual effect.

2 Cut out contrasting weights of lettering—regardless of what the words actually say.

3 Try gaining contrast in a "portrait" layout with heavy and lightweight lettering counteracting each other. This would be less successful if there were equal quantities of each weight.

④ Another idea, this time in "landscape," uses lightweight text counterbalanced with heavier title words.

Nen possidentem n OUI DECORUM Sugaicanterrections recurrent normers beals Constantes.

TEXTURE TECHNIQUES

5 Try photocopying the writing onto acetate sheets that can be moved around the page to encourage more ideas.

6 The overlaid texts make interesting visual patterning, which can be easily moved, and colored backgrounds can be explored.

7 Use "L"-shaped corners to decide the final cropping of the design, and don't be afraid to explore unusual options.

Alphabetical designs

ABSTRACT ALPHABETICAL DESIGN ALLOWS YOU TO EXPLORE THE VISUAL DYNAMICS OF LETTERS PLACED UPON PAPER WITHOUT WORRYING ABOUT REFERENCE TO THE LANGUAGE CONTENT. INSTEAD OF DESIGNING A LAYOUT FOR A LIVELY QUOTATION OR AN INTERESTING, EVOCATIVE PIECE OF POETRY, THE CONCERN IS ONLY THE VISUAL IMPACT OF THE SOLID LETTER SHAPES AND THE SPACE, OR INTERRUPTION OF SPACE THAT SURROUNDS THEM. POSITIVE AND NEGATIVE SPACE, AND THEIR RELATIONSHIP WITH EACH OTHER, IS THE BASIS OF GOOD DESIGN.

INCREASED CREATIVITY

It also serves as an exercise in imaginative design, for it is the placing of the shapes rather than the meaning of the text that will suggest excitement, spontaneity, tension, precision, or tranquillity. Since it is not primarily meant to be read, there is also plenty of opportunity for you to explore color, technique, rhythm, and feeling.

LETTER TEXTURES

In calligraphy, the overall aim is to produce a uniform texture of words, using black and white, which is aesthetically pleasing. Studying letterforms carefully and understanding their construction will help you achieve this. Having gained a skill, and practiced various letterforms, you can become more imaginative and creative in your designs.

There are many variations to consider, and often the words of the text itself can offer inspiration by suggesting color changes or illustrations. However, the letter construction, weight, and height can be altered and explored.

The ratio of nib-width to letter height that you have learned is a rule only until you understand what happens to the shapes; then the rules can be thoughtfully and purposefully changed. The changed weight of a letter can give a different "feel" to text. This is because the space around and inside the letters also changes. Experiment to see how the results differ. Decreasing the nib-width height will make the text more dense; increasing the nib-width height gives the letters more space. Compress the letter widths with the surrounding space and observe what happens to a line of written text. Write these same letters in a block to see how different they can appear. Words can be expanded, enlarged, or narrowed. Text can be made to stretch, tighten, and dance. Experimenting with letterforms should be analytical, constructive, and consistent.

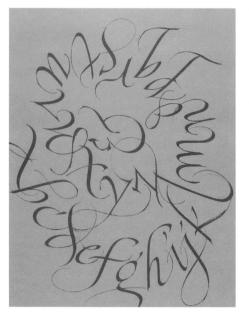

These dancing, flourished italic letters form an interesting spiral, intermingling and moving together to produce a flowing design. Calligraphy by Ros Pritchard

This letter "D" is full of vitality and excitement, executed with great confidence using a ruling pen and black ink. Further interest is added by using an automatic pen for the weighted areas. Calligraphy by Rachel Yallop

There is a tension created in the vigorous, interwoven top letters, which then links with the more precise and careful design in the alphabet below, giving this panel two distinct elements. Calligraphy by Mary White

Blue, green, and silver marbled paper forms the background for this set of green alphabets. The final row of silver provides an effective highlight. Calligraphy by Annie Moring.

The imaginative use of space and weight in this alphabet makes it delightfully elegant and subtle. Calligraphy by Peter Thornton

Interpreting the text

LOOK AT THE TEXTURES IN THE ALPHABET WORKBOOK (PAGES 32–137) AND ANALYZE THE VARIATIONS. DIFFERENT TEXTURES CAN BE CREATED WITHIN THE TEXT TO CONVEY A VARIETY OF IDEAS. CLOSELY WRITTEN GOTHIC TEXT CREATES A HEAVY, DARK, TEXTURED PAGE, AND INVITES A DIFFERENT RESPONSE THAN THE DELICATE, FLOWING LETTERS OF ITALIC DO.

TEXTURE AND RHYTHM

Make notes of what you see and make small thumbnail sketches; keep cutouts from magazines and papers, take photographs of objects, lettering, other crafts; save pieces of colorful and textured fabric, paper bags, and unusual papers, anything that interests or stimulates you. Create your own library or file of ideas; it will encourage you to become more aware of your surroundings. Learn how to observe and analyze. Use what you discover in your designs.

Study the work of other calligraphers and other arts, such as silkscreen printing, fabric designing, weaving, and embroidery. Walk along the beach and study the pattern of pebbles, or the countryside and look at the structure created by hedges and trees. Observe sunsets and analyze the sequence of their colors, very pale blue, bluish-red, pale yellow along its edges. When they are carefully and lightly blended, orange hues emerge. It is a very subtle change.

Look at the ripples on water and notice the way they run and what colors there are. Water is rarely all blue—there are browns, greens, and light (white).

Nature offers some very simple answers if you are prepared to look for them. Study a red rose and its leaves. The leaves are not green as you first thought; they contain vast amounts of red, as does the flower. The color red permeates into the green, changing it in many areas.

Texture is an important feature of this work. Experimental pen-drawn letterforms have been treated with different materials, including crayon and gold gouache. Burnished gold and fine white vertical lines add finishing touches. Calligraphy by Isabelle Spencer

INTERPRETING THE TEXT

This beautifully designed and executed alphabet of capitals shows a personal and individual italic letterform which is extremely lively and flowing. Calligraphy by Werner Schneider

Here, italicized stenciled letterforms, boldly colored yellow, appear down the center of the page. They are flanked by elegant formal versal letters, their classical nature contrasting with the weight and texture of the stenciled letterforms. Calligraphy by Michael Harvey

The principles of color

COLOR HAS A STRONG INFLUENCE ON OUR LIVES AND THE WAY WE FEEL AND BEHAVE. IT IS STRONGLY LINKED TO MOOD AND THOUGHT. RED SUGGESTS ANGER, EXCITEMENT, DANGER, IMPULSIVENESS, AND PASSION. BLUE CAN SUGGEST SERENITY AND COOLNESS AND BLACK INDICATES SOBRIETY AND FORMALITY.

COMMON COLOR ASSOCIATIONS

Think of the seasons: greens for spring, yellows for summer, browns and reds for autumn, and blues and grays for winter. Already we have a palette of colors to describe our written words.

It is well known in the color sciences that color conveys a richer degree of information than black and white imagery. Observe your own response to carefully planned color advertising and black and white.

Any visual piece of work can be enhanced by the addition of color. It may be used in the writing itself, in the form of border decoration, as a subtle or vibrant background, or as illustration. Careful and thoughtful use of color can produce harmony, set a mood, emphasize an idea, or convey a dramatic feeling about the subject of a piece.

Using color in your work successfully will depend on your knowledge of materials and techniques, and how suitable each will be to the subject matter and design.

DESIGNING WITH COLOR

Bright colors shout for attention; light, soft colors can link areas in a design in a subtle way. When you begin, avoid using too many colors; limit yourself to a maximum of three. If the writing is very uniform and simple, two or three colors can be used without overloading the design. If, however, the writing is very varied in texture, weight, and letterform, only use one color. Too many elements in design cause confusion, making it difficult to locate a focal point. The focal point is the statement you are making with your work.

Heavyweight, freely written capitals. Subtle color changes in the letters add to the interest, as does the background texture. The smaller white letters offer a contrast. Calligraphy by Godelief Tielens

THE PRINCIPLES OF COLOR

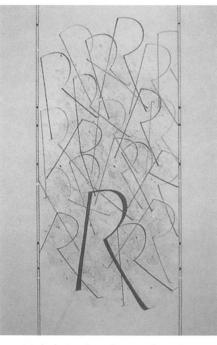

A sensitively designed panel using only one letter of the alphabet. It is beautifully executed with fine, controlled lines, and highlighted with small rectangles of raised gold and color on a delicate background of crosshatching. Calligraphy by Gaynor Goffe

Russian icons were the inspiration for this colorful rendition of a poem by Kathleen Raine. There is an almost three-dimensional quality in its texture. Drawn and painted letterforms over watercolor washes. Calligraphy by Polly Morris

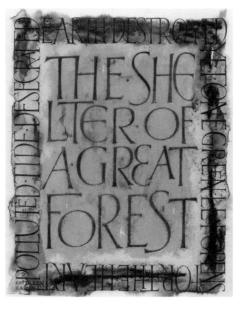

In this unusual piece of calligraphy, large torn paper shapes provide a great contrast to the delicate well-executed capitals and their finely formed serifs. Calligraphy by Brian Walker

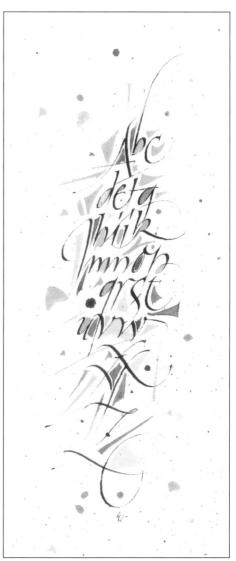

A small delicate panel of freely written italic in indigo gouache plus black ink. The subtle colored shapes in and around the letters are painted in watercolor. Note how the letterforms progressively increase in size and freedom from top to bottom. Calligraphy by Brian Walker

Choosing and mixing color

THE RANGE OF COLOR AND MEDIA IN AN ART SUPPLY STORE CAN BE OVERWHELMING. ALL MEDIA—WATERCOLOR, GOUACHE, ACRYLIC INK, PASTEL, PENCIL, WATERCOLOR PENCIL—CAN BE USED IN CALLIGRAPHY. WITH PRACTICE, A NUMBER OF THEM CAN ALSO BE USED IN COMBINATION.

A BEGINNER'S PALETTE

Manufacturers create most of their different ranges to match, although confusingly, individual items are not always called by the same names. To make mixing easier, it is advisable to begin with six colors; two reds, two blues, and two yellows. This will allow a greater degree of understanding when the mixing of colors is required.

In effect, you are dividing each primary color into two. Cadmium red contains a little yellow (orangey-red), alizarin red contains blue (bluish-red). Ultramarine contains red (reddishblue), cerulean blue contains yellow (yellow-blue). Lemon yellow has a blue tinge, while cadmium yellow contains just a small amount of red.

MIXING COLOR

The color wheel is made up of red, blue, and yellow, the three basic or primary colors, so-called because they cannot be made by mixing other colors. When they are mixed together in equal amounts, they produce three secondary colors. Red and blue create violet, blue and yellow produce green, and yellow and red make orange. If you are unfamiliar with color, try mixing violet, green, and orange.

By mixing a primary color with a secondary, a tertiary color is produced. Try it yourself; you should now have twelve different colors.

By mixing the colors directly next to each other on the wheel, you will produce the purest orange, violet, and green. Therefore, by mixing alizarin red and ultramarine, for example, the best violet or purple will be produced. Try mixing cadmium red and cerulean blue, and you will discover that red and blue do not always make purple. This mix produces a warm gray or brown, depending on the amount of each color you use. Try different mixes. Make notes about the colors you used and what was produced and keep them as a reference. For example, complementary colors create visual vibration. Green letters on red are difficult to read because they neutralize each other when used in equal amounts. However, they can be advantageous when used in small amounts, as they add vibrancy to the page.

The color wheel shows how all mixes derive from three basic colors—red, blue, and yellow.

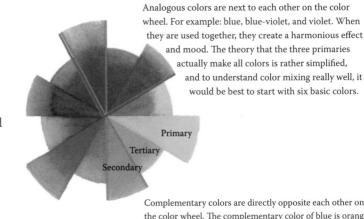

Complementary colors are directly opposite each other on the color wheel. The complementary color of blue is orange. Another way to remember is to say that the complementary color of blue is the mixture of the two other primary colors. Red and yellow = orange.

Understanding mixtures

When colors are placed next to one another you can see the color bias more clearly. These swatches show how the choice of primary color affects the mixture. Those closest together on the wheel create intense secondaries, while those furthest apart create neutrals.

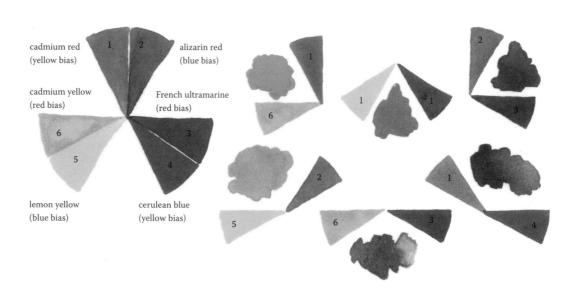

DIFFERENT MEDIA

Using different media will allow you to appreciate the qualities of each. The letter "B" (*right*) is written in acrylic ink. It is shiny and smooth and waterproof. Watercolor produces a transparent effect, while gouache creates a flat, matte, and denser color.

For subtle illustrations or

for background washes, watercolor works well because it is generally transparent when it is applied. It is also light when it is used in the pen, producing a slightly watery effect.

Gouache

Although gouache is basically the same as watercolor, it has a white pigment, or filler, added to render it opaque, which allows denser coverage when used. It is preferred by graphic designers and is ideal for using in pens and for bright illustrations. However, it tends to streak when it is used with a brush to create thin washes. Through experience, you will understand the properties of both.

Acrylic inks

The use of acrylic inks for color work is fairly new. Although they tend to be generally too thin for writing small letters, they are very effective when used with larger pens, particularly when the colors are blended like watercolors. They are bright and permanent once they have been applied and provide a good, stable background on which to write. They can be heavily diluted for several washes or applied directly for vibrant effects.

Writing with color

IT CAN BE INTERESTING TO EXPERIMENT WHEN WRITING WITH COLORED INKS, PRODUCING LETTERFORMS THAT ARE EITHER TRANSPARENT OR OPAQUE. INTRODUCE VARIATIONS IN NIB SIZE OR TEXTURAL EFFECT AND SEE HOW YOU CAN MAKE MARKS THAT CONTRAST WITH AREAS OF SOLID COLOR IN BACKGROUND WASHES.

You will need

Pans or tubes of color Water Paintbrush Dip pen with detachable nib Palette Paper Pastels

Mix the color to a creamy consistency, which will be thicker than ink. Be sure to mix enough to do all the writing. When two colors are mixed together, it is always difficult to mix more of the same blend because color will change when it dries.

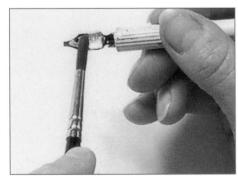

2 Add the color with a brush from the side or from underneath. Adding color to the top of the nib (unless it has the reservoir on top—a Brause nib) will create blotches of paint.

3 When the paint supply just begins to thin, replenish it by adding more paint to the nib with the brush. Two or more colors can be used to create very interesting effects.

Bndndnbanbncnn Bndnanbnendnenfn anhníjnk

A Rinse your brush before adding a second color to the nib. The two colors will blend as you write, making a gradual change which is more visually appealing than an abrupt one.

WRITING WITH COLOR

5 Add other colors in the same way to create soft color blends.

6 Make shades of one color lighter by adding white to the mix.

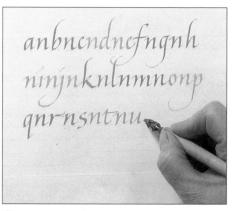

Try using analogous colors that sit together on the color wheel, such as cadmium yellow and cadmium red.

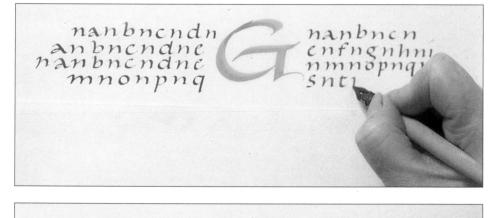

8 Use two complementary colors, such as blue and orange, red and green, or yellow and purple. This will create a vibrant effect.

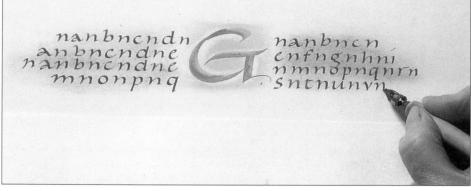

9 Here, orange and blue were used, then pastel was dusted on in the same colors to highlight the composition.

Colored backgrounds

YOU CAN USE COLORED PAPERS FOR SINGLE BACKGROUND COLOR. FOR ADDITIONAL INTEREST, STICK CUT OR TORN PIECES ON WITH PVA OR CRAFT GLUE TO CREATE CONTRAST. YOU CAN BUILD UP A WHOLE COLLAGE AND THEN WRITE ON IT. HOWEVER, YOU MAY WISH TO CREATE YOUR OWN BACKGROUND COLOR FROM PAINT OR INKS.

BACKGROUND WASHES

Creating background color with washes requires practice to understand all the possibilities. Follow these steps for laying a flat wash. If the color needs to be darker, simply repeat the process once the first layer is dry.

You will need

Stretched paper (see opposite) Large, soft brushes Watercolor paints Lots of water Deep palette or mixing bowls Clean water for rinsing the brushes

Tilt the board 1 to 2 inches (2 to 4cm) at the top end. Mix the paint with water. Load a large, soft brush with paint and draw it horizontally across the top of the paper.

Load the brush again. Now, do a second stroke in the same way, slightly overlapping the first stroke. Continue working in this way toward the bottom of the sheet.

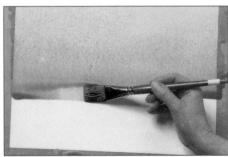

③ Do not patch any areas that have been missed. To prevent streaking, there should be enough liquid in each line to create a long puddle at the bottom of each stroke.

When you reach the bottom, rinse the brush, dab off the excess water and run it along the bottom puddle to pick up the excess paint. Lay the board flat and dry it as before.

COLORED BACKGROUNDS

STRETCHING PAPER FOR BACKGROUND WASHES

Washes need a great deal of water, which will wrinkle the paper unless it is heavyweight (356gsm). Lightweight paper will probably need stretching. Once your stretched paper has dried, leave it taped to the board while laying a wash.

You will need

Paper

Board (particle/medium density fiberboard, or plywood) Sink or bowl Sponge Brown gummed tape

Make sure the board is slightly bigger than the paper, to allow for the tape.

Place the paper in cold or tepid water, keeping it flat. Leave it there for a few minutes to make sure it becomes thoroughly wet.

3 Holding two corners, lift the paper from the water and let the excess water drain. Place carefully on the board, lowering gently to exclude the air.

Use a sponge with great care to blot the surface. On a large sheet of paper, always work away from the center. Do not apply any pressure as this will damage the surface.

• Cut four strips of gummed paper tape to place along the four sides of the paper. Wet each piece with a fairly damp sponge.

6 Tape one side and its opposite side. Then tape the other two sides. Allow an overlap of tape on the paper of about ½ to ¾ inch (10 to 15mm) and press each down firmly.

When all four sides are taped, lay the board flat, away from direct heat and let it dry. Lay a wash with the paper in place and do not remove until thoroughly dry.

LAYING A GRADED WASH

This is a similar process to laying a flat wash, but this time the color grows lighter as you work your way down the paper.

1 Tilt the board. Mix the paint in a small jar. Load a large brush and draw it horizontally across the paper. After one or two strokes, add more water to the mixture.

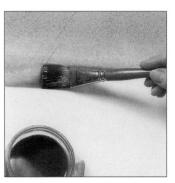

2 Continue down the paper, adding water to the paint after each stroke.

3 The color should now appear lighter as it proceeds down the paper.

4 Finish the wash by soaking up the watery paint with your damp brush. Lay flat. Once it is dry and you are satisfied with the result, you can remove the paper from the board and write on it.

LAYING A TWO-COLOR WASH

In this example, you lay flat washes of two colors, working each from an opposite edge of the paper toward the middle.

Mix the two colors required in two separate suitable containers. Tilt the board at the top and lay a wash to the center.

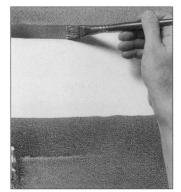

2 Turn the board around and, using the second color, work again to the center, overlapping the two colors slightly.

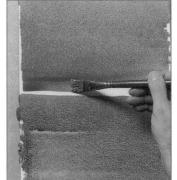

3 Allow the colors to bleed into one another.

 The mix of color can be controlled by turning the board to let the paint blend more readily. Lay flat to dry.

LAYING A VARIEGATED WASH

This process involves using a wet-on-wet technique, wetting the paper first and allowing a few minutes for the water to soak in.

1 Mix three or four colors. Once the wet paper starts to look matte rather than shiny, load a large brush (No. 8 to 10) with the first color and paint some areas of paper, leaving others white.

2 Rinse the brush and load it with the second color. Dab it into the white spaces. Watch what happens as it blends and moves on the damp paper.

3 Add more color to desired areas. Brighter color can be added by using thicker paint. If it appears too bright, tone the color down by adding more water. This way you can control the amount and depth of color in the background.

(4) Now that the desired effect has been achieved, lay the board flat to dry. If the results seem disappointing, before the paper dries, wet it under running water—a shower head is ideal and carefully sponge the paint away. Dab off excess water. Leave it to dry and begin again.

Fire, versal "K." In this intriguing piece, a variegated wash has been laid on watercolor paper. The depth of color in the darker area marks a strong contrast to those areas that have been left white. Calligraphy by Gemma Black

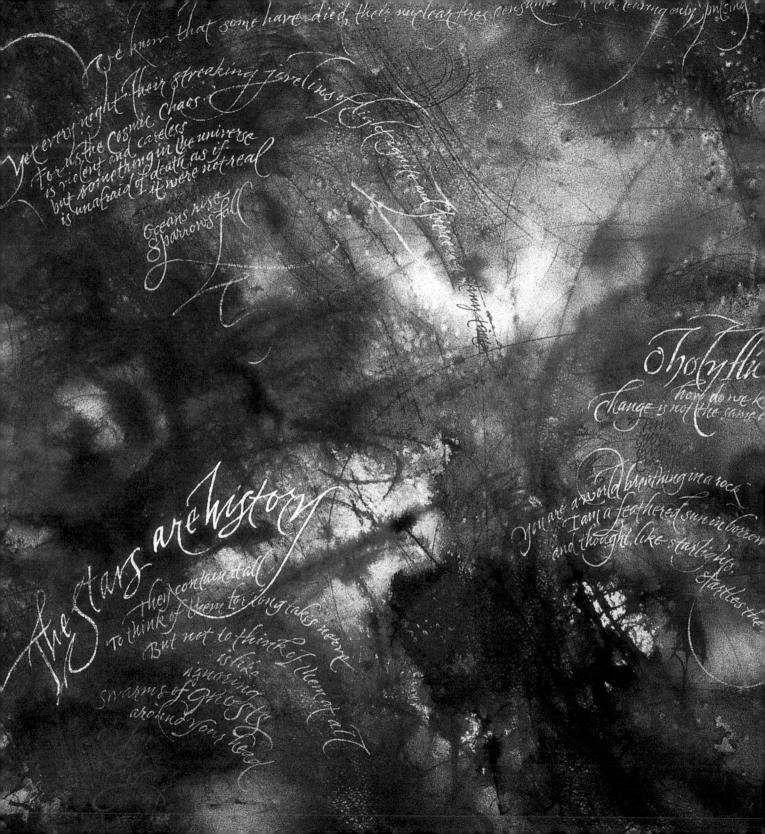

Decorative Detail

With the principles of design and color well established, you are ready to move on to more advanced techniques for producing great works of calligraphic art. By now, you will also have had plenty of practice at writing the various scripts in the Alphabet Workbook, and will be very familiar with a number of them. There is great fun to be had in embellishing your texts and this section offers instruction on how to do so. Here you will find a number of ways to complete your pieces with embellishments to letters—such as flourishes and ornamental elements and inspiration for decorative borders. There are also step-by-step instructions for designing and gilding illuminated letters. Armed with the skills at hand, you will be able to create an impressive range of calligraphic works.

Flourishing

FLOURISHING, THE ORNAMENTAL EMBELLISHMENT OF A LETTER OR LETTERS, REQUIRES SOME STUDY BEFORE IT CAN BE USED EFFECTIVELY. THERE ARE INNUMERABLE EXAMPLES THAT YOU CAN REFER TO, IN BOOKS, MANUSCRIPTS HELD IN MUSEUM COLLECTIONS, AND THE WORK OF ENGRAVERS ON GLASS OR METAL.

SEEKING INSPIRATION

Discover the shapes formed by flourishing, what space they occupy, how thick lines cross thin lines, and how their diagonals run parallel. Make sketches and, where possible, put tracing paper over the flourishing and trace the flowing lines. Study a text to decide whether the work should be treated with a subtle or elaborate amount of flourishing. Begin with simple solutions, always remembering that the strokes must be perceived as a natural extension of the letters, not as additions. Plan well in plenty of rough drafts and practice with a relaxed arm movement, using whatever instrument feels most comfortable. Experiment by taking thin strokes upward and working the downstrokes by applying more pressure.

Accomplished and elaborate flourishing needs much study and practice. As you gain confidence, flourishing will become quite a logical extension to much of your calligraphic work. Signwriting, memorial inscriptions, civic documents, certificates, letterheads and single-letter logos, and delicate personal messages all provide opportunities for flourishing.

USING A POINTED BRUSH

A pointed brush is an excellent tool to assist in developing a rhythmic and fluid style. It is a good idea to practice making

1 Successful flourishing should be accomplished in a relaxed manner and flow naturally. Flourishes should blend with the work and not appear too contrived.

2 The brush moves with great agility to create expressive arcs and lines. Varying the pressure on the brush produces lines that vary from thick to thin in one continuous stroke.

traditional flourishing shapes and simple marks before attempting to apply the lines as extensions of a letter.

3 Flourishing exercises can be interesting pieces in their own right. Here the addition of red dots, made with the tip of the brush, provide a finishing touch.

USING A SQUARE-CUT BRUSH

A small square-cut brush will mimic the thin and thick lines of a broad nib.

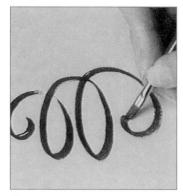

1 Practice using a square-cut brush. Do not create too much resistance in its movement.

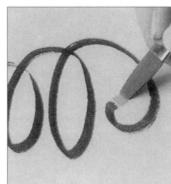

2 A large square-cut brush is used here to add red dots as a finishing touch.

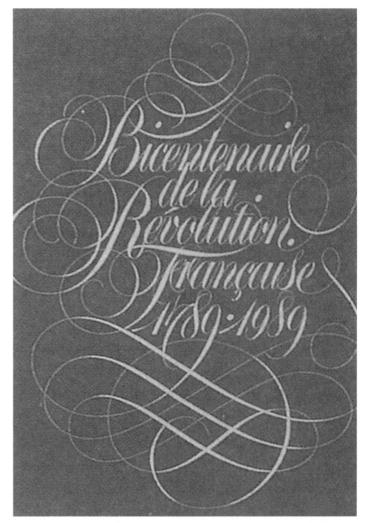

An exuberant display of flourishing using copperplate-style lettering. The final piece was produced by silk-screening one color in reverse. The artwork was prepared in black on scratchboard. Calligraphy by Jean Larcher

USING DOUBLE POINTS

1 Employing double points to make flourishes provides an opportunity to introduce letters to the exercises. The double points are treated in the same manner as a square nib, but can be manipulated with greater freedom of movement across the page.

2 Double pencils allow an energetic flourish to emerge and be applied as an extension to a letter. The flourish on the italic letter "h" is drawn to resemble a ribbon unfurling.

DECORATIVE DETAIL

Ornament

CHANGES IN ARTISTIC STYLE CAN OFTEN BE SEEN AS RUNNING PARALLEL TO SOCIAL AND POLITICAL CHANGES OCCURRING IN PARTICULAR PLACES AND TIMES. THE EVOLUTION OF ORNAMENT FALLS WITHIN THIS PATTERN OF EVENTS, REFLECTING THE RISE AND DECLINE OF EARLY CIVILIZATIONS AND THE EXCHANGE OF IDEAS BETWEEN DIFFERENT CULTURES BROUGHT ABOUT BY TRADE, MILITARY CONQUEST, AND RELIGIOUS INFLUENCES.

DESIGNING CALLIGRAPHIC ORNAMENT

Ornament may fill an entire margin, create a border for the text, or a background for a capital letter. Special attention needs to be paid to proportion and the symmetry of shapes and colors. Begin by including simple geometric figures that constitute the basic vocabulary of ornament: square, circle, triangle, oval, and lozenge. Introduce a connecting element with lines, chains, spiraling cables, interlacings, zigzags, waves, or a running scroll. Repetition of any of these motifs can create pattern areas within the design. You can attempt ambitious solutions by starting with basic shapes and then including motifs from the natural world.

The size of ornament should relate closely to the scale of writing and size of the page. If the ornament is in a manuscript book, the scale should remain consistent throughout the work.

Spirals, knotwork, frets, and other linear forms require careful attention. The construction methods of Celtic ornament provide the best key to this kind of interlacing. To avoid confusion, complete each stage of the construction throughout the entire design before moving on to the next stage.

BASIC METHODS OF ARRANGEMENT

The best starting point for learning to apply ornament is to study basic construction methods. Simple patterns can be generated on a network of lines crossing each other at different angles.

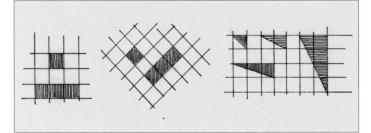

Begin by building patterns along lines placed at right angles to
 one another and at equal distances (graph paper is useful here). Fill
 in individual shapes to produce squares and diamonds, and adjacent
 squares to produce oblongs. Introducing oblique lines that cut across
 the squares and oblongs produces triangles.

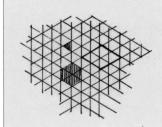

2 To create ornament based on hexagonal shapes, the lines are placed at an angle of 30 degrees, and crossed by vertical lines.

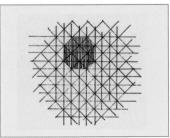

3 Placing lines at an angle of 45 degrees, and crossing them with vertical and horizontal lines creates octagonal shapes.

DEVELOPING METHODS OF ARRANGEMENT

Altering the lines and shapes applied to the basic network of lines begins to extend the language of ornament.

 Here the horizontal and vertical lines provide the framework of a pattern known as "embattled," used extensively in coats of arms.

2 Here the lines of the embattled pattern have been curved to create a "meander."

3 A squared grid, set at 45 degrees to the horizontal, creates the diamond, which is used here as a framework for the chevron zigzag.

4 Using the same network, but curving the apexes of the zigzag, creates the wave.

The squared network provides the foundation for construction of the fret. This familiar geometrical figure forms the basis of many fine ornamental borders.

5 The same network, with the addition of horizontal lines, is the basis for the blunted zigzag and the interlaced patterns.

(8) The spiral is created by rounding the straight lines and sharp angles of the fret.

6 The geometric lines of the zigzag are here rounded to produce the scallop. The interlaced pattern produces a scale pattern.

(9) The wave and the running scroll are adaptations of the spiral.

LAYING OUT ORNAMENT

The diagrams on the previous page illustrate some of the elemental forms and lines found in styles of ornamental art, upon which more elaborate details can be built. The same principle of networks is used here to show some methods of laying out ornament, including an example of combining ornament with a letter.

VARIATIONS FOR LAYING OUT

The method shown here involves filling in each square. This is known as "diapering."

This alternative of the diaper method demonstrates a more dense-looking pattern.

Working on the same squared grid, but omitting alternate squares. This method is known as "checkering."

Diapering and checkering can be effectively combined to create solid patterns.

This version employs the same principle, but allows larger spaces between the filled-in areas. This is referred to as "spotting" or "powdering."

Applying the ornament in rows, and leaving some rows void, creates "striping." Versions of striping constructed in a narrower vein are called "banding."

A combination of striping and banding produces another layout, called "paneling."

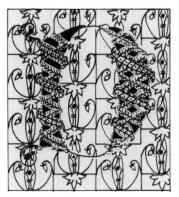

Using an arrangement of lines drawn at 30 degrees to the horizontal on a squared grid, ornament is applied to both a letter "D" and the background.

Borders

BORDERS CAN BE INCORPORATED VERY SUCCESSFULLY IN MANY DESIGNS. SURROUNDED COMPLETELY OR PARTIALLY BY A BORDER, A BLOCK OF TEXT OR LINES ON A CARD CAN BE GREATLY ENHANCED. BORDERS SHOULD COMPLEMENT THE CALLIGRAPHY; THEY SHOULD NOT OVERPOWER THE TEXT NOR LOOK TOO TIMID.

USING BORDERS

Borders define a space and can "tidy up" a piece of visual work, but cannot save it if the letterforms and spacing are not wellplanned in the first place. To demonstrate the power of the border, take a freely drawn piece of lettering or ornament and simply surround it with straight lines. The difference in visual impact is immediate; the effect is the same as framing a picture.

JOINTS FOR BORDERS

The structure of a border framing a work needs consideration. Frames are formed in several ways, including oblique, square and joggled miter. The corner is the best place to start when designing a border to form a full or semienclosure.

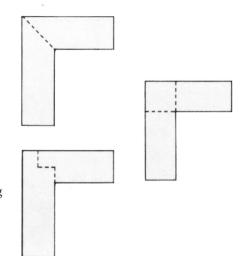

There are four basic components of border design:

- 1. Repeat horizontal marks, or filling-in worked as a continuous running pattern
- 2. A series of vertical marks
- 3. A fusion of horizontal and vertical elements
- 4. An arrangement of panels.

BORDERS: BASIC STROKES

The broad pen can be used to produce simple and pleasing marks that, either alone or in combination, can be repeated to create a decorative border. Changing the pen angle increases variety and interest even within the same border.

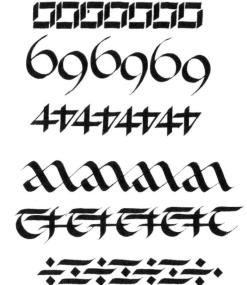

DECORATIVE DETAIL

BORDERS: TOOLS AND TECHNIQUES

Mix and match techniques in your design. For example, use diagonal lines interspersed with dots made with a broad nib. Almost any tool is suitable for building up a border—brush, pen, fiber-tip pen, or pencil. Experiment with different tools and media to add variety to the strokes and marks. Introducing color to a border requires some planning, but, when used well, color makes a very effective addition. Working on graph paper will build your confidence, giving a framework to the design as you twist and turn the broad nib to invent new arrangements. This exploration also makes a good practice exercise. Spend time roughing out the design of the border, and make the critical decision as to whether it will form a full or partial enclosure for the text. A semi-enclosure is most likely if a decorative heading is part of the piece.

POINTED BRUSH BORDER

Manipulate a pointed brush with gouache, to produce varying weights of mark.

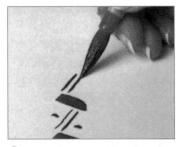

1 Using the pointed brush with no noticeable pressure produces fine lines.

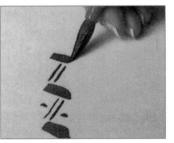

2 Applying a little pressure and pulling down quickly through the stroke produces a contrasting bold line.

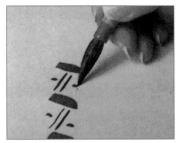

3 Delicate dots can be added using the tip of the brush. Control of the dot size is dictated by the pressure placed on the brush.

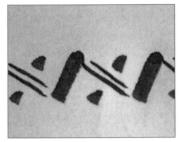

The dots in this pattern were made by placing the brush on the paper, then pulling it downward as it was lifted off again.

FIBER-TIP BORDER

Fiber-tip pens with chiseled nibs are useful for working out border patterns, as they are ready to use and available in a variety of colors.

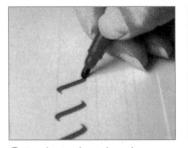

(1) Employing basic broad pen strokes, a line is drawn in a single smooth action.

2 Turning a thick pen to an angle of 90 degrees to the writing line, square dots are placed at the top of the slanted line.

3 Dots are placed at the base of the slanted line. The same pen, held at 10 degrees to the horizontal, produces a thin stroke.

4 This red and green border could have more lines and shapes added or stand alone as complete.

BLACK-AND-WHITE BORDER

The width of stroke varies according to the direction in which the pen is moved while retaining a fixed nib angle.

1 Here, a black fiber-tip pen, held at an angle of 45 degrees to the writing line, produces thick downward strokes.

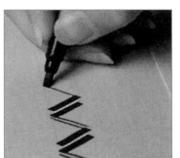

2 Holding the pen at the same angle and moving in an upward direction produces thin strokes.

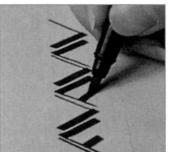

(3) Inserting short, thick strokes between the major lines of the pattern breaks up the white space.

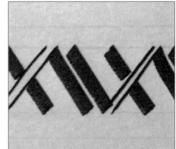

(4) The application of additional shorter strokes to break up the white space produces a more interesting and pleasing result.

LETTER BORDER

Borders constructed from letter shapes can be used successfully, especially if the letters are chosen to represent or allude to something referred to in the piece they surround.

1 If no obvious links present themselves, letters that contrast with or balance each other can be selected.

2 Repeating the letters, with their elegant proportions and thick and thin strokes, leads to the illusion of an arrangement of shapes rather than actual letters.

3 The inclusion of a spot color, as a simple device, can add a surprise element and further disguise the actual letter shapes.

(4) The final picture perfectly illustrates how the letters have become mere vehicles in the creation of this border. The work has a balance of black and white and reads as a row of shapes and lines, rather than letters.

Illumination

INITIALLY, THE TERM "ILLUMINATION" REFERRED TO THE ADDITION OF COLOR—USUALLY RED LEAD—TO A FIRST LETTER OR WORD IN A PIECE OF WRITING. ITS PURPOSE WAS TO INDICATE A CHANGE IN THE TEXT, WHICH WAS WRITTEN IN BLACK. SOME MINIMAL COLOR DECORATION MAY ALSO HAVE BEEN USED.

THE EVOLUTION OF ILLUMINATION

In time, the interpretation of illumination expanded to include manuscripts on stained vellum adorned with letters and decoration executed in gold and silver. These precious metals on richly ornamented pages reflected the surrounding light.

Initially, the scribe responsible for writing the text added the ornamentation, but, as different aspects of the work developed, other craftspeople joined the workshops. The illuminator, the most skilled, became a designer, colorist, and illustrator, and in great style accomplished the task of bringing life to the page.

Illumination is really about the calligrapher's own experience, especially in terms of design and color sensitivity. It presents a wonderful opportunity to exploit pattern, color, texture, and pictorial imagery. There are no rules to follow, but you can understand the range of possibilities if you spend time looking at some fine examples of the illuminated page.

The presentation of a piece of calligraphy can be greatly enhanced by the introduction of a decorated letter. The letter may be very simply decorated, grossly distorted or heavily embellished with marks, lines, and symbols, forming ornate patterns. Careful thought must be given to the positioning of the letter in relation to the body text and to the layout of the page as a whole. Some of the traditionally used arrangements are illustrated here.

A page from the Egerton manuscript has a refined border on one side, which continues off the top of the page. At its base, the foliage border is linked with the illustration, and is dragged along over the shoulder of an angel. A miniature painting is contained in the counter shape of the first initial letter "D." Linear and spiral patterns, and trailing fine lines decorate the Lombardic versal letters. The strong influence of the uncial letter shapes is clear throughout the work.

Designing an illuminated letter

THERE ARE MANY WAYS TO SOURCE DESIGN IDEAS, SUCH AS STUDYING HISTORICAL, DESIGN, AND PATTERN BOOKS, VISITING MUSEUMS, EXPLORING THE DESIGN POSSIBILITIES OF OTHER CRAFTS SUCH AS TAPESTRY, WEAVING, AND EMBROIDERY, OR USING NATURAL OBJECTS, PLANTS, AND ANIMALS AS INSPIRATION. IN FACT, ANYTHING THAT STIMULATES YOUR ARTISTIC EYE. HERE, A LETTER "O" IS DECORATED AND ILLUMINATED, ILLUSTRATING THE EASIEST METHOD OF APPLYING A DESIGN.

You will need

Tracing paper Pencils: HB and 2H Ruler 300gsm hot-pressed watercolor paper Masking tape No. 00 sable or synthetic pointed brush PVA medium or gesso (see page 14) Gouache paint

① Use an HB pencil to draw top and bottom rules on the back of some tracing paper to mark guidelines for the letter. Draw a vertical line as a guide for centering the letter. Turn the tracing paper over.

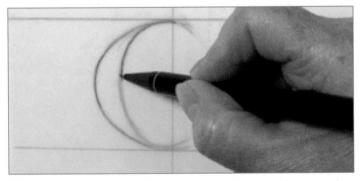

2 Start to draw the letter between the top and bottom rules, using the vertical line to draw one half of the letter first.

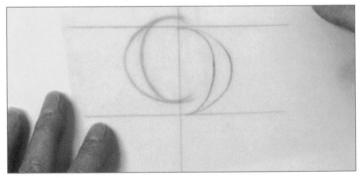

3 To draw the second half of the letter you can fold the tracing paper at the vertical line and trace over the first half. Or you can use a second piece of tracing paper to transfer both halves to a third piece of tracing paper. Either way, the two sides of the "O" will match.

DESIGNING AN ILLUMINATED LETTER

Using several small pieces of tracing paper, draw and trace various design ideas that could fit into the center of the letter.

5 Combine the designs with the letter shape by placing them on top of, or underneath, the traced letter. This enables you to see which designs you prefer. You can make many variations by moving the motifs around or by piling several pieces of tracing paper on top of one another to make a composite design.

6 When you are satisfied with the result, tape the pieces of tracing paper together, being careful not to alter the position of the pieces. Place one large sheet of tracing paper over the top of all the pieces.

The whole design can be placed in a handdrawn box to add interest. Try this out on the tracing paper to see if you like the idea.

8 Trace the completed design carefully using a 2H pencil. Tape the new tracing onto watercolor paper with two tape hinges at the top. Prepare a carbon copy by scribbling with an HB pencil onto tracing paper and rubbing the excess graphite away with a piece of waste paper. Slide the carbon, penciled-side down, underneath the hinged tracing. Using a sharp 2H pencil, trace the design.

9 Paint on gesso or PVA where the gold is to be placed and gild the letter (see pages 182– 187). Paint the design using gouache paint and a No. 00 sable or synthetic pointed brush. You may choose bright or subdued colors.

Applying gold

GOLD HAS THREE UNIQUE QUALITIES: IT DOES NOT TARNISH BUT RETAINS ITS BRILLIANCE, IT CAN BE BEATEN EXTREMELY THIN, AND IT CAN STICK TO ITSELF, WHICH MEANS THAT SUBSEQUENT LAYERS CAN BE ADDED TO CREATE BRILLIANCE. THERE ARE A NUMBER OF WAYS OF APPLYING GOLD.

Gold needs a size or glue to make it stick to paper or vellum. As these support materials are flexible, the gum also needs to be flexible. Gum ammoniac and plaster-based gesso were the traditional media used in the past by historical scribes and illuminators, and are still used by today's professional illuminators. These sizes have been applied for nearly 1,500 years. Gold will also stick to egg white (glair) and rabbit-skin glue, both of which were also used in historical manuscripts.

Modern sizes include acrylic and water varieties, as well as PVA (polyvinyl acetate) medium, also known as craft glue. Shell gold and powdered gold are variations of the traditional gold leaf. The two techniques of applying gold are known as flat and raised gilding. As the names suggest, flat gilding lays flat on the page, while raised gilding uses a thicker layer of glue to raise the gold from the surface.

Flat gilding

Raised gilding

Contraction of the second of t

WHEN TO GILD

When using gold, it is important to complete any writing first. This is when most of the planning takes place and where mistakes generally occur. All your hard work and time spent gilding and painting will go to waste if a piece has to be discarded because of a writing error. It is also better to apply gold before painting, because gold sticks to everything that is sticky, such as gum arabic contained in paint. Therefore, write first, then apply the gold, and then paint the design.

Spring, Summer, Autumn, Winter, by Lorna Bambury. Raised gold, shell gold and gouache on vellum.

PAINTING AN ILLUMINATED LETTER

As has already been discussed, paint should not be applied until the rest of the work is done and the gilding is complete and dry. Use a fine artists' No. 1 brush to apply the first gouache color. Then make further applications of gouache as you build up the design, allowing the previous coat to dry before applying the next, and rinsing your brush in clean water each time. The first color used should be a mid-tone, then add in the shadows (darker colors) and highlights (mixed with white). Add the final highlights in white gouache. This use of tints and shades will give the design form. Try to mix up enough color to complete each phase in one go, otherwise the shade may vary.

Blue and red were often used together. When one is placed against the other the blue appears bluer and greener and the red looks very bright. Outlining in black will also make the colors appear brighter. All colored forms in manuscript illumination can have a brown/black or black outline. Be careful not to overdo the white highlighting, otherwise the illustration can appear too busy.

Finished illuminated letter "Q" from page 187.

Completed illuminated letter "O" from page 179.

Illuminated letter "N" by Tim Noad. Sponged gouache on vellum, letter in raised gold leaf on gesso. Flourish in powdered gold.

Flat gilding

THE MODERN MATERIALS YOU CAN USE FOR FLAT GILDING INCLUDE POWDERED AND SHELL GOLD, ADDED TO GUM ARABIC FOR USE. ACRYLIC GOLD MEDIUM AND WATER GOLD SIZES (GLUES) CAN BE USED FOR SMALL GILDED AREAS, WHILE PVA MEDIUM IS BEST FOR ADHERING GOLD LEAF TO PAPER OR VELLUM OVER LARGER AREAS.

POWDERED OR SHELL GOLD GILDING

Backgrounds, small filigree patterns, and fine painting can be gilded using shell or powdered gold. The gilding can also be burnished, although the finish is rather dull. Powdered and shell gold can be used on both paper and vellum.

Shell gold is real gold powder mixed with gum arabic, available in tablet form. Use an artists' brush to wet the tablet with distilled water, then apply the shell gold like paint. When it is dry it can be lightly burnished with an agate burnisher. Powdered gold is real gold powder without the gum, so it needs to be mixed with gum arabic, after which it can be painted on in the same way as shell gold. Powdered gold is sold by the gram. Place 0.5g of powdered gold in a small opaque pot with a lid, such as a film canister. Use an eyedropper to add 20 drops of gum arabic and just enough distilled water to reach a thick, creamy consistency. Once mixed, fill the pot with water, replace the lid, and leave to stand for 12 hours. Pour the water into a second similar pot, keeping the gold at the bottom barely covered with water. The second pot can be kept for replenishing the first with water as it dries out. It can also be used to rinse the gold particles from your brush when you are painting.

① Shell gold produces a good, flat surface. Drop a little distilled water onto the gold tablet. Using a fine No. 00 artists' brush, apply an even coat of gold. Rinse the brush in a small pot of distilled water. Apply a second coat when dry and burnish carefully.

2 Gold gouache is applied easily with a fine artists' brush and can produce good flat color that can be built up and burnished. The gold color, however, is a little dull and brown.

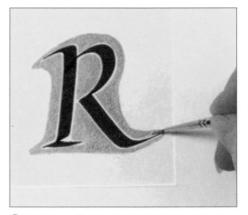

3 Gold metallic powder is a good and much cheaper substitute for real gold powder. Mix it with a drop of gum arabic to make the resulting paint stick to the paper in the same way as powdered gold. Metallic powder shines very well but is a little textured in appearance.

LEAF GILDING

Acrylic gloss medium and water-based gold sizes are ideal glues with which to guild, and they shine brilliantly. For large areas they are not so successful, since they are difficult to apply evenly. PVA medium or craft glue can be used to produce a flat shiny surface of gold on paper by using a 50:50 ratio mix of glue to distilled water. Large areas can be successfully painted using a thin layer of PVA. It is a good idea to add a small amount of red watercolor paint to whichever glue you choose to turn it pink. This makes it easy to see where it has been applied.

You will need

Paper Synthetic brush or dip pen Size: either acrylic or water-based gold size, or PVA medium and distilled water (50:50) Transfer gold leaf Soft brush Glassine (drafting vellum) paper Agate burnisher

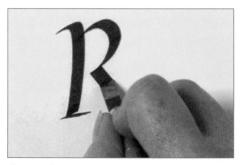

1 First, form your pen-written letter. Here we are going to gild a background. Cover the rest of your work with a protective sheet of paper to keep it clean, leaving only the design area exposed.

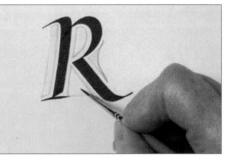

2 Use a synthetic brush or dip pen to paint on the size or area to be gilded. Do not retouch any unsatisfactory areas since this will make grooves. Instead, leave to dry for at least 30 minutes, after which you can scrape away any unwanted size.

3 When the medium is dry, roll a tube of paper and breathe through this onto the size twice with deep breaths to make it sticky. Lay the transfer gold face down on the sized area and press firmly through the backing sheet. Lift the sheet to ensure the gold has stuck. Repeat until the whole area is covered with gold.

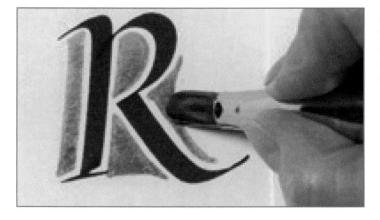

G Brush away the excess gold. Leave for 12 hours to ensure that the medium is fully dry. Cover the gilding with glassine paper and burnish with a burnisher. Burnish again directly onto the gold.

Raised gilding with PVA

RAISED GILDING CAN BE ACHIEVED USING A MODERN MEDIUM MADE FROM PVA OR CRAFT GLUE, WHICH IS Available from craft stores. It works well on paper, but do not use it on vellum or skin.

You will need

300gsm hot-pressed watercolor paper Tracing paper and pencil Dip pen with India ink or technical pen Paper No. 0 or 00 synthetic brush PVA medium and distilled water Glass sheet Transfer gold leaf Silk square Soft brush Glassine (drafting vellum) paper Agate burnisher

APPLYING PVA

PVA (polyvinyl acetate) medium can be applied either by building up several layers of thin medium, or by using one coat of thick medium. For the first method, dilute the medium with 50 percent distilled water, and allow a drying time of 30 minutes between each application. For the onecoat method, the medium should be like thick cream and may only require a small amount of water for dilution. When dry, PVA medium is transparent, so it is a good idea to add a small amount of red watercolor paint to the medium to turn it a light pink color. This makes it easy to see where you are painting and where it is when dry.

1 Trace your design onto 300gsm hot-pressed watercolor paper (see pages 178–179).

2 Outline the drawing with a dip pen and India ink or a technical pen. Cover the rest of your work with a protective sheet of paper to keep it clean, leaving only the design area exposed.

3 Using a No. 0 synthetic brush lay a blob of PVA medium (diluted or not) and gently pull it along the area to be sized. Resist the urge to "paint" it in small strokes, which will cause streaking and grooves. Move the blob quickly and add more PVA patches as you work.

RAISED GILDING WITH PVA

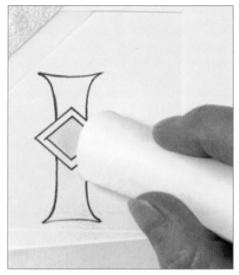

When dry, lay the work on a glass sheet.
 This helps to condense the warm breath. Use
 a small paper tube to breathe onto the PVA
 twice with deep breaths. This makes it sticky.

5 Lay the transfer gold leaf, gold-face down, on the sized area and press firmly through the backing sheet with your fingers.

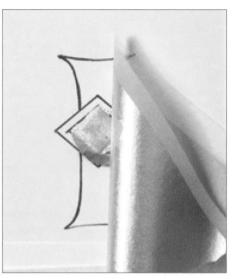

● Lift the sheet to ensure the gold has stuck. Repeat steps 5–7 until the whole area is covered with gold.

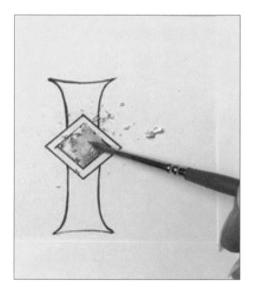

7 Brush away the excess gold and polish gently with a square of silk. Leave for 12 hours to ensure that the medium is fully dry.

8 Cover the gilding with glassine paper and burnish with an agate burnisher.

(9) Burnish again directly onto the gold for a brilliant shine.

Raised gilding with gesso

GESSO CAN BE USED ON VELLUM AND PAPER AND PROVIDES A RAISED "CUSHION" AND ULTIMATELY A HARD SMOOTH SURFACE ON WHICH TO APPLY GOLD. ONCE APPLIED TO THE SUPPORT AND DRIED, GESSO CAN BE REACTIVATED BY BREATHING ON IT, WHICH MAKES IT SLIGHTLY DAMP AND STICKY AGAIN. EVERY APPLICATION OF GOLD ON THE RAISED CUSHION OF GESSO WILL IMPROVE THE SHINE, MAKING THE GILDING APPEAR RICH AND OPULENT. GESSO CAN BE MADE IN BATCHES AND STORED IN AN AIRTIGHT CONTAINER TO BE USED AT A LATER DATE.

MAKING GESSO

This mix should make 16 small cakes. A quarter to half a cake will make one gilded letter.

You will need

8 parts slaked plaster of Paris (available at art supply stores). This could be substituted with calcium sulfate dihydrate.

3 parts powdered white lead carbonate

1 part sugar

Pinch of Armenian bole, or a touch of red watercolor paint

1 part seccotine (fish glue)

2 parts distilled water

Eyedropper

Mortar and pestle

Measuring spoon (1/2 teaspoon)

Polythene film

SAFETY FIRST

Gesso contains white lead carbonate, which is an accumulative poison. Remember never to use the measuring spoons, pestle and mortar, or mixing items you have used with gesso for food. Always wash your hands thoroughly after mixing or reconstituting gesso and before eating or drinking. ① Use a measuring spoon to apportion the ingredients of the gesso recipe accurately. A level half teaspoon (2.5ml) used as a scoop is enough to make a good supply. It is a good idea to count each measure onto paper to check how many scoops you have for each of the ingredients.

2 Thoroughly mix all the dry ingredients together in the mortar first and then add the Armenian bole (or red watercolor). Add the seccotine and a little distilled water (use the eyedropper) and grind well with a pestle until the mixture is smooth and creamy. Use a spoon to deposit 1 inch (2.5cm) cakes of gesso onto a sheet of polythene film and leave to dry. Store in an airtight plastic container.

3 To use, place one cake into a small pot. Add three drops of distilled water. Let soak for 20 minutes. Add another drop of water if required.

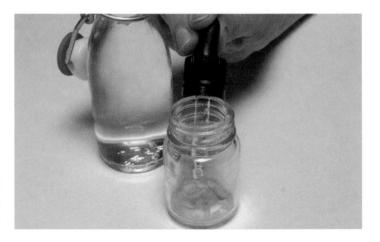

RAISED GILDING WITH GESSO

GILDING WITH GESSO

You will need

One cake reconstituted gesso Tracing paper 2H pencil 300gsm hot-pressed watercolor paper Synthetic No. 000 brush or dip pen Craft knife with curved blade Paper Burnisher Smooth agate stone Masking tape Glass sheet Transfer gold leaf Glassine (drafting vellum) paper

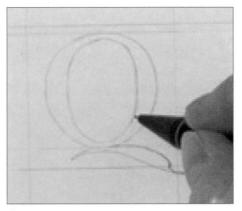

 Trace your design onto a sheet of 300gsm hot-pressed watercolor paper.

2 Load a fine No. 000 brush or dip pen with gesso and apply the small blob to the letter. Pull the blob along the letter rather than paint it on, because this will cause streaking. Work quickly, carefully teasing the gesso into small areas. Avoid retouching any areas or creating bubbles. Leave to dry overnight.

3 Inspect for any rough or uneven areas and scrape smooth with the curved blade of a craft knife or scalpel. Do this with your work on a piece of disposable paper and do not blow any dust into the air. When the surface is smooth burnish with a burnisher (not your best one) or smooth agate stone.

4 Secure your work to a small glass sheet and cover your work with protective paper. Make a small breathing tube and have your transfer gold, glassine paper, and burnisher ready. Two deep breaths onto the gesso will revive the medium. Work quickly, laying the transfer gold onto the letter. Press it firmly with your finger. Repeat until the whole letter has been covered with gold.

5 Cover the letter with a sheet of glassine paper and burnish it using your burnisher. A second application of gold will give a brighter shine. Burnish directly onto the gold using your burnisher.

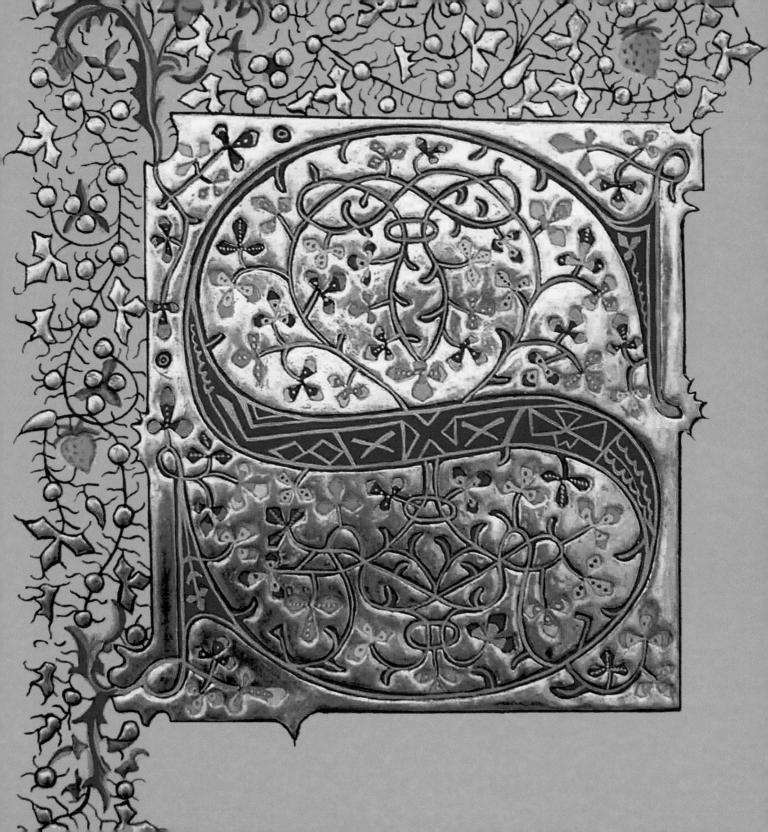

Projects

By now, you will be familiar with all aspects of creating calligraphic art at an advanced level. You are bound to have numerous ideas for expanding the skills you have acquired so far to produce a wide range of wonderful pieces. The intention of this is to present step-by-step instruction that will help you to take this step with confidence. Here is the perfect chance to practice the skills and techniques presented in earlier sections of the book in a series of self-contained projects. They explore various aspects of design, color theory, and the addition of decorative details, and act as a springboard for executing works of your own.

Letterhead

DESIGNING A LETTERHEAD IS A STRAIGHTFORWARD AND REWARDING PROJECT FOR CALLIGRAPHY BEGINNERS. IT CAN ALSO PROVIDE INTERESTING DESIGN CHALLENGES FOR MORE ADVANCED CALLIGRAPHERS WHO HAVE MORE SCRIPTS AND DECORATIVE TECHNIQUES AT THEIR DISPOSAL.

WHICH SCRIPT?

You will need to consider which type of lettering is most appropriate to the person or business whose letterhead you are designing. Do you want the letterhead to look quiet and formal or eye-catching and lively? If the former, a Roman bookhand or formal italic is a good choice. If the latter, a vigorously written cursive italic might be attractive. Relative emphasis within the design can be provided by variations in the size, weight, color, and letterform used.

A further element you may wish to incorporate is a motif or logo. This could be a simple graphic or a sophisticated illustration, depending on your skill and the requirements of your client.

The placement of each element in the design in relation to the whole needs to be carefully worked out. Do you want a close vertical texture for impact or wide spacing for elegance? Is the alignment to be to the right, left, centered, or asymmetrical? And how is the letterhead to be placed on the page?

Beyond the design considerations, you also have to plan how the artwork is to be submitted to the printer. A preliminary discussion with the printer to establish the requirements can avoid expensive mistakes.

The letterhead project shown on the following pages is for a ceramics studio. It needed to convey the handcrafted character of a professional business.

Calligraphic lettering provides an original company identity that can be used on a letterhead and a business card.

SCRIPT AND LAYOUT

The first task is to choose a script that is consistent with the image the business wants to project. Uncial or half uncial seem good initial choices here, with their craft-based associations. After trying various scripts, the half uncial script, with its attractive rounded letterforms, is selected for development.

Having decided on a script, the next stage is to work out a layout. The main issues to be determined at this stage are the size of the lettering and its alignment. Rough pencil sketches are usually adequate for this purpose. In this example, it is decided that the name of the business should be rendered in the largest size. The relative size of the rest of the text needs to be worked out. Experiments with a logo are also tried at this stage.

TRUMM LITLE PEVEN OFREMMOS 33 MARIN STREET. LITLE HEVEN

Centered layout, two text sizes

The saucho tracke haven ceramics

Ragged left-oriented layout, three text sizes

23 MAIN ETTERT

Left-oriented layout with logo, three text sizes

The STUDIO

03 MATN & I

Right-aligned layout, three text sizes

THE FINAL DESIGN

Elements of the second and third layouts have been incorporated into the final design. The text arrangement of the second layout (with slight adjustments to text size) is combined with the logo suggestion of the third. The letterhead is to be centered on the paper.

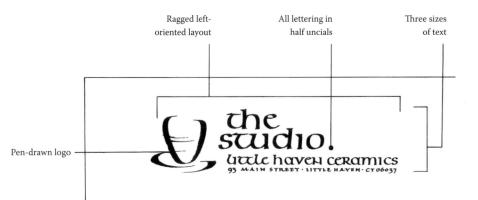

EXECUTING THE WORK

You will need
Paper
2H Pencil
Ruler
Dip pen and India ink
300gsm hot-pressed watercolor paper
Scissors
Rubber cement
Triangle
Blue pencil

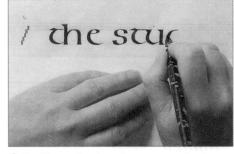

1 Decide on the size of your text and rule your paper with lines. Here, the lettering is larger than it will appear in the final printed form. Reduction sharpens the letterforms.

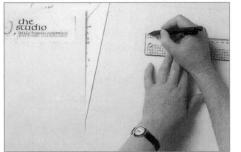

3 Make any final adjustments to the layout before pasting down the lettering and artwork. Start by ruling your paste-up paper with your pencil guidelines.

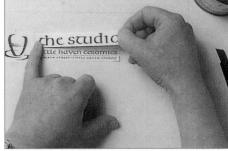

Photocopy each element—reducing them in size where necessary—and paste them carefully in position to show the final effect.

2 Decide on the logo, if there is to be one. This example is drawn using a No. 0 nib on a textured watercolor paper. This gives a rough appearance to the work.

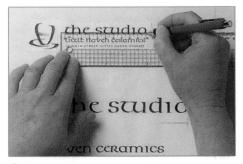

5 Measure the elements on the paste-up and work out what percentage of the original they are so that instructions can be given for a photocopied reduction.

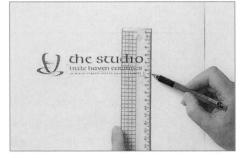

6 Also make a note of the exact positions of the artwork and lettering on the paste-up.

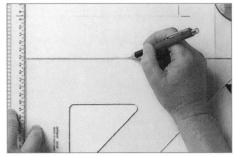

7 Mark the margins and precise guidelines for the positioning of the letterhead on the paper for a final "camera-ready" paste-up for the printer. Use blue pencil, which will not show up in the printing.

8 The final paste-up of the artwork and reduced-size photocopy of the lettering should now be complete for printing. Give the printer separate instructions on the color and type of paper to use.

Wedding invitation

FORMAL INVITATIONS, SUCH AS THOSE FOR WEDDINGS, BIRTHDAYS, AND CHRISTENINGS, CAN BE GREATLY ENHANCED BY CALLIGRAPHY, USED ALONE OR COMBINED WITH TYPE. HANDWRITTEN LETTERS AND SIMPLE LETTER DECORATION FLOURISHING CAN ADD THE INDIVIDUAL TOUCH THAT TYPE ALONE LACKS.

WHICH SCRIPT?

Formal scripts, such as italic, are suitable for occasions such as weddings, christenings, or banquets, but there are no hard-andfast rules. The invitation could be written entirely in capitals, or in areas of upper and lowercase letters to suit the text and overall design. You might combine compatible scripts, use a suitable embellished capital, change to a larger nib for the main names, or write them in a different script. Even the most formal invitation might benefit from a discreet border or small decorative device or illustration.

Designing an invitation for printing means preparing artwork in the form of a paste-up, with calligraphy written in black and with color instructions for the printer. If you are reproducing the invitations by photocopying, they can be copied in black and white or color onto white or colored paper sufficiently thick to cut or fold into cards. Your invitation will usually need to comply to a regular size and shape used by the printer, and, if you work larger, you will have to prepare your artwork to scale.

The wedding invitation shown here had to give prominence to the names of the bride and the groom, while conveying varying levels of information about the wedding and reception clearly and attractively.

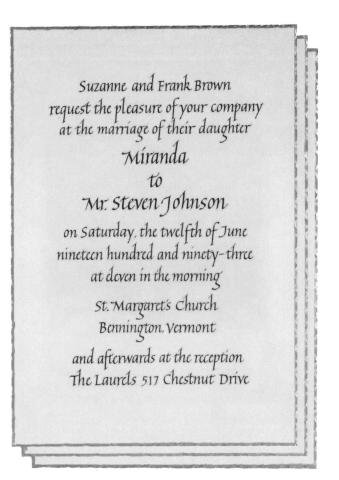

The invitation is printed on a white card with a sliver deckled edge. The result is elegant and reserved.

THUMBNAILS

The first part in the planning process is to sketch out a few layout alternatives from the text supplied. At this stage, it is the format of the invitation and the distribution of the words within that format that are the main concerns. This example tries out four options, all with centered text. The wide vertical format is selected for development.

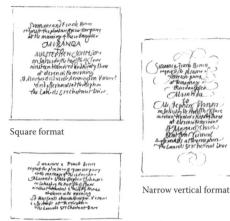

Wide vertical format

Horizontal format

SUZANNE ANA FRANKBROWN Standard italic minuscules with capitals SUZANNE ANA FRANKBROWN Narrow italic minuscules with capitals SUZANNE ANA FRANKBROWN Standard italic minuscules with extra spacing SUZANNE & FRANKBROWN Italic capitals with slight flourishes

CHOOSING A SUITABLE PAPER

EXPERIMENTING WITH LETTERFORMS

minuscules from wide to narrow are tried.

Italic minuscules and capitals—being both formal and

decorative—were the obvious choice for this kind of occasion. The precise details of width and spacing, however, need to be worked out. An all-capitals version and three versions of the

The choice of paper or card for calligraphic work that is to be printed is subject to considerations that are different from those taken into account when selecting a surface to write on. For printed work, you are primarily concerned with color, weight, and texture. Obtain samples from the printer and judge them in relation to the color of ink you are using and the overall effect you are aiming to achieve. TA

WEDDING INVITATION

EXECUTING THE WORK

You will need

Layout paper 2H pencil Ruler Dip pen with India ink Scissors Rubber cement Triangle Blue pencil

(1) Once you have chosen your script, begin to write the text. This example is written using a No. 4 nib to 5 nib-widths. Writing of this size is designed to be reduced in printing to the dimensions of the finished invitation.

2 Decide on any areas of text that require a different script or treatment. Here, a preliminary decision is made to render the names of the bridal couple in swash capitals, using a Mitchell's No. 3 nib.

3 Try alternative versions for comparison. This example shows the names written in italic minuscules in the larger nib size.

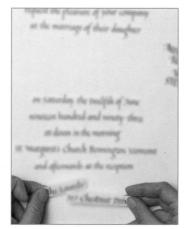

Cut your text into lines and start a paste-up, assessing the spacing by eye. When you have an arrangement you like, you can measure the lines more accurately for a ruled guide on the final paste-up.

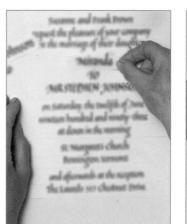

5 Once your paste-up is complete, look through any alternatives you have done for preferences. Here, the capitalized version of the couple's names was pasted up first, then replaced with the minuscule version.

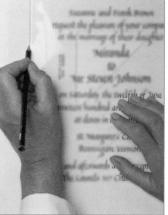

6 With all the text satisfactorily pasted into position, rule your margins using blue pencil to show the printer the final proportions required. The margins must be in proportion to the size of the final printed invitation.

Poetry broadsheet

A BROADSHEET IS A SINGLE SHEET OF PAPER CONTAINING ONE OR MORE POEMS, SECTIONS OF A POEM OR PIECES OF PROSE THAT ARE LINKED BY THEME AND CAN BE READ ACROSS THE SHEET, WITH NO NEED TO TURN PAGES. A BROADSHEET DESIGN SHOULD NOT BE TOO COMPLICATED, OR IT MAY DETRACT FROM THE MEANING OF THE TEXT AND APPEAR CONTRIVED. A SIMPLE APPROACH IS USUALLY THE KEY TO SUCCESS.

A CREATIVE PROCESS

The broadsheet is a good project for the inexperienced calligrapher, and one to which you can return as you progress, because it offers plenty of opportunity for practicing newly acquired skills and using them creatively. Working on texts and themes helps you release and develop your imagination and find ways of interpreting your personal reactions to the passages you choose to write. This can be a stimulating experience and a source of fun. A finished broadsheet can be framed and displayed. The choice of quotations is crucial, because a personal interest in the theme will give the work excitement and a sense of discovery. If you enjoy the time spent on the project, this will communicate itself to the viewer.

In the broadsheet shown here, texts were "hung" around a central piece of writing. The calligrapher was fascinated by the sense of wildness and the closeness with nature reflected in some early Irish poems. The core text was powerful and deeply imaginative and the additional quotations enhanced this feeling while also creating atmosphere. The theme linked the contrasts of beauty and harshness in a landscape integrally bound up with the lives of its inhabitant birds and animals. The scripts were chosen to create interplay between the central and the surrounding texts, while harmonious colors, repeated shapes and images, and gentle contrasts served to unify the design.

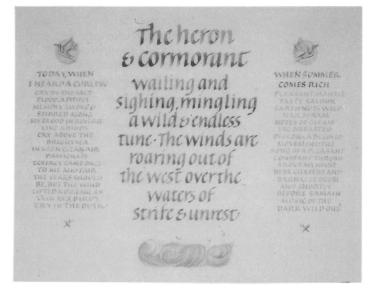

The completed panel shows a delicate harmony of text and illustration. To display the work a natural limed-wood frame is selected, whose muted color does not overwhelm the subtle colors of the lettering.

POETRY BROADSHEET

THE EVOLVING IDEA

The initial design ideas for both the text and the illustration in this project are developed simultaneously. The calligrapher sketches areas to represent the component elements, so that the final design will form a unified whole.

The design is a triptych with the main text centered and the two subsidiary texts on either side. At this stage, the calligrapher's notes indicate that she plans for the focus of the piece to be reinforced by rendering the main text in a darker tone than the subsidiary texts—a decision that is later partially reversed. Thumbnail sketches with accompanying notes show the development of the illustration ideas.

THE FINAL ROUGH

The calligrapher refines her ideas in a rough layout in which she determines the positions of the three component poems and the illustration areas. The text is rendered in italic script and in colors approximating those to be used in the finished piece in order to make the rough as accurate as possible.

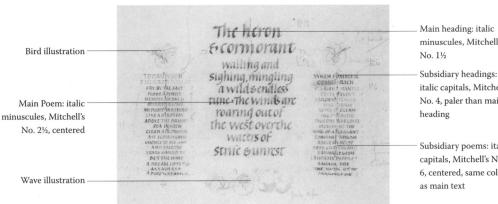

italic capitals, Mitchell's No. 4, paler than main

Subsidiary poems: italic capitals, Mitchell's No. 6, centered, same color

EXECUTING THE WORK

You will need

Scrap paper 2H Pencil Ruler Dip pen and India ink Mixing palette Scissors Rubber cement 300gsm watercolor paper Selection of watercolor paints Fine No.00 artists' brush Triangle L-shaped cards

1 Start by writing the text using a range of selected colors in order to judge their effect. Try different colors on scraps of paper first.

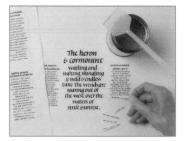

2 Photocopy the text, cut it out and paste in position, placing the central panel first. Ensure that the panels are evenly balanced with equal numbers of lines.

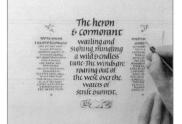

3 With all elements placed in position, measure the line spacing on the paste-up for transferring to the final version on textured watercolor paper.

Work on any illustrations, experimenting with different color treatments before making a final decision.

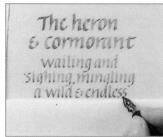

(5) Start the final writing, completing the central panel first, because its position determines the placement of the other elements in the piece.

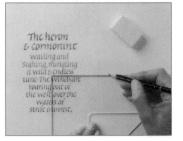

6 Using the paste-up as a guide, rule lines to mark the position of the side panels in relation to the central panel.

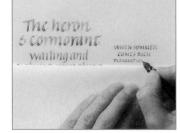

7 Write the side panels along the ruled guidelines.

8 Add the illustrations, drawing them carefully in pencil before adding any color.

9 Decide on the margins once the work is complete. Use L-shaped cards to judge the margins and pencil them in. Trim the broadsheet to size.

Poster

CALLIGRAPHY CAN BE A STRIKING ALTERNATIVE OR COMPLEMENT TO PRINT IN POSTER DESIGN. A CALLIGRAPHIC POSTER IS AN IDEAL CHALLENGE WHATEVER YOUR LEVEL OF SKILL, GIVING YOU THE CHANCE TO PUT YOUR WRITING AND DESIGN ABILITIES TO PRACTICAL USE.

AN EYE-CATCHING DESIGN

A successful poster should catch the eye of the intended audience and present the essential information clearly, so that it can be read "on the run." Some posters suffer from "overload," with too much happening and no central focus; others are simply dull. You can use lettering alone to create an eyecatching focus or choose suitable imagery to fulfill this role. It is important to create an atmosphere in the poster that is suitable to the subject by wise choice of styles and sizes of lettering, and by considered use of space and illustration (if needed). Whether you are creating a notice for a classical concert or an announcement for a contemporary dance performance, all the design elements must be carefully selected and balanced.

A poster can be reproduced at a low cost and look attractive, even if it has to be in a single color. Designing for one color stimulates imaginative use of both contrasts created by the lettering itself and of the space in and around the text. Color can be introduced, if needed, by using colored paper or adding a splash of color by hand to each poster. In posters, as in all design, there are no absolute rules, but experience provides helpful hints. The poster shown here is a low-budget design for a jazz concert to be printed in black on a photocopier. The poster needs to suggest a dynamic but controlled atmosphere while conveying a clear and eye-catching message.

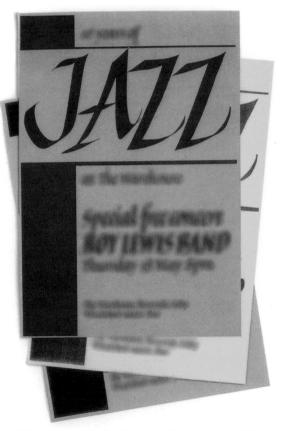

Printed posters. The finished artwork is printed onto different colored papers and the green paper is selected for the final print run.

ASSESSING THE TEXT

In most cases the client supplies the text for the poster, as in this case, in the form of typed copy. The first task is to organize the information into "bite-size" pieces and sort them according to their relative importance. There is also an opportunity for the calligrapher to edit the text for greater impact.

DESIGN ELEMENTS

Consider whether the poster would benefit from the inclusion of a graphic element—a relevant photograph or a decorative border, for example. Here, bold vertical and horizontal bands of black ink are tried out in various positions on the poster as a means of strengthening the focus on the word "Jazz."

STEPHAL FRAM CHAN

ROY LEVALS BAND

THUMBNAIL SKETCHES

Use thumbnail sketches to try various layout ideas that incorporate different sizes and styles of lettering. Here, the word "Jazz" provides the main focus.

Focus in upper half,

aligned left to solid

band in margin

solid bands at top

left

and bottom, aligned

Horizontal orientation

upturned lettering at left margin

main lettering

in left marain

breaking into band

THE FINAL DESIGN

Choose the thumbnail that works best for you. In this case, it is the last one. It provides the best combination of elements, with the broken black band providing contrast and emphasis, leading the eye down the poster to the subsidiary information. Work up a final rough based on your thumbnail. Firm up your decisions on letterform, weight, and size. In this example, the lettering is in compressed italic, which conveys an appropriate sense of controlled energy. Variations in size and weight provide different levels of emphasis.

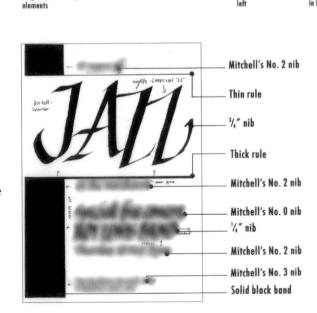

EXECUTING THE WORK

You will need

Paper 2H Pencil Ruler 12mm pen Scissors Rubber cement Indelible fiber-tip pens Correction fluid Fine marker pen

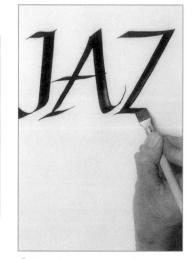

1 Start by writing out the text in preparation for a preliminary paste-up. At this point it is still possible to fine tune the size and weight of the lettering.

2 Make a full paste-up of the poster, using photocopies of the lettering. Make any final adjustments to the position of the text.

3 Measure the line spacing on your rough paste-up and transfer these measurements to the final paste-up.

4 Cut and paste the text into position on the final paste-up.

S Finish the poster design. Here, black bands and rules were carefully drawn in with fiber-tip pens. Use correction fluid to cover up any unwanted marks.

6 Use a fine marker pen to fill any unevenness in the bands and to ensure the black areas are "solid." The poster is now ready for reproduction.

Concertina book

THIS PROJECT EFFECTIVELY COMBINES MANY ELEMENTS. THERE IS A DRAMATIC JUXTAPOSITION OF THE TWO VERY DIFFERENT WRITING STYLES AND THE USE OF THREE DIFFERENT PAPERS FOR THE BOOK ITSELF, CLEVERLY MAKING USE OF RECYCLED CALLIGRAPHY, WHICH IS GIVEN NEW LIFE BY BEING COVERED BY FRAGILE JAPANESE TISSUE PAPER.

WELL-CONCEIVED DESIGN

The need for the design to flow horizontally through the book provides interesting possibilities for both the calligraphy and the layout. Color can often provide a unifying element throughout the book, no matter how limited its use is.

The concertina book shown presents a free-flowing, lowercase alphabet. The linear nature of the written alphabet seems to lend itself well to this horizontal treatment, and the continuous nature of a concertina book works well with the idea of working one's way from "a" to "z." Below the alphabet, the design allows for a more personal text in a different letterform— in this case, simply a line of poetry in capital letters.

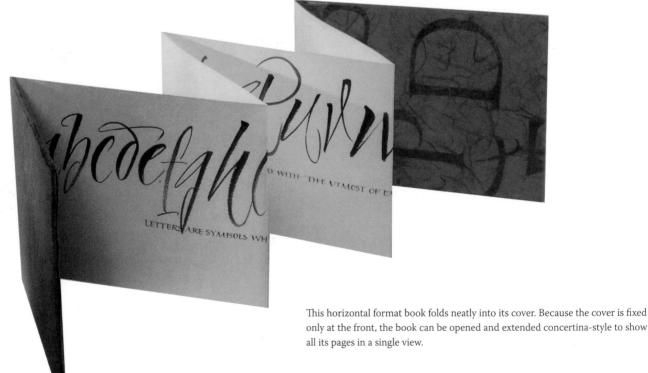

CHOOSING THE BOOK FORMAT

Decide on the size of book you would like to make. Each of the four panels in this example measures 6¾ inch (17cm) in width with 1 inch (2.5cm) left at each end for the cover flaps. The strip is made from watercolor paper and folded in a zigzag fashion to make the concertina. Be sure that the panels are equal in size and fit together snugly. Run a bone folder along the creases to make them crisp. The book cover is made from two pieces of board that are slightly larger than the one of the paper panels. Two offcuts of existing calligraphy add a decorative element. Each is covered with Japanese tissue paper and then wrapped around one of the boards. This is a great way to recycle slightly imperfect work.

DECIDING ON THE LETTERING

Fine brush lettering has been selected for the alphabet text in this project, and provides a freeform style with its expressive marks and sweeping strokes. Several practice runs on watercolor paper allow the calligrapher to experiment with the different effects achieved by altering the angle of the brush to the paper. The linear nature of the design is paramount, so a baseline is ruled up to serve as a guide while still allowing the freedom to move above and below the line. The calligrapher focuses on the sweep and flow of the letters and considers how one letter relates to the next. Several attempts are made in order to achieve a perfect rhythm and will serve as rough guide for the finished piece, executed in a subtle blue-green gouache. A contrasting letter style is selected for the line of poetry—in this case very fine-lined copperplate in black ink.

PROJECTS

EXECUTING THE WORK

You will need

300gsm watercolor paper Bone folder 2H pencil Ruler Fine sable paintbrush Black ink Gouache Distilled water Palette Copperplate nib 2 pieces of board Recycled calligraphy paper Japanese tissue paper Scissors Glue

1 Prepare your watercolor paper, ruling in pencil guidelines for the two lines of text. Mix green and blue gouache with distilled water and make a start on the alphabet.

4 Write in the line of poetry using black ink. Run the letters into the descenders of the alphabet here and there for greater interest.

2 Continue to write the letters using bold, expressive, sweeping brush strokes. Use shade and tone to mirror the flowing letter style. Adjust the letterforms as needed.

3 Use your rough examples as a guide, but do not feel constrained by them. Allow the letters to flow freely, bearing in mind the constraints of the format.

(5) Start work on the cover. The end boards need to be slightly bigger than the book page, and the decorative papers twice the width of each board.

6 Glue a piece of recycled calligraphy to a piece of Japanese tissue paper and wrap it tightly around one board vertically, gluing the seam.

Repeat with the second board. This will give you wholly covered boards with open edges on the short sides.

8 Do not seal the short sides, as this is where the concertina flaps are inserted.

Isip the flaps of the concertina into the board covers. As long as the covers are firmly wrapped in paper they will be secure.

Decorative border

ALTHOUGH GOOD CALLIGRAPHY SHOULD BE ABLE TO STAND ALONE, THERE ARE SITUATIONS IN FORMAL OR CREATIVE WORK WHERE DECORATION CAN ENHANCE A TEXT. DECORATIVE BORDERS FROM EASTERN AND WESTERN HISTORICAL MANUSCRIPTS ARE AN INFINITELY VARIED SOURCE OF REFERENCE FOR CONTEMPORARY CALLIGRAPHY. THESE BORDERS MAY INFLUENCE YOUR OWN DESIGNS, BUT TRY TO USE THEM IN NEW AND CREATIVE WAYS.

AVAILABLE RESOURCES

The wealth of designs in Western manuscripts include simply colored linear borders, sometimes consisting of bands of varying widths and color. These may be plain or divided into decorated rectangles or feature repeating patterns of geometric or intertwined plant elements. Sometimes the border is an extension of a decorated initial letter. A myriad of plant designs, including complex floral designs, are found in Flemish, French, and Italian manuscripts from the late medieval period onward.

Possibilities for contemporary borders abound. Apart from plants and geometric shapes, patterns and symbols from different cultures or religions can be a source of ideas. Whatever the design, small illustrations can be introduced at intervals, perhaps enclosed in circles or other shapes. As with any other form of decoration, the border must be appropriate to the subject and script, and form an integral part of the work as a whole. Plant borders may be contained by colored or gilded lines of suitable width, or left with the plants themselves forming the outer edges of the design.

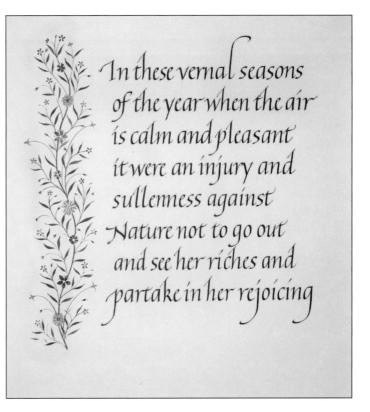

The finished work: the delicate floral border together with the elegant italic text would be overwhelmed by a heavy frame and mount.

FIRST THOUGHTS

The first step is to decide on the page format and on the placement of the borders. Sketch out the various options as thumbnails. Here, the final design is vertical with a single border along the left-hand margin.

Border at left and below	Border below	Border on all sides	Border at top	Border at left
	Democratic and the second	A CONSIGNATION		
			>>94 10" N/ 799. (P 8)_	1

1 x and board as

DESIGNING THE BORDER

Try out a number of designs of varying complexity. Decide whether you wish to include any repeating elements. Here are some options to consider:

1 Simple alternating flower and foliage motif with a strong central linear element.

2 Undulating central stem with a non-repeating design.

3 Three-part design of non-repeating complex flower and stem pattern.

4 Complex flower and stem pattern with strong central emphasis and repeating color combinations.

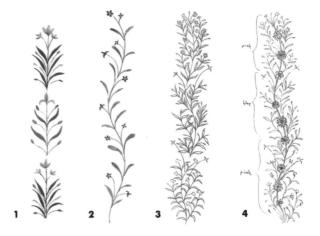

THE FINAL DESIGN

Once you have chosen your border design, decide on the script you want to use for the piece and the color scheme for the border. Keep them clear and bright, but not so strong as to overwhelm the text. Create a rough paste-up to see how the different elements work together.

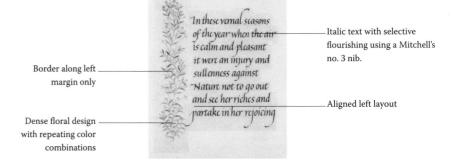

DECORATIVE BORDER

EXECUTING THE WORK

You will need

Layout paper 2H pencil Ruler Dip pen and ink Scissors Rubber cement 300gsm hot-pressed watercolor paper Tracing paper Graphite paper Watercolors Fine brush

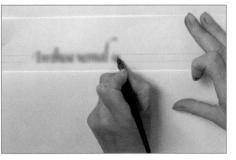

Having decided on the script for the piece, write the text for a final paste-up.

2 Paste the text line by line, cutting each line to length only when you have established its length.

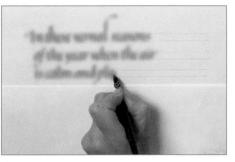

3 With the paste-up complete, you can measure the ruling lines and transfer them to hot-pressed watercolor paper, before writing out the final version of the text.

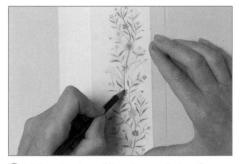

4 Make a tracing of the chosen design for your floral border. Placing a pad of paper under the drawing helps you to obtain a good-quality line.

5 Transfer the traced design to its final position on the writing sheet by placing graphite paper between the tracing paper and the paper. Simply draw over the tracing, pressing firmly.

6 Complete the final illustration by applying watercolor with a fine brush.

Celtic angular knotwork "A"

THE MOST LAVISHLY DECORATED CELTIC MANUSCRIPTS ARE TO BE FOUND BETWEEN THE SEVENTH AND NINTH CENTURIES, IN PARTICULAR, THE *BOOK OF KELLS* AND THE LINDISFARNE GOSPELS. CELTIC KNOTWORK, SPIRAL PATTERNS, AND INTERLACING ADORN THE PAGES AND ANIMALS, BIRDS, AND FIGURES ARE INCORPORATED INTO THE ELABORATE AND COMPLICATED GEOMETRIC DESIGNS. TO ACCOMPANY UNCIAL OR HALF-UNCIAL SCRIPT WITH A DECORATIVE LETTER, IT WOULD BE USEFUL TO STUDY THE HISTORICAL MANUSCRIPTS WRITTEN DURING THESE TIMES, OR SOME OF THE MANY BOOKS WRITTEN ON CELTIC DESIGN.

You will need

Tracing paper HB and 2H pencils Ruler 300gsm watercolor paper Black technical pen Artists' brushes: Nos. 00 and 1 Gouache: black; scarlet lake; zinc white; ultramarine blue; green Shell gold or gold gouache Burnisher or silk square

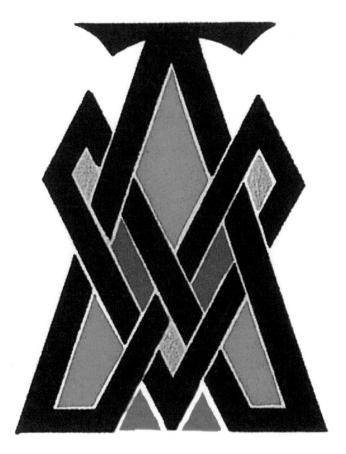

CELTIC ANGULAR KNOTWORK "A"

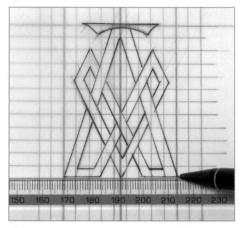

1 First trace your design using an HB pencil. This Celtic angular knotwork "A" has been adapted from a display capital found in the *Book of Kells.* It may be useful to make a grid on which to design your letter before tracing.

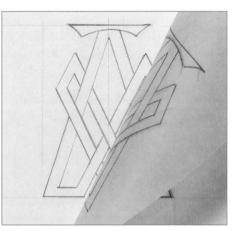

2 Transfer the completed letter from the tracing paper to 300gsm watercolor paper using a sharp 2H pencil.

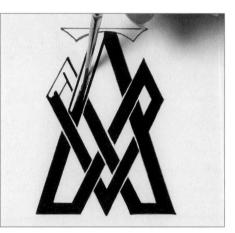

3 Draw around the design accurately, using black technical pen, then fill in the center of the stems using a No. 00 artists' brush and black gouache.

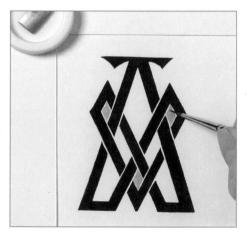

④ Using a No. 00 artists' brush, paint the area shown with shell gold or gold gouache. When the gold is dry it can be polished with a burnisher or a piece of silk. No gold was used in the *Book of Kells*, instead the scribes would have used orpiment (arsenic trisulfide), a highly poisonous yellow that shone like gold.

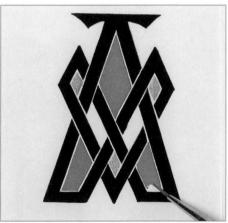

5 Using a No. 1 artists' brush, paint the red areas using scarlet lake gouache with a touch of zinc white added. Be careful to leave a gap around the color. This adds to the brilliance. In historical times this may have been necessary to keep some colors from touching one another, because of the corrosive reaction between them.

6 Now add the blue, using ultramarine blue gouache with a touch of zinc white. Finally, add green gouache to the bottom of the letter to complete the design. To enhance the letter further a row of red dots can be placed around the letter, as on the letter "X" on page 210.

Celtic inspiration

THE SCRIPT IN CELTIC MANUSCRIPTS WAS FROM THE UNCIAL FAMILY OF MAJUSCULES. MANY OF THE DECORATIVE LETTERS SHOWN HERE ARE UNCIAL IN ORIGIN, CURVED AND FLUID. YOU CAN PHOTOCOPY OR TRACE THE BLACK LINE LETTERS AND USE THE COLOR EXAMPLES FOR INSPIRATION.

CELTIC "X"

The inspiration for this much simplified, but exciting letter design was from the Chi-Rho page of St. Matthew's Gospel in the *Book of Kells*. Leave it modern and plain, or color or pattern it as you wish.

CELTIC "M"

You can easily adapt stylized bird letters from those found in Celtic manuscripts.

An exuberant pen-written "X" with which to begin a line of uncial or half-uncial writing. One letter extension ends in simple pattern.

This "M" is copied from a decorative letter in the *Book of Kells*, with a simple knotwork pattern in the right-hand counter.

An angular display capital with a gold center.

A simple "M" typical of those from insular Celtic manuscripts. Alternative colors can be used and red dots applied to the outside.

An angular capital with a simple but effective knotwork stem and the whole letter surrounded by red dots.

An angular display capital, adapted and simplified, from the *Book of Kells*.

CELTIC "P"

The stylized head of a dog has been made to fit into the bowl of the letter. You could use this design with "D" and other rounded letters. Use any colors to decorate the motif.

A simple "P" with the stem extended into a lozenge design.

This letter features simple plait and knotwork designs within the stems and can be applied to any letter of the alphabet.

A Celtic angular display capital. Here a modern color combination has been applied.

CELTIC "H"

This uncial "H" is decorated with a stylized bird. You can use the traditional bright red and blue colors to decorate it, or you can explore more modern harmonious combinations.

This simple display capital is similar to those found in the Lindisfarne Gospels. Any color combinations can be applied when painting.

The predominately blue and purple uncial "H" contains simple spiral endings to the letter, and interlacing within the stem.

This letter "H" is based on the Celtic uncial form, but appears more modern by the addition of the gold diamond decoration.

Romanesque "N"

ROMANESQUE DESIGN EMERGED IN EUROPE DURING THE LATE ELEVENTH AND TWELFTH CENTURIES. MANUSCRIPT ART AT THAT TIME WAS INFLUENCED BY EARLIER WESTERN ART—PARTICULARLY CELTIC AND ROMAN—AND ALSO MODIFIED BY BYZANTINE AND ISLAMIC DESIGN. THE DECORATION WAS RICH IN COLOR AND GOLD, AND THE LARGE, ILLUMINATED INITIAL LETTERS OF THE DISPLAY PAGES OFTEN CONTAINED A NARRATIVE SCENE. THE BORDERS OF THE PAGES ALSO CONTAINED FIGURES AND ANIMALS AND MUCH OF THE DECORATION WAS SYMBOLIC IN NATURE.

You will need

Tracing paper 2H pencil 300gsm watercolor paper Black technical pen Paper cover Synthetic brush for gum or size **PVA** glue Transfer gold leaf **Glass** sheet Soft brush Glassine (drafting vellum) paper Burnisher Transfer silver leaf No. 000 artists' brush Gouache: Winsor blue; ultramarine blue; zinc white; and scarlet lake

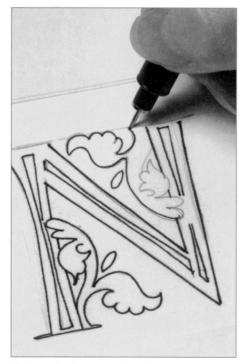

1 Trace the letter template from page 215 on to 300gsm watercolor paper using a sharp 2H pencil. Draw over the lines with a black technical pen.

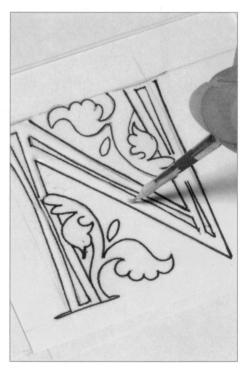

2 Cover the rest of the work with protective paper, leaving only the area you are working on exposed. Use a synthetic brush to apply PVA glue to the areas of the letter you wish to gild with transfer gold leaf (see pages 182–183). Leave to dry for 30 minutes.

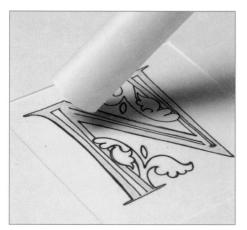

3 Secure the work to a glass sheet, make a small paper tube, and have the transfer gold leaf at hand. Breathe through the paper tube onto the PVA.

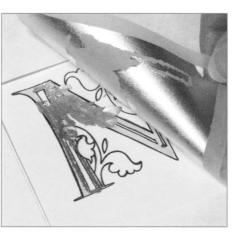

Apply the gold face down and press firmly. Continue until the whole letter is covered, then brush away the excess gold with a soft brush. Leave overnight for the PVA to dry, then burnish through glassine paper before burnishing directly. Brush away the loose particles of gold with a soft brush.

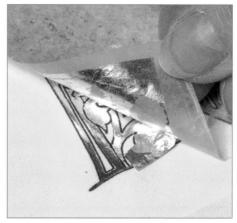

(5) Paint the acanthus design with PVA and leave to dry for 30 minutes. Protect the gold with glassine paper, breathe onto the gum, and press down the transfer silver leaf. Silver will not stick to itself like gold does, so it must be laid in a single layer—you may want to practice on spare paper first. Silver will tarnish in time adding interesting effects.

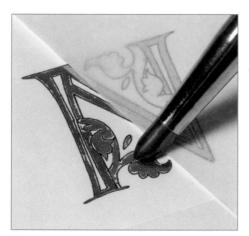

6 Brush away any loose particles of silver and burnish the silver through glassine paper. Then burnish the silver directly.

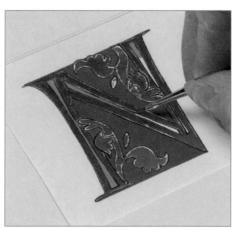

Paint the blue areas with a gouache mix of Winsor blue and ultramarine blue with a touch of zinc white, using a No. 000 artists' brush. Paint the red areas inside the letter stem with scarlet lake gouache.

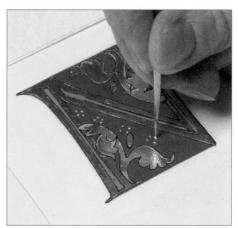

8 You can add further simple patterns to the background with fine white or red dots.

Romanesque inspiration

THE MANUSCRIPTS OF THE ROMANESQUE PERIOD CONSIST OF A WEALTH OF INITIALS CONTAINING ACANTHUS FOLIAGE WITH STYLIZED FRONDS AND COILING TENDRILS. THE ILLUMINATION IN THE LARGE MANUSCRIPTS WAS LAVISH, CONSISTING OF DISPLAY PAGES AND LARGE INITIAL LETTERS WITH GOLD AND SILVER DECORATION. THOUGH MOST OF THE MANUSCRIPTS OF THIS PERIOD WERE ECCLESIASTICAL, BOOKS FOR SCHOLARS WERE ALSO BEING PRODUCED.

ROMANESQUE "C"

This black line drawing has Celtic interlacing on the letter and vines springing from the "C" into the letter counterspace.

ROMANESQUE "L"

A black line "L" adapted from the incipit page of a German Gospel Book from the Benedictine Abbey of Helmarshausen, c.1120–1140. It shows spiraling interlacing vines, executed in gold and silver on a blue and green background.

A modern interpretation of twelfth-century "C," with interlacing vines. Make sure that the intertwining stems look as though they really do grow from one another. The application of green gouache instead of the historical blue and red makes this letter look more modern.

Painted with gold gouache, this letter appears more modern. Altering the more traditional medieval colors of red, blue, and green will change it yet again.

This letter has been adapted from a mid-twelfthcentury medieval "E." This can be done with most letters of the alphabet, using the fundamental characteristics of historical design.

This delicate versal has been "modernized" by using flat gold and complementary colors for the decoration.

An "arabesque" initial letter has ornamentation of fine, linear foliate designs derived from Islamic art. The pen-drawn versal in two contrasting colors is typical of those found in the manuscripts of France and England in the late twelfth century.

A fanciful pen-drawn versal in red, adapted from those found in the Winchester Bible, England, 1160–1175.

ROMANESQUE INSPIRATION

ROMANESQUE "N"

A simplified twelfth-century-style letter, with acanthus leaves curving around the letter stems. The background colors were often divided into red, blue, and green in order of color importance.

ROMANESQUE "Q"

A black line "inhabited" letter —containing a human figure drawn in English mid-twelfthcentury style.

This elegant pen-drawn versal is typical of those of the late twelfth century, which were usually drawn in red, blue, or green with the flourishing in a contrasting color. Here, a small amount of gold has been added to make the finished design more interesting.

English Romanesque initial "Q" from a late twelfth-century Psalter (Ms, Auct D.2.8). On the original the outer circle is gray, the inner circle, green, and the center square is orange.

A late twelfth-century versal in contrasting colors has been drawn with a pen and filled with paint.

Here is a pen-drawn uncial typical of the twelfth-century English letters that uses two contrasting colors with flourished plant-like tendrils. The stem has added white dots for decorative effect.

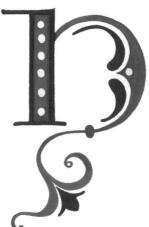

Letter "Q" adapted from a copy of Gratian's Decretum, France, c.1140, which became the most important law book of the twelfth century.

Renaissance "F"

RENAISSANCE IS A FRENCH TERM MEANING "REBIRTH," AND APPLIES TO THE 200-YEAR PERIOD FROM THE MIDDLE OF THE FOURTEENTH CENTURY THROUGH TO THE MID-SIXTEENTH CENTURY. THIS LETTER HAS BEEN INSPIRED BY THE WHITE, VINE-STEM DESIGN OF THE EARLY ITALIAN MANUSCRIPTS, IN POPULAR USE BETWEEN 1450 AND 1470.

You will need

Tracing paper 2H pencil 300gsm watercolor paper or vellum Brown technical pen No. 00 synthetic brush Gesso (see page 186) Craft knife with curved blade Burnisher Smooth agate stone or old burnisher **Glass** sheet Paper tube Transfer gold leaf and loose leaf gold Soft brush Scissors Tweezers Glassine (drafting vellum) paper Artists' brushes: Nos. 00-0000 Gouache: ultramarine blue; Winsor blue; zinc white; scarlet lake, alizarin crimson; Winsor green; lemon yellow; permanent white Shell gold or gold gouache

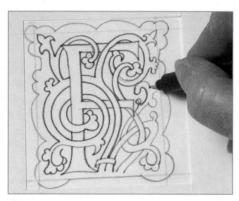

1 Trace the black line design from page 218 and transfer it to a small sheet of 300gsm watercolor paper using a sharp 2H pencil. Outline the letter using a brown technical pen.

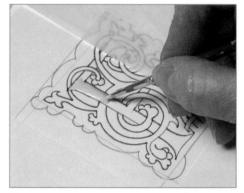

2 Use a synthetic brush to paint the stem of the "F" with gesso. Create a cushion to give a raised surface for the gold, in keeping with the original manuscript letters (see page 187).

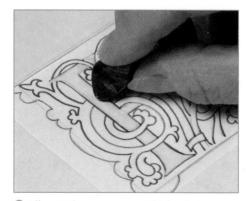

3 Allow 12 hours or overnight for drying, then scrape away any unevenness, lumps, or untidy edges with a curved craft knife and burnish with an old burnisher or a smooth agate stone.

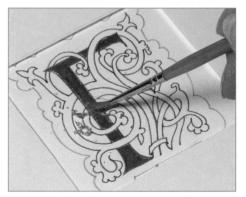

4 Secure the work to a glass sheet, make a small paper tube, and have the transfer gold leaf to hand. Breathe on the gesso and apply the transfer gold leaf to cover the whole letter (see page 187). Brush away any loose particles.

(5) Now apply the loose leaf gold. Gold sticks to gold, so there is no need to breathe on the letter again. Open the book of gold, holding the spine carefully so the gold does not fall out. Using clean scissors, cut a small square of gold, including the backing paper.

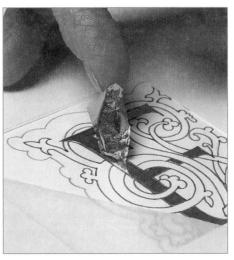

6 Pick up the gold and backing paper with clean tweezers or carefully with your fingers, and lay it gently where you require it. Cover the area with glassine paper and press firmly on to the letter.

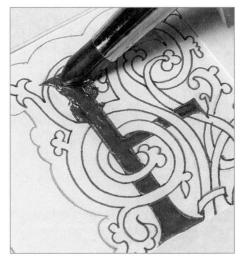

⑦ Burnish carefully through the glassine paper then directly onto the gold. Cover the whole letter in the same way and brush away any loose particles.

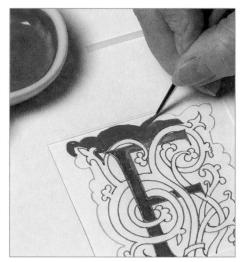

Now you are ready to paint with gouache.Mix the blue by using ultramarine blue,Winsor blue, and a touch of zinc white and fill in the background.

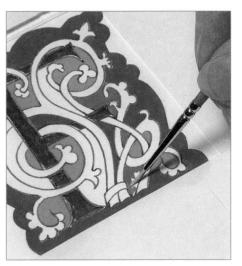

(9) For the red areas use a mix of scarlet lake, alizarin crimson, and zinc white. Try to create a good balance in the design. Mix the green using Winsor green, lemon yellow, and a touch of zinc white and paint the appropriate areas.

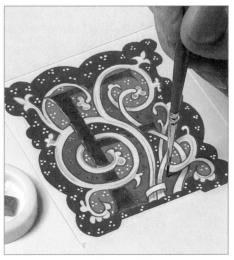

10 Apply the small white dots on the blue and red areas with a No. 000 brush and permanent white gouache. Add dots of shell gold or gold gouache (see page 182) to the green areas to complete the letter.

Renaissance inspiration

THE HIGHLY DECORATIVE AND BEAUTIFULLY ILLUMINATED MANUSCRIPTS OF THE RENAISSANCE SHOWED A NOTICEABLE CONCERN WITH REALISTIC INTERPRETATION AND SMALL MINIATURES, WHICH WERE A REFLECTION OF THE REALISTIC STYLES OF THE FRESCO PAINTERS AT THE TIME OF THE ROMAN EMPIRE.

RENAISSANCE "F"

A black line drawing of the white vine-stem design of the fifteenth century. This letter can be traced and colored as illustrated on page 217. You can, of course, use other colors.

RENAISSANCE "K"

This black line letter is typical of fifteenth-century design.

This raised gilded letter with a painted red gouache background is typical of sixteenth-century decorative capitals.

This elegant interlacing design can be applied to any letter of the alphabet. It is interesting to note that the vine does not emanate from the letter, as it would with Romanesque motifs, but only spirals around it.

This three-dimensional letter was copied from the marginal decoration of a French Book of Hours, c.1520, originally made for Francis I of France. His initial letter was incorporated into the elaborate border decoration.

This sixteenth-century-style letter has been painted to imitate a classical Roman inscriptional letter. This was a feature seen in many of the initial letters of the Renaissance.

This light blue "K" was inspired by an initial letter from a fifteenth-century Bruges Book of Hours.

A raised gilded classical letter based on those found in great abundance in the Florentine Books of Hours written in the first half of the sixteenth century. The line decoration can be white or in shell gold.

RENAISSANCE "S"

This black line letter was inspired by the printed letters of Geoffroy Tory of Paris.

This design is inspired by the late-fifteenth– early-sixteenth century letters that used sculptured leaves and twig-like stems to create the patterning.

An example of a late-fifteenth– early-sixteenth century French trompe-l'oeil style letter, with all the modeling creating a threedimensional effect. This style of letter is usually placed within a box with a gilded background and decorated with flowers and fruit.

RENAISSANCE "V"

This black line letter has been adapted and simplified from a highly decorative manuscript written in Florence in 1488. The beautiful Roman capital was originally executed in raised gold.

A classical-style sixteenthcentury Roman letter painted to look like chiseled stone, accompanied by delicate pen decoration.

This letter is copied from

the Sforza Hours, from an

illustrated and illuminated

page by the Milanese

illuminator and priest,

Giovan Pietro Birago,

fifteenth century.

working at the end of the

This gilded letter on a raised gesso ground is based on the letters of Florentine manuscripts of the early sixteenth century.

The vine in this white vine-stem motif does not grow from the letter, but twists and curves gracefully around the letter shape as a design in its own right.

219

Arts and Crafts "T"

MUCH OF THE WORK THAT WILLIAM MORRIS CREATED WAS INSPIRED BY HIS LOVE OF NATURE AS A BOY, AND BY STUDYING MEDIEVAL ART, HISTORY, AND MANUSCRIPTS. THESE TWO INFLUENCES WERE FUNDAMENTAL TO HIS DESIGNS, WHERE LEAVES—PARTICULARLY THE MEDIEVAL ACANTHUS LEAF—FLOWERS, AND ANIMALS ARE INTERTWINED AND REPEATED THROUGHOUT. WILLIAM MORRIS WAS MUCH INVOLVED IN THE ARTS AND CRAFTS MOVEMENT, WHICH WAS SUBSEQUENTLY FOLLOWED BY ART NOUVEAU AND THE GRAPHICS AND LETTERING OF THE EARLY-TWENTIETH CENTURY.

You will need

Tracing paper 2H pencil 300gsm hot-pressed watercolor paper Black technical pen Synthetic brush PVA glue and distilled water Paper Transfer gold leaf Soft brush Silk square Glassine (drafting vellum) paper Burnisher Artists' brushes: Nos. 000 and 1 Gouache: permanent green deep; cadmium yellow; zinc white; permanent white;

Winsor blue

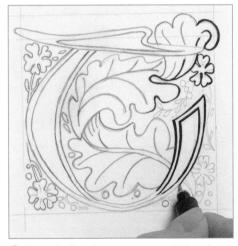

1 Trace the line drawing on page 222 and transfer it to a sheet of hot-pressed watercolor paper using a sharp 2H pencil. Outline the design with a black technical pen or, as here, draw an outline with a pen or synthetic brush using permanent green deep gouache with a small amount of black added.

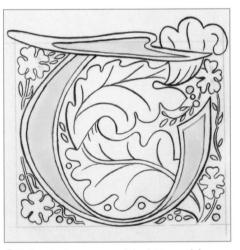

2 Paint the inner area of the letter and four dots in the background with thin PVA glue to give a flat gilded surface that is in keeping with the design. Allow to dry.

ARTS AND CRAFTS "T"

3 Breathe onto the letter and apply transfer gold leaf until the size is covered. Finish the gilding by brushing away excess leaf with a soft brush or a silk square. Burnish the work gently.

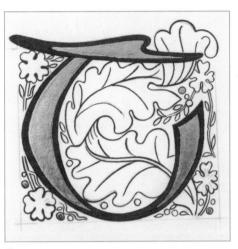

4 With a small No. 000 artists' brush, paint the bars around the gold in permanent green deep gouache.

6 Mix green deep gouache with cadmium yellow and a touch of zinc white to paint the acanthus leaf within the letter and stems and leaves elsewhere in the design. Mix Winsor blue with zinc white to paint the flowers.

6 Using the same blue, paint inside the letter. Add more zinc white to paint the edges of the petals. Paint the highlighted line around the edges of the flowers using a mix of permanent white with a touch of Winsor blue.

7 Use a No. 1 brush to paint the background color of the square with permanent green deep. Mix more cadmium yellow and zinc white into the permanent green mix to enable you to paint the highlights on the leaves. Finally, mix cadmium yellow and permanent white gouache to dot the vellow centers of the four blue flowers.

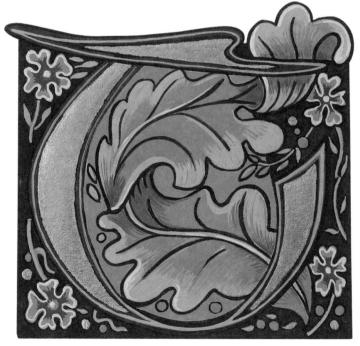

Arts and Crafts inspiration

THERE ARE MANY WONDERFUL EXAMPLES OF DESIGNS CREATED DURING THE LAST QUARTER OF THE NINETEENTH CENTURY AND THE FIRST QUARTER OF THE TWENTIETH CENTURY FROM WHICH TO FIND INSPIRATION. SOME OF THE DESIGNS ARE REMINISCENT OF NOT ONLY MEDIEVAL ART BUT ALSO GOTHIC AND RENAISSANCE LETTERS.

ARTS AND CRAFTS "T"

The black line drawing of the William Morris inspired "T" used for the project on the previous pages. The basic letter can be gilded and painted as it was in the project, or adapted to suit your own ideas for decoration.

ARTS AND CRAFTS "U"

A black line drawing adapted from a William Morris design that was itself adapted from the letters of the Renaissance. This letter could be gilded on a colored background with white flowers and tendrils. Alternatively, it would look quite different if the background were gilded and the letter painted.

The basic letter design is similar to the turn-of-thecentury "T," but with a different plant motif and leaf designs inserted into the letter shape itself.

This "U" is based on a nineteenth-century gilded letter, but has a modern, abstract feel. Only one color and gold have been used for a more striking effect.

This decorated letter is typical of the rounded letter shapes of the Art Nouveau period, where simple, fluid letters adorned the posters and commercial art of the first half of the twentieth century.

The design of this letter "U" was created using simple decorative shapes and colors similar to those used by Charles Rennie Mackintosh, an outstanding exponent of the Art Nouveau style.

A gold Roman "T" adapted from a design by Ida Henstock, an illuminator and a working colleague of Grailly Hewitt, both calligraphers of the early twentieth century.

A simple rounded letter similar to those that can be found on the posters of the prolific graphic designer Alphonse Mucha in the early twentieth century.

ARTS AND CRAFTS "A"

A black line drawing "A" inspired by William Morris' designs. You can apply color to the background and leaves and gold to the outer line of the letter. Alternatively, you could apply gold to the background.

The influence of Arts and Crafts

can often be seen in Art Nouveau

ARTS AND CRAFTS "I"

The fluid movement of cloth is evoked in this carefully colored leaf

the shapes are sculpted by adding

adding white to the principal color.

tones and highlights, created by

This black line drawing, Arts and Crafts in style, features a simple repeat "tulip" design within the stem of the letter.

This Art Deco "A" reflects the antithesis of Arts and Crafts styling from which it emerged, painted in flat coordinating color, and geometrical in form.

styling. This letter from an alphabet by Arnold Bocklin characterizes the soft flowing curves and lines and the absence of geometric design. Transfer gold leaf has been pressed into the background color.

An expressive "A" adapted from those drawn by Alphonse Mucha, whose sensitive and subtle approach to color and design can be said to be synonymous with much Arts and Crafts and Art Nouveau design.

with the choice of colors.

A typical Arts and Crafts design adapted from a Renaissance white vine motif, just as William Morris himself did. The green leaves and tendrils travel through and around the gilded letter.

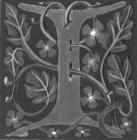

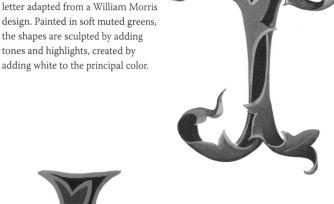

Similar to the William Morris "I," the shape of this

letter has been simplified and another mood created

Modern letter "H"

MODERN CALLIGRAPHIC AND ILLUMINATED WORK CAN BE FUNCTIONAL OR DECORATIVE, SUBTLE OR EXPRESSIVE, SUBDUED OR OUTRAGEOUS. TODAY WE CAN ADAPT LETTERS FROM A WEALTH OF HISTORICAL OR MODERN EXAMPLES AND WE CAN MANIPULATE DESIGNS AND IDEAS WITH THE USE OF PHOTOCOPIERS, DIGITAL CAMERAS, OR COMPUTERS, OR WE CAN CHOOSE TO WORK WITH TRADITIONAL METHODS AND MATERIALS TO CREATE A VARIETY OF LETTERS, WORDS, AND DESIGNS.

You will need

Tracing paper 2H pencil 300gsm hot-pressed watercolor paper Black technical pen or a ruling pen No. 1 artists' brush and No. 00 synthetic brush Soft brush Transfer Smooth agate burnisher Gesso (see page 186) **Glass sheet** Paper Glassine (drafting vellum) paper Craft knife with curved blade Gouache: scarlet lake; zinc white; ultramarine blue

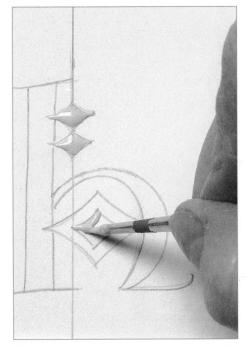

1 Trace the design onto 300gsm hot-pressed watercolor paper using a 2H pencil. Apply the gesso to the diamonds, using a No. 00 synthetic brush, teasing the shapes into fine points. Create a "cushion" for the gold (see pages 187). Allow 12 hours for drying, then scrape away any unevenness, lumps or untidy edges with a curved craft knife.

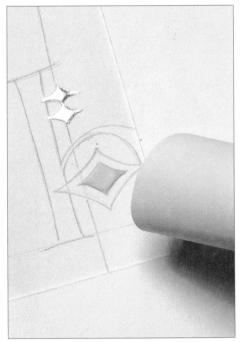

2 Secure the work to a glass sheet, make a small paper tube, and have the transfer gold leaf ready. Cover the rest of the work with protective paper, leaving only the area you are working on exposed. Breathe twice onto the gesso through the tube and apply the transfer gold face down.

MODERN LETTER "H"

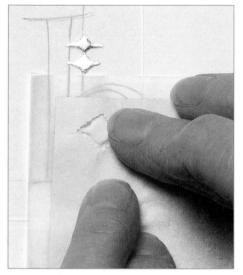

3 Press down firmly to make the gold stick. Repeat until all the gesso has been gilded.

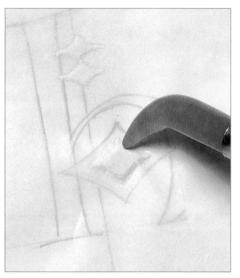

4 Burnish the letter carefully through glassine paper to ensure that the gold has adhered in every crevice.

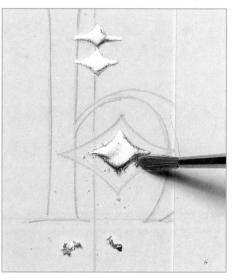

5 Brush away any loose gold with a dry brush. Trim any jagged areas with a craft knife.

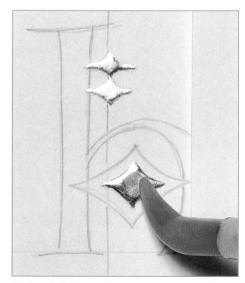

6 Carefully burnish directly onto the gold to polish it.

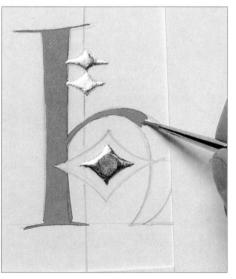

Using a No. 1 artists' brush, paint the red letter using scarlet lake gouache with a touch of zinc white added to make it opaque.

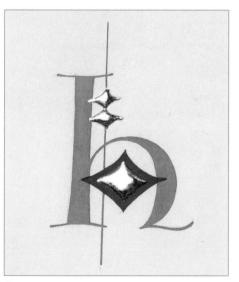

8 Paint the diamond edge with ultramarine blue. Finally, draw the red vertical line with a ruling pen filled with scarlet lake gouache, mixed with zinc white.

Modern inspiration

POETRY AND PROSE, WORDS AND LETTERS PROVIDE THE CALLIGRAPHER AND LETTERING ARTIST WITH AN ENDLESS SOURCE OF INSPIRATIONAL MATERIAL TO EXPRESS EMOTION, COMMUNICATE IDEAS, OR INVENT DECORATIVE DESIGNS. THE VARIETY OF LETTER SHAPES, RELATED IDEAS, AND RESULTING COLOR IMAGES THAT CAN BE CREATED IS INFINITE AND THE MOODS AND FEELINGS SUGGESTED ARE ENDLESS. SOME OF THE LETTERS HERE ARE EXUBERANT AND LIVELY, OTHERS ARE SUBDUED.

MODERN LETTER "B"

This "B" is written using a pen and black ink in the versal hand. The letter can be written and decorated in colored ink or gouache.

This green italic "B" is written with a manipulated pen stroke. A smaller pen was used for the branches and the gold leaves were created with patent gold pressed onto painted PVA leaves.

An automatic or coit pen dipped in Winsor

blue gouache can be used to create this italic

letter. The diamond shapes are patent gold on

This raised PVA-gilded "B" is surrounded by painted boxes in complementary gouache colors.

for a muted effect.

A drawn, modern, formal italic "G" is

painted in subtle, harmonious colors

MODERN LETTER "G"

A black pen-written flourished italic "G" created with two different-sized nibs. The design involves simple added decoration.

Written with multiple pen strokes, this freeform "G" benefits from decoration with bright color, making it appear exuberant and stylish. The gold dots are made with transfer gold leaf on raised PVA.

This foundational letter was written with a pen dipped in thin PVA. A second application was applied using a brush. When dry, transfer gold was applied. The background squares are painted in PVA with silver leaf applied.

raised PVA.

MODERN INSPIRATION

MODERN LETTER "R"

The main letter is written with a large pen and the fine line decoration created using a technical pen.

A flourished italic letter is written freely in cadmium red gouache and decorated with a smaller nib.

MODERN LETTERS "Y" AND "Z"

An automatic or coit pen was used to create this black pen-written "Y" leaving gaps halfway down the stems for decorative effect.

This lowercase "y" was freely written using masking fluid. The geometric design was painted around the letter using transparent inks and a gold square placed in the top corner using PVA and patent gold. The masking fluid was then removed, leaving a white letter.

This geometric design was made using a drawing compass and triangle, to create a bold and dynamic letter "R."

This drawn letter "Z" can be painted in gold gouache or gold metallic powder with added gum. Gold dots and a painted background complete the design.

A pen-written italic capital "R" was traced when dry. The letter was repeated four times to create a design. One was gilded with patent gold on PVA. The letters behind were painted.

A drawn "Z" painted in metallic copper powder mixed into scarlet red gouache.

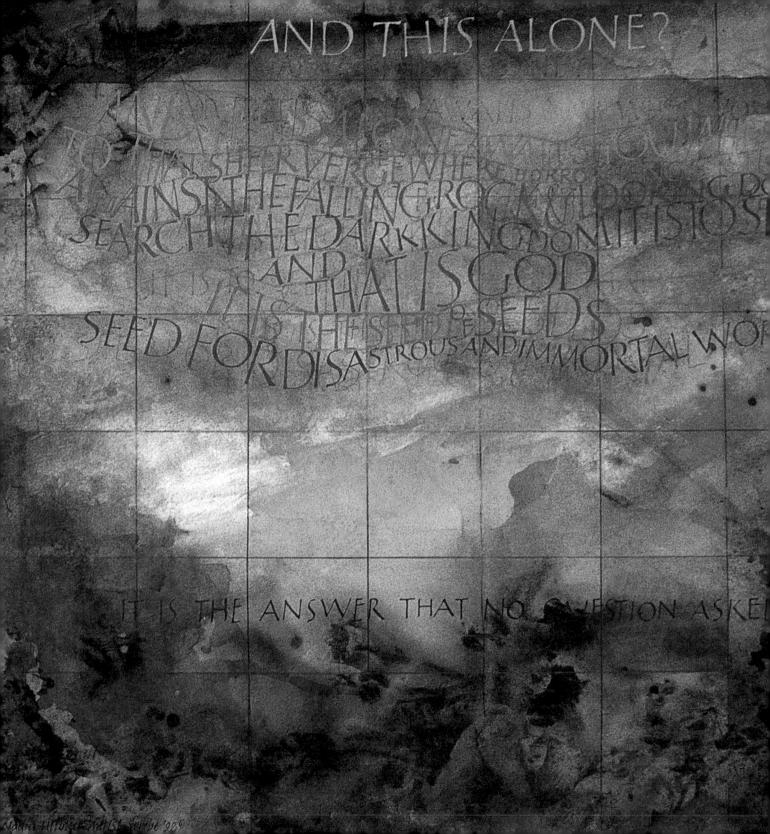

Gallery

Feast your eyes on the following pages. Here, many calligraphers display their diverse and creative solutions for putting words onto paper and other surfaces. The selected works are loosely grouped into categories to complement each of the main sections of material in this book: The Alphabets; Design & Color; Decorative Detail; and The Projects. Almost all works could qualify under more than one heading, so do not confine yourself to one section if you are looking for specific inspiration.

Calligraphic scripts

THESE WORKS DEMONSTRATE THE SHEER VERSATILTY OF THE ALPHABETS FEATURED IN THE WORKBOOK SECTION OF THIS VOLUME. HERE YOU CAN SEE HOW UPPER AND LOWERCASE LETTERS HAVE BEEN USED TO GREAT EFFECT IN CAPTURING THE MOOD OR INTENTION OF A PIECE. WHILE SOME EXAMPLES FEATURE DIFFERENT WEIGHTS OF A SINGLE SCRIPT, OTHERS RELY ON CONTRASTING TWO OR MORE FOR IMPACT.

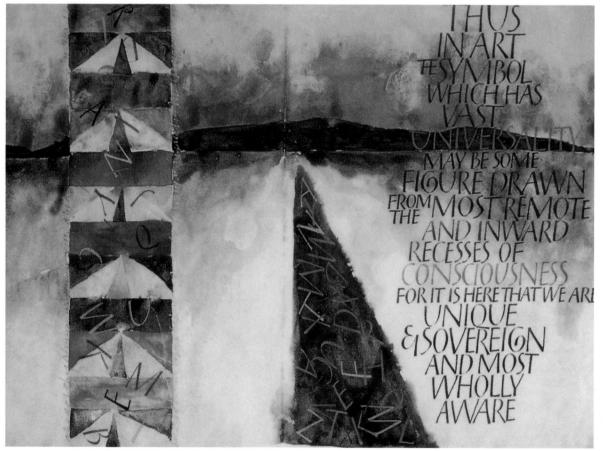

Crossroads

Nancy R. Leavitt This imaginative interpretation of a text by Karl Young uses a close-knit vertical texture of differentsize versals. Subtle color changes set off the lettering from the background, which brings all elements of the design together.

CALLIGRAPHIC SCRIPTS

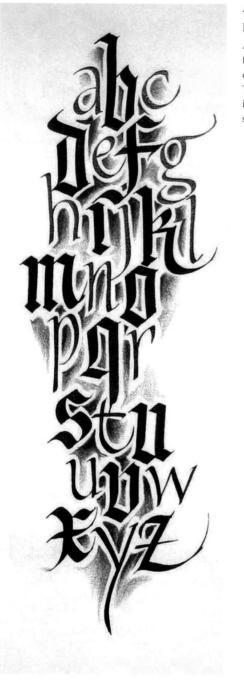

Alphabet

Jan Pickett

A lightweight foundational script is contrasted with Gothic. This was rendered in ink, edged pens, and soft pencil.

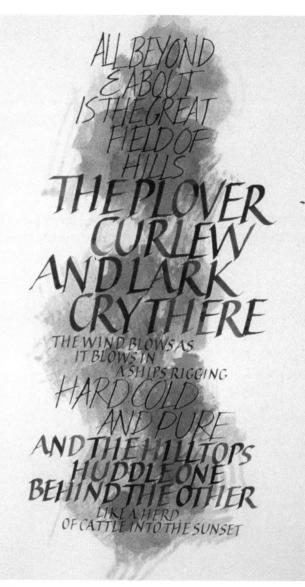

The Plover

Louise Donaldson

Written over a wash background, this calligraphic interpretation of a passage from a poem by Robert Louis Stevenson is written in three weights of italic capitals. The larger capitals are written with a plain stroke pen with color change in the pen. The lightweight letters are written with a ruling pen.

MAXIMA RES EFFECTA VIRI·TIMOR OMNIS ABESTO QUOD SUPEREST

THE MOST IS DONE AND FOR THE REST LET ALL YOUR FEARS LIE DEAD

The Most is Done

Angela Swann

The text, taken from the Aenid by Virgil, exemplifies the use of Roman capitals in a formal context. It is written using bleedproof gouache on textured watercolor paper.

Faith, Prayer

Veiko Kespersaks Experimental capitals in gouache on handmade paper.

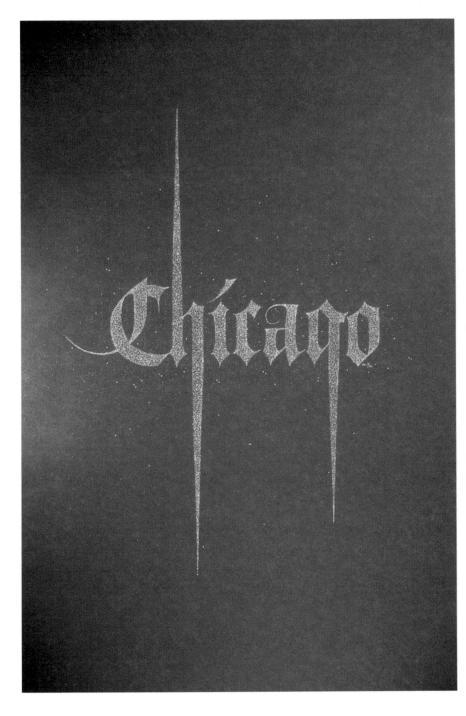

City Lights

Gerald Moscato

Gothic letters with extensions give character to the city's name. Bleach in technical pen and stippled background in black buck-eye paper.

Alphabet

Ann Bowen

Ruling pen, white and gold gouache freeform italic on BFK Rives.

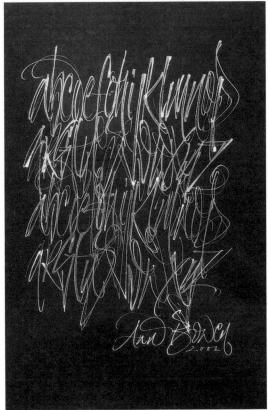

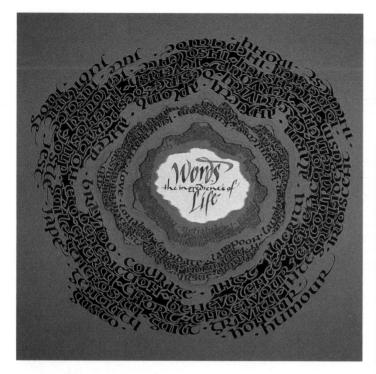

Words-the ingredients of life

Jan Pickett

The central lettering is based on italic, and the outer lettering is uncial. Walnut ink on layers of torn paper.

Trajan and versal (detail)

Gemma Black

This piece involves watercolor painting that is cut back in around drawn letters in five layers. Watercolor versals, gouache foundationals.

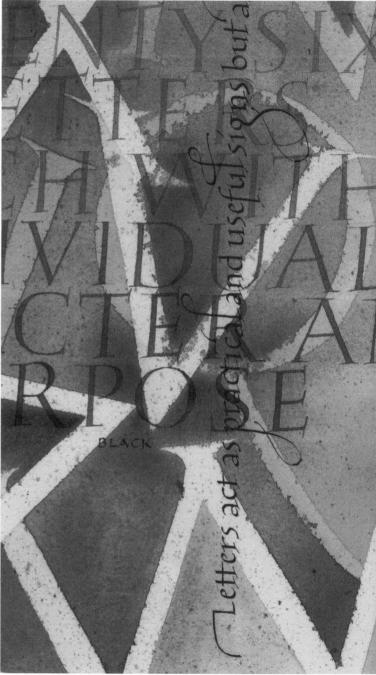

And This Alone?

Nadia Hlibka

Double-stroke versals in gouache over acrylic and watercolor background, color pencil throughout.

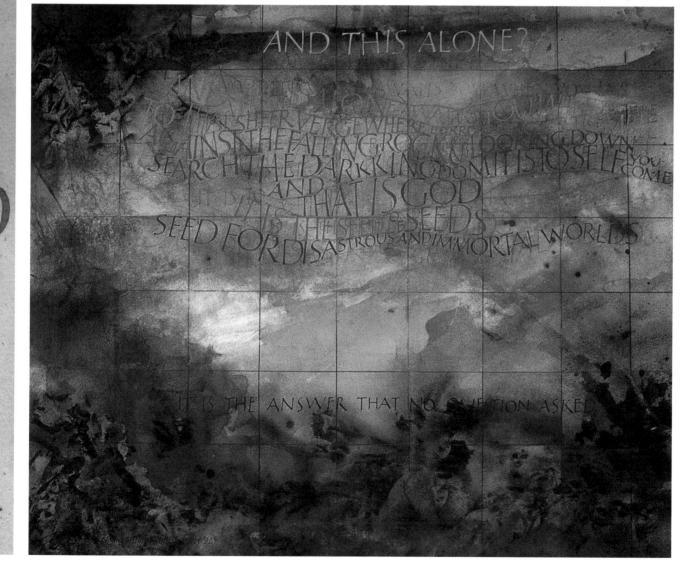

Design & color

THERE ARE INFINITE WAYS TO ENHANCE A PIECE OF CALLIGRAPHY THROUGH GOOD DESIGN AND COLOR APPLICATION. AS YOU WILL SEE IN THIS SELECTION, SOME SOLUTIONS ARE AS SIMPLE AS WRITING A TEXT ON A COLORED WASH. OTHER EXAMPLES INCLUDE THE CLEVER ORGANIZATION OF TEXT, ADDED PICTORIAL ELEMENTS, AND CAREFULLY THOUGHT-OUT LAYOUT.

Awakening

Combining large- and small-scale writing can create effective contrast, but sizes must by harmonized through the design of a piece. The text is written in gouache on a Conté crayon background.

The Dance

The blue and yellow background behind the gold lettering gives the impression of sky and yellow grass.

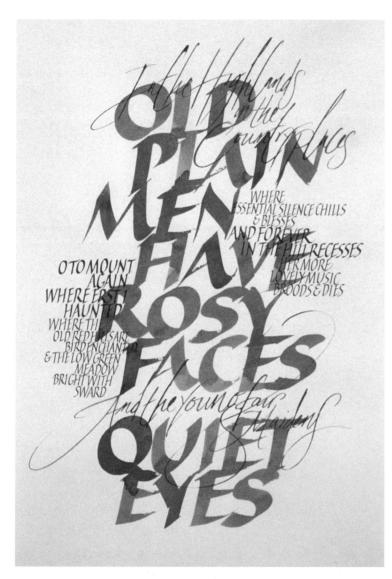

In the Highlands

Louise Donaldson

This panel based on a poem by Robert Louis Stevenson uses contrasting styles and sizes of colored lettering.

The Fish

Janet Mehigan

Written in gouache in a lightweight italic script, this rendering of a poem by Rupert Brooke is an example of the effectiveness of a simple fish-shaped layout.

• The cool curving world he files And ripples with dark cestasies The cind luxinous lapse and steal Shapes all his universe to rick and know and be the clinging stream Closes his memory, alcoons his dream Those silent waters weave for him the tops the roots o the short and dides Superb on unreturning takes Those silent waters weave for him the warman masses bulge and gape Musterious and shape to shape These momently through whort and hollow And form and line and solid follow and form and line and solid follow and form and line and solid follow and sort world, a shifting world Bulbous or pulled to thin or curled Or serpenane or driving arrows There shipping wave and shore are one And wead and mud. No ray of sun But glow to glow fides down the deep The hughing of thiring glooms The strange soft-handed dopth subdues Drawned colour there bit black to hues As death to living, decomposes Red darkness or the heart of roses shore and when the blown, decomposes Red darkness or the heart of roses shore and when the blown, decomposes Red darkness or the heart of roses shore and when the blown, decomposes Red darkness or the heart of roses shore and when the blown, decomposes and darkness or the heart of roses shore and when the blown decomposes and darkness or the heart of roses shore and when the blown decomposes and darkness or the heart of roses shore and when the blown decomposes and darkness or the heart of roses shore and when the blown decomposes and darkness or the heart of roses shore and when the blown decomposes and darkness or the heart of roses shore and when the blown decomposes and darkness or the heart of roses shore and the blown decomposes and the decomposes and the blown decomposes and the darkness or the heart of roses shore and the heart blown decomposes and the darkness or the heart of roses shore and the roses shore darkness As death to twing, accomposes "Red darkness of the heart of roses "Blue brilliant from dead starless skies "And gold that lies behind the cues "The unknown unnameable sightless white "That is the essential flame of night "Lustreless purple hooded green "The myriad hues that lie between, "Darkness and darknessl..." And all s one "Green the covacing avier, due Darkness and darkness!... And all's one Gentle embracing, quice, dun The world he rests in the world he knows Perpetual curving, Only — grows "An eddy in that ordered falling A knowledge from the gloom, a calling Weed in wave, gleam in the midd — The dark fire leaps along his blood "Dateless and deathless blind and still The intrucate impulse works its will "His woven world drops back and he Sans providence, sans memory "Unconscious and directly driven "Eades to some dank sufficient heaven Fades to some dank sufficient heaven

Alphabet Expressions 1-2-3 An Vanhentenrijk

Roman capitals, heavyweight, and freeform italic in bleedproof white and oil pastels on paper.

To the Ends of the Earth

Janet Mehigan Ranulph Fiennes' extract backed by a serene landscape.

Versetzt by Remco Campert

An Vanhentenrijk

The success of this piece relies on its elegant swirling arrangement. Sumi ink, bleedproof white, automatic pen on paper.

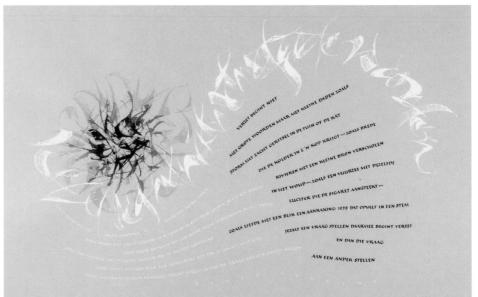

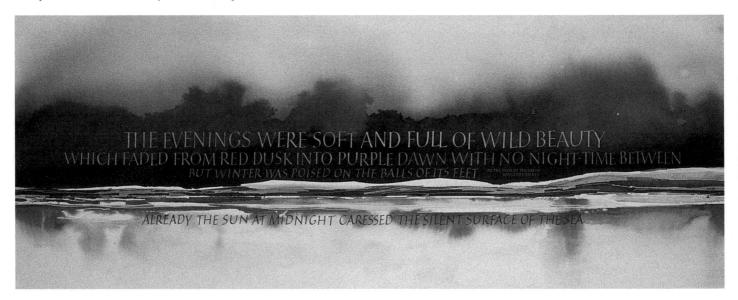

DESIGN & COLOR

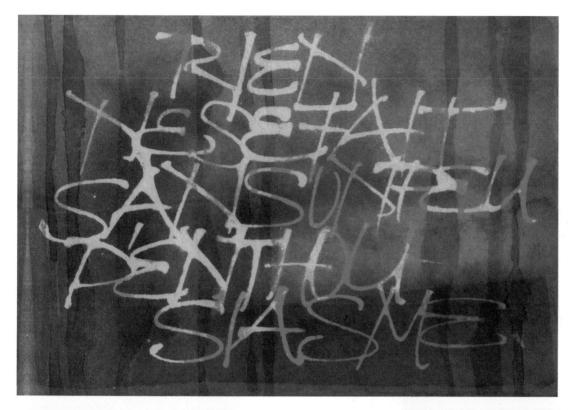

Rien

Lieve Cornil

A striking, graduated background with the letters lifted out of it. Inks, bleach and automatic pen; freeform italic capitals on paper.

Decorated "A"

Jill Quillian

Paste paper background, colored pencil drawing "A," based on a versal capital, with gold gouache flourishes.

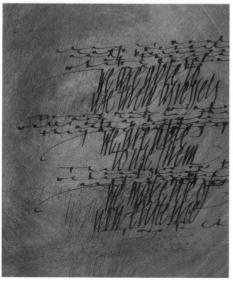

Tao Te Ching

Paivi Vesanto

The tight-swirling colors of the pastel background add to the movement of this lively piece.

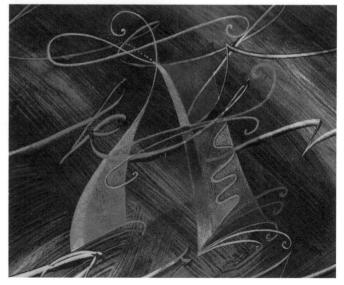

Decorative detail

MUCH OF THE FUN IN PRODUCING AN EXCITING WORK OF CALLIGRAPHY LIES IN THE EMBELLISHMENTS THAT CAN LIFT AN OTHERWISE ORDINARY PIECE OF TEXT TO AN ENTIRELY NEW LEVEL. THE PIECES IN THIS SECTION DEMONSTRATE HOW ADDING FLOURISHES, ORNAMENTAL DETAILS, DECORATIVE BORDERS, AND GILDED ELEMENTS OF ALL KINDS MANAGE TO DO JUST THAT.

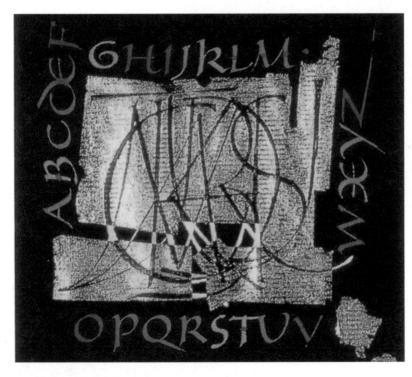

Alphabet design

Donald Jackson

This eye-catching alphabet design shows a delicate tension between elegant gilded classical Roman capitals and the freely written uncial-influenced capitals.

Poetry panel Paivi Vesanto

Elegant flourishes form a natural part of these freely written italic and italic capitals.

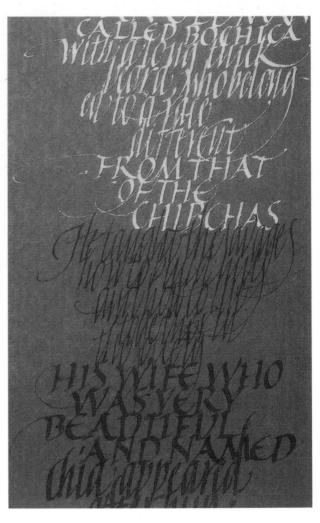

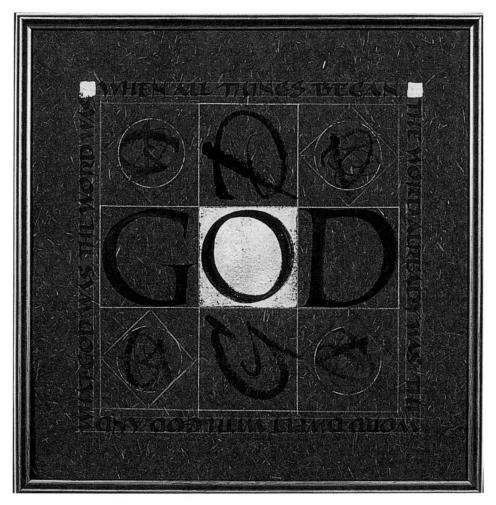

GOD

Mary Noble

Gold leaf on acrylic gold size, gold gouache lines, edged and pointed brushes, gouache on dyed tissue.

DECORATIVE DETAIL

Golden sunlight

The cursive italic script in this piece is embellished with gold leaf, which helps to lift the letters out from the watercolor wash.

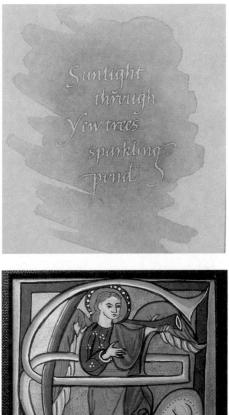

Angel

Viva Lloyd

Copy of thirteenth-century Psalter, St Michael with serpent in letter "E." Shell gold, gouache on vellum.

Letter "L" Cherrell Avery

Traditional methods and style of Flemish fifteenth-century illuminated initials. Color pigments with glair and gold leaf on gesso.

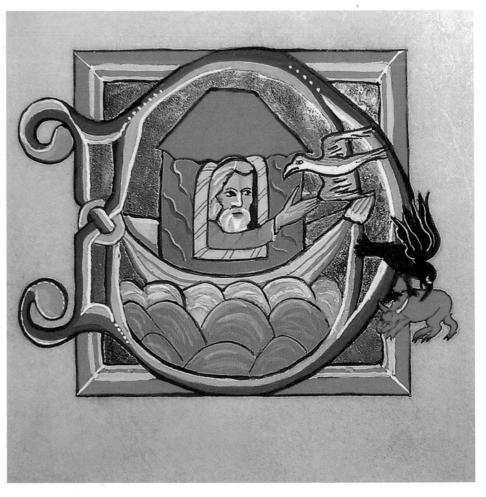

Noah's Ark

Viva Lloyd

This letter "D" is a copy from a thirteenth-century Psalter, Strasbourg. The decoration is raised and burnished gold on gesso, gouache, on vellum.

Peace be with you Autumn

The gold lettering of this piece contrasts sharply with the dark background.

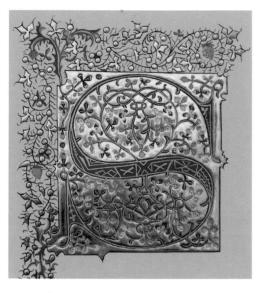

Janet Harper/George Thomson

This beautiful letter "S" is based on one found in an early fifteenth-century manuscript.

Draper's Company Anniversary Charter

A formal document with exquisite gouache, watercolor, and gilded borders.

One Year is Sufficient (detail)

Donna Stenstrom Flourished italic lettering.

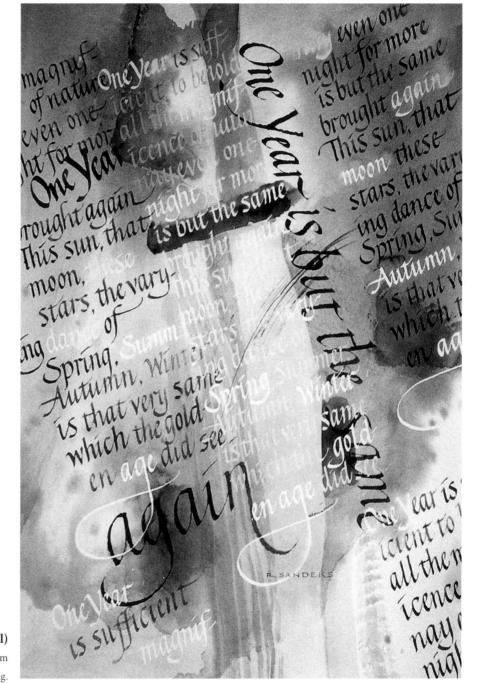

Project inspiration

PERHAPS YOU HAVE TRIED YOUR HAND AT A NUMBER OF THE PROJECTS IN THE PREVIOUS SECTION. COLLECTIVELY, THEY OFFER A WAY FOR YOU TO GAIN CONFIDENCE USING THE SCRIPTS AND TECHNIQUES MASTERED SO FAR. ON THE FOLLOWING PAGES, YOU WILL FIND EXAMPLES OF HOW SIMILAR PIECES HAVE BEEN EXECUTED IN A RANGE OF DIFFERENT WAYS. THEY ARE THE PERFECT SOURCE OF INSPIRATION FOR WORKS OF YOUR OWN DESIGN.

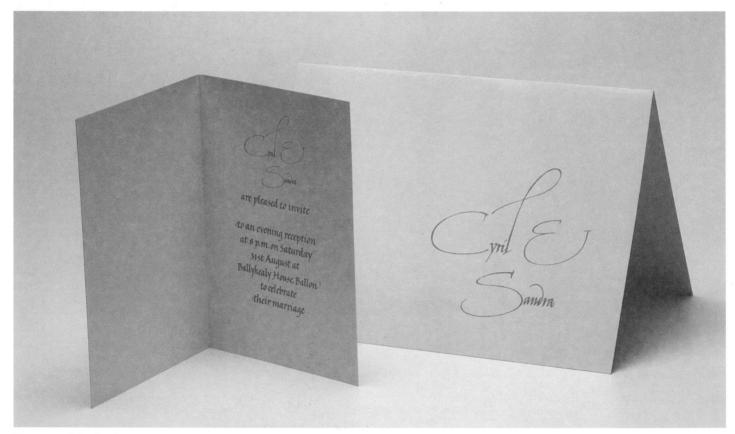

Decorated invitation

Timothy Noad

In this original design for a wedding invitation, simple decorative motifs provide added interest. The text is written in formal italic with emphasis provided by changes of scale.

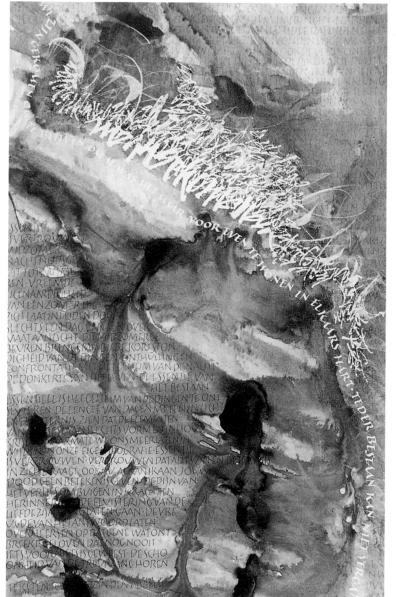

Over de dood heen by Claire Vanden Abbeele

An Vanhentenrijk

Roman capitals and freeform italic. Sumin ink, walnut ink, bleedproof white, oil pastel, with Brause, ruling and automatic pens, on Steinbach paper.

PROJECT INSPIRATION

The letter "G"

Lilly Lee

Design and concept inspired by Napa Wine Auction promotional cards themed on Penti.

Speak to the Earth

Suzanne Moore

This centerfold shows an unusual and sensitive presentation of a double page spread. The close vertical texture of capitals balances and harmonizes with the illuminated symbol on the facing page.

Creative Studies

Jenny Kavarana

This exhibition poster uses bold white lettering based on Rudolf Koch's Neuland alphabet with a dark background. Close interline spacing and subtle use of color between the letters makes for a more striking design.

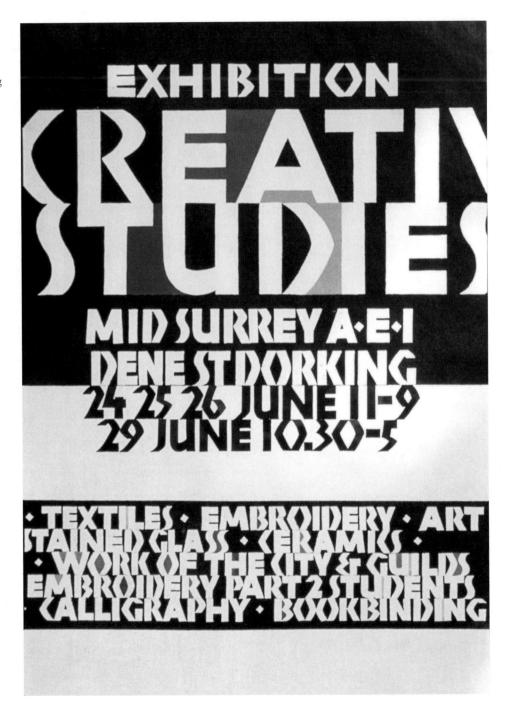

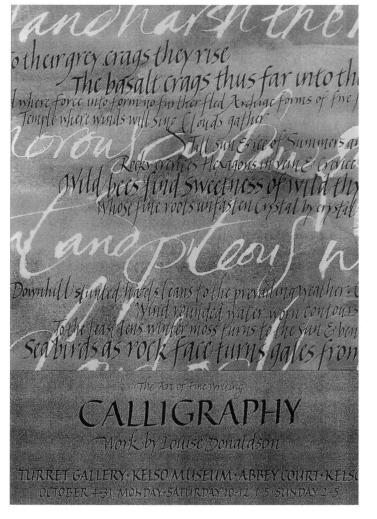

Exhibition poster

Louise Donaldson

This piece of work uses ruling pen with masking fluid lettering under a graduated wash alongside broad-nib pen calligraphy.

God at Work, 1 Thessalonians

Judy Dodds

Poster design for St Christopher Episcopal Church. Drawn and written Roman and italic capitals. Watercolors on cold-pressed watercolor paper.

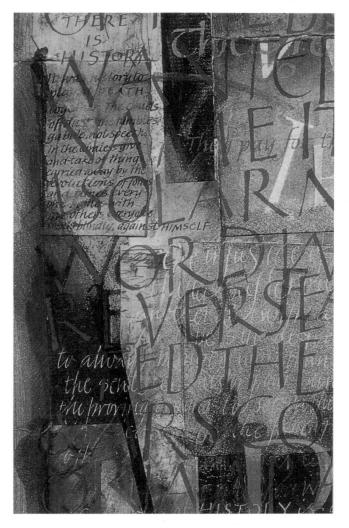

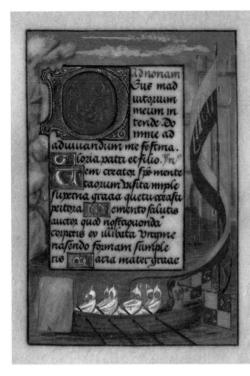

Royal Barge

Neil Bromley

The Royal Barge of King John, reproduced on vellum.

Mystic Art

Mike Kecseg

Gothic, italicized copperplate, and drawn versals. Pointed pen, broad-edge pen, stick ink, gouache, gold.

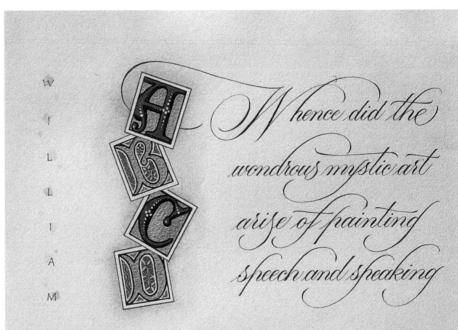

abcdefyhijkhnnoporstnonenz

to the eyes that we l M A racing madic line are 5 S taught how to embod E and colour thoug V mile please

PROJECT INSPIRATION

GOLD

Valerie Dugan

Built-up versals. Watercolor, transfer gold on gum ammoniac, on vellum.

Cara Wallia derelicta

Ann Bowen

Letters based on versal forms; Welsh and Latin. Gold leaf on gesso, gouache on vellum.

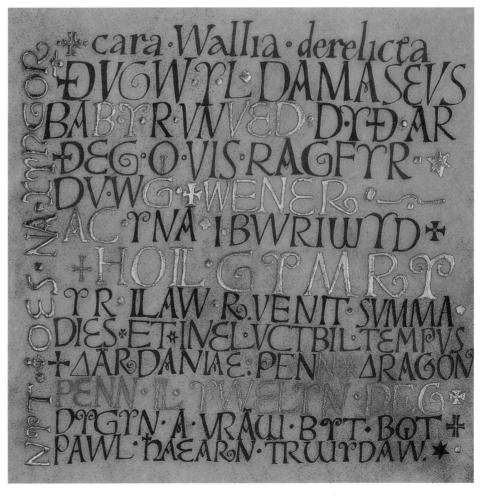

Resources

SUPPLIERS

Paper & Ink Arts 3 North 2nd St. Woodsboro, MD 21798 Tel: 301 845-9845 Online: www.paperinkarts.com

John Neal Bookseller (books, calligraphy tools and materials, gilding materials) 1833 Spring Garden Street Greensboro, NC 27403 Tel: 800 369-9598 Online: www.johnnealbooks.com

Winsor and Newton (fine art supplies) 11 Constitution Avenue Pescataway, NJ 08854 Tel: 0800 445-4278 Online: www.winsornewton.com

Blick

1–5 Bond Street New York, NY 10012 Tel: 212 533-2444 Online: www.dick.blick.com New York Central Art Supply 62 34th Avenue New York, NY 10003 Tel: 212 473-7705 Online: www.nycentralart.com

Writer's Bloc 4230 SE King Road #120 Portland, OR 97222 (no retail) Tel: 503 442-0908 Online: www.writersbloc.com

Quietfire Design (online only) Online: www.quietfiredesign.ca

CALLIGRAPHY SOCIETIES

Calligraphic Society of Arizona P.O. Box 27695 Tempe, AZ 85285 Online: www.calligraphicsocietyofarizona. org

Society for Calligraphy, Southern California P.O. Box 64174 Los Angeles, CA 90064 Online: www.societyforcalligraphy.org

Chicago Calligraphy Collective P.O. Box 316592 Chicago, IL 60631 Online: chicagocalligraphy.org

Calligrapher's Guild of Jacksonville P.O. Box 5873 Jacksonville, FL 32247 Online: www.calligraphers.com/florida/ jacksonville

Society of Scribes P.O. Box 933 New York, NY 10150 Tel: 212 452-0139 Online: www.societyofscribes.org

SUGGESTED OTHER READING

Portland Society for Calligraphy P.O. Box 4621 Portland, OR 97208 Online: www.portlandcalligraphy.org

Philadelphia Calligrapher's Society Online: www.philadelphiacalligraphers. org

Houston Calligraphy Guild P.O. Box 421558 Houston, TX 77242 Online: www.calligraphers.org

The Washington Calligraphers Guild P.O. Box 3688 Merrifield, VA 22116-3688 Online: www.calligraphersguild.org Medieval Illuminators and their Methods of Work, Jonathan JG Alexander 1992 The Lindisfarne Gospels, Janet Backhouse 1981

Historical Scripts, Stan Knight 1984/1998

Lettering Art – Library of Applied Design, Joanne Fink and Judy Kastin 1993

Understanding Illuminated Manuscripts – A guide to Technical Terms, Michelle Brown 1994

The Art of Colour Calligraphy, Mary Noble and Adrian Waddington 1994

A History of Illuminated Manuscripts, Christopher de Hamel 1986/rep 1994

The Illuminated Page, Janet Backhouse 1997

The Painted Page: Italian Renaissance Book Illumination, Jonathan JG Alexander 1994

The Art of Illuminated Letters, Tim Noad and Patricia Seligman 1994

The Beginner's Guide to Calligraphy, Janet Mehigan and Mary Noble 2001

The Book of Kells, Bernard Meehan 1997

Calligraphy, Illumination & Heraldry, Michelle Brown & Patricia Lovett 2000

Calligraphy Techniques, Mary Noble 2001

Illumination for Calligraphers, Janet Mehigan 2001

Illuminated Scripts and their Makers, Rowan Watson 2003

The Calligrapher's Bible, David Harris 2003

Calligraphy, Claude Mediaville 1996

Illuminating the Renaissance, Thomas Kren and Scot McKendrick 2003

Glossary

ACRYLIC MEDIUM

This modern adhesive dries clear. It is great for adhering gold leaf.

ARCH

The part of a lowercase letter formed by a curve springing from the stem of the letter, as in "h," "m," "n."

ASCENDER

The rising stroke of a lowercase letter.

BASELINE

Also called the writing line, this is the level on which a line of writing rests, giving a fixed reference for the relative height of a letter and the drop of a descender.

BLACKLETTER

The term for the dense, angular writing of the gothic period.

BOOK HAND

Any style of alphabet commonly used in book production before the age of printing.

BOWL

The part of a letter formed by curved strokes attaching to the main stem and enclosing a counter, as in "R," "P," "a," "b."

BROADSHEET

A design in calligraphy contained on a single sheet of paper, vellum, or parchment.

BUILT-UP LETTERS

Letters formed by drawing rather than writing, or having modifications to the basic form of the structural pen strokes.

CHARACTER

A typographic term to describe any letter, punctuation mark or symbol commonly used in typesetting.

CODEX

A book made up of folded and/or bound leaves forming successive pages.

COUNTER

The space within a letter wholly or partially enclosed by the lines of the letterform, within the bowl or "P," for example.

CROSS-STROKE

A horizontal stroke essential to the skeleton form of a letter, as in "E," "F," "T."

CUNEIFORM

The earliest systematic form of writing, taking its name from the wedge-shaped strokes made when inscribing on soft clay.

CURSIVE

A handwriting form where letters are fluidly formed and joined, without pen lifts.

DEMOTIC SCRIPT

The informal script of the Egyptians, following on from hieroghyphs and hieratic script.

DESCENDER

The tail of a lowercase letter that drops below the baseline.

FACE (ABBR. TYPEFACE)

The general term for an alphabet designed for typographic use.

FLOURISH

An extended pen stroke or linear decoration used to embellish a basic letterform.

GESSO

A smooth mixture of plaster and white lead bound in gum, which can be reduced to a liquid medium for writing or painting.

GILDING

Applying gold leaf to an adhesive base to decorate a letter or ornament.

HAND

An alternative term for handwriting or script, meaning lettering written by hand.

HAIRLINE

The finest stroke of a pen, often used to create serifs and other finishing strokes, or decoration of a basic letterform.

HIERATIC SCRIPT

The formal script of the ancient Egyptians.

HIEROGLYPHS

The earliest form of writing used by the ancient Egyptians, in which words were represented by pictorial symbols.

IDEOGRAM

A written symbol representing a concept or abstract idea rather than an actual object.

ILLUMINATION

The decoration of a manuscript with gold leaf burnished to a high shine; the term is also used more broadly to describe decoration in gold and colors.

INDENT

To leave space additional to the usual margin when beginning a line of writing, as in the opening of a paragraph.

INTERLINEAR SPACING

The spacing that occurs between two or more lines that allows sufficient space to accommodate ascenders and descenders.

IONIC SCRIPT

The standard form of writing developed by the Greeks.

LAYOUT

The basic plan of a two-dimensional design, showing spacing, organization of text, illustration, and so on.

LOGO

A word or combination of letters designed as a single unit, sometimes combined with a decorative or illustrative element; it may be used as a trademark, emblem, or symbol.

LOWERCASE

Typographic term for "small" letters as distinct from capitals, which are known in typography as uppercase.

MAJUSCULE Another word for capital letters.

MANUSCRIPT

A term used specifically for a book or document written by hand rather than printed.

MINUSCULE Another word for lowercase letters.

ORNAMENT

A device or pattern used to decorate handwritten or printed text.

PAPYRUS

The earliest form of paper, a coarse material made by hammering together strips of fiber from the stem of the papyrus plant.

PARCHMENT

Writing material prepared from the inner layer of a split sheepskin.

RAGGED TEXT

A page or column of writing with lines of different lengths, which are aligned at neither side.

RUSTIC CAPITALS

An informal alphabet of capital letters used by the Romans, with letters elongated and rounded compared to the standard square Roman capitals.

SANS SERIF

A term denoting letters without serifs or finishing strokes.

SCRIPT

Another term for writing by hand, often used to imply a cursive style of writing.

SERIF

An abbreviated pen stroke or device used to finish the main stroke of a letterform; a hairline or hook, for example.

STEM

The main vertical stroke in a letterform.

TEXTURA

A term for particular forms of Gothic script that were so dense and regular as to appear to have a woven texture. Textura is a Latin word, meaning "weave."

VELLUM

Writing material prepared from the skin of a calf, having a particularly smooth, velvety texture.

WEIGHT

A measurement of the relative size and thickness of a pen letter, expressed by the relationship of nib-width to height.

X-HEIGHT

The height of the basic form of a lowercase letter, not including the extra length of ascenders or descenders.

Index

Page numbers in **bold** refer to illustrations.

alphabet, the 8 alphabetical designs 152 anglo-saxon half-uncials 56, ascenders **18**, 29, Avery, Cherrell, *Letter "L" Awakening*

Bambury, Lorna 180 banding 172 bâtarde 9, 94, 95, 141 141, 143 strokes 94, 98 variations 96-7, 96, 97 workbook 98-105 Black, Gemma 165, 234 blunted zigzags 171 book hands 142 Book of Kells 8, 207 books 8, 142 borders 173, 174, 174, 177 black-and-white 175 decorative 205-6, 205, 206, 207 designing 206, 206 execution 207 floral 205, 205, 206, 206 gilded 243 inspiration 205 joints 173, 173 letter 175 placement 206, 206 strokes 173, 173 thumbnails 206, 206 Botts, Timothy 140 Bowen, Ann, Alphabet 233, Cara Wallia derelicta 249 broadsheets 196-7, 196, 197, 198 Bromley, Neil, Royal Barge 248 brushes 168, 169, 174 business cards 190

capitals 28 experimental 232 line spacing 18, 18 swash 107, 109, 109 Carolingian 8, 63, 64, 64, 141, 141, 143 pen angle 62 strokes 62 variations 64-5, 64, 65 workbook 66-73 Celtic angular knotwork 207-8 certificates 141 checkering 172 chevron zigzags 171 cnut charter foundational 133, 133 color 156, 157, 236-9 analogous 158, 161 bias 159, 159 changes 152, 156, 160-1, 230 choice 158 complementary 158, 161 media 159 mixing 158, 160 primary 158, 159, 159 shades 161 writing with 160–1 color washes 47, 157, 162 graded 164, 247 two-color 164 variegated 165 color wheel, the 158, 158 compressed angular italic 108, 108 compressed foundational 132, 132 compressed slanting foundational 133, 133 compressed sloped half-uncials 57, 57 compressed tall half-uncials 56, 56 compressed uncials 49, 49 concertina books 202-3, 202, 203, 204 contemporary gothic 85, 85 contrast 150, 150, 151 copperplate 9, 118, 119, 141, 141, 143, 248 flourishes 169 nib-width 36-7 pen angle 118 strokes 118 variations 120-1, 120, 121 workbook 122-9 Cornil, Lieve, Rien 239 cropping 151

decorative details **240–3** decorative versals 77, 77, 141 descenders 29, **35** design examples **236–9** desk 17 diapering **172** Dodds, Judy, *God at Work, 1 Thessalonians* **247** Donaldson, Louise **231, 237, 247** double points **169** *Draper's Company Anniversary Charter* **243** Dugan, Valerie, *GOLD* **249**

embattled pattern expanded Carolingian 65, expanded flourished Carolingian 65, expanded sloping half-uncials 56, expanded uncials 49,

flourishing **119**, 168, **169**, copperplate italic 109, **109**, Roman capitals 41, techniques **168**, formal italic 108, **108**, 109, **109**, foundational 7, 9, 130, **131**, 141, **141**, lowercase 29, pen angle 130 strokes **130** variations 132–3, **132**, workbook 134–7 freeform italic **233**, **239**, **240**, frets **171**

Garrett, Ian 83, 131 gesso 186, 186–7, 216, 224–5, 242, 249 gilding 180, 213 borders 243 burnishing 183, 185, 187, 213, 216–17, 225 flat 180, 182–3, 182, 183 with gesso 186, 186–7, 216–17, 224–5, 242, 249 gold leaf 183, 183, 216–17, 221, 241, 242, 249 INDEX

kit 14, 14 powdered gold 182, 182 with PVA 184, 184-5, 220-1 raised 180, 184, 184-5, 186, 186-7 shell gold 182, 182, 217 transfer 249 Goffe, Gaynor 47, 157 Golden sunlight 241 gothic 9, 82, 83, 141, 141, 143, 231, 233, 248 pen angle 82, 86, 90 strokes 82 variations 84-5, 84, 85 workbook 86-93 Gothic prescissus 9 gouache 159 graphics 7 greeting cards, script choice 143, 143 guard sheet 16, 17 gum sandarac 27, 27 half-uncials 8, 55, 141, 141 pen angle 54 strokes 54 variations 56-7, 56, 57 workbook 58-61 Harper, Janet 243 Harvey, Michael 157 heavy and chunky Roman capitals 40, 40 heavy compressed foundational 133, 133 heavyweight Carolingian 65, 65 heavyweight copperplate 120, 120 heavyweight foundational 132, 132 heavyweight italic 109, 109 heavyweight Roman capitals 40, 40 heavyweight shallow half-uncials 57, 57 heavyweight uncials 48, 48 hexagonal shapes 170 Hibka, Nadia, And This Alone? 235 highlighting 181 history 7 humanist script 9

illuminated letters 176, **176**, **177**, **178–9**, 181, **181**, **212–15** illustrations 152, **177**, **198** informal and freely written foundational 133, **133** ink 22, 27, **27**, 159 ink pots 17 interlaced patterns **171** interline spacing 18, **18**, 29, 37, **37**, **246** invitations. *see* wedding invitation italic 9, 106, **107**, 141, **141**, **155**, **231**, **234**, **243**, **247** arches 29 freeform **233**, **239**, **240**, **245** pen angle 106 strokes **106** variations 108–9, **108**, **109** workbook 110–17

Jackson, Donald, *Alphabet design* **240** Jeffery, Juliet **95** Johnston, Edward 7, 9, 130

Kavarana, Jenny, *Creative Studies* Kecseg, Mike, *Mystic Art* Kespersaks, Veiko, *Faith, Prayer* Koch, Rudolf

Larcher, Jean 169 layout 146, 147 alignment 147, 148, 148 balance 148 cutting and pasting 148-9, 148, 149 letterheads 190, 191, 191 margins 144 ornament 172, 172 sizing up 146 wedding invitation 193 Leavitt, Nancy R, Crossroads 230 Lee, Lilly, The letter "G" 245 left-handed calligraphers 21, 21 letter textures 152, 152, 153 letterforms 7, 28, 29, 29 Art Deco 223 Art Nouveau 222, 223 Arts and Crafts 220-3 Celtic 207-11 geometric 227 modern 224-7 Renaissance 216-19 Romanesque 212–15 letterheads 190-1, 190, 191, 192 letters characteristics 28-9, 28 contrasting 237 illuminated 176 texture 152 light source 16 lightweight bâtarde 96, 96 lightweight Carolingian with club serif 65, 65 lightweight compressed uncials 48, 48 lightweight compressed versals 76, 76 lightweight expanded italic 108, 108

lightweight foundational hand 132, lightweight free uncials 48, lightweight half-uncials 57, lightweight pointed bâtarde 97, lightweight Roman capitals 40, lightweight uncials 49, lines 18, **18**, **19**, 37, Lloyd, Viva **241**, logos 190, lombardic versals 76,

margins 144, 144, 145, 145 Marns, Frederick 119 meanders 171 mediumweight copperplate 121, 121 Mehigan, Janet 63, 75, 107, 237 modern formal Carolingian 64, 64 modern gothic 85, 85 modern quadrata gothic 84, 84 modern versals 77, 77 Moore, Suzanne, *Speak to the Earth* 245 Moring, Annie 153 Morris, William 220, 222, 223 Moscato, Gerald, *City Lights* 233

neuland Roman capitals 41, 41246 nibs 17, 17, 22, 27 aligning 22 double point 169 size checking 36, 36 nib-width height, increasing and decreasing 152 nib-width scaling 34 Nielson, John, Pi 30 no wedges half-uncials 56, 56 Noad, Tim 181, 244 Noble, Mary 55, 241 numbers 30, 30, 31, 31

octagonal shapes ornament 170, **170**, **171**, 172, outlining 181 oval half-uncials 57,

paneling **172** paper 15, **153**, 153, 194 slippery 27, **27** stretching **163** patterns, building **170** *Peace be with you Autumn* **242** pens angle 17, 20, **20**, **23–4** fiber-tip **174** INDEX

pens (continued) flexible 118 holding 20-1 holding left-handed 21, 21 won't write 27 Pickett, Jan, Alphabet 231 Poetry 143, 143, 146 posters 142, 246, 247 design 142, 199, 199, 200, 200 execution 201 powdering 172 pressure and release Roman capitals 41, 41 printing 7, 9, 190, 193, 195 Pritchard, Ros 152 protractors 17 PVA medium 184, 184, 220-1 Quillian, Jill, Decorated "A" 239 Renaissance Roman capitals 40, 40 reservoir, the 26 rests 17 Roman capitals 8, 9, 141, 141, 232, 238, 240, 245, 247 combining styles 140 geometric relationships 39 pen angle 38 strokes 38 variations 40-1, 40-1, 41 width 28 workbook 42-5 rotunda 9, 84, 84 running scrolls 171 rustics Roman capitals 41, 41 San Vito, Bartolomeo 9 sans serif Roman capitals 41, 41 sans serif versals 76, 76 scale patterns 171 scaling 34 scallops 171 Schneider, Werner 155 serifs 28, 28, 29, 29 shallow heavyweight half-uncials 57, 57 shallow slab serifs Carolingian 64, 64

shaped gothic 85, 85 sharpened expanded italic 108, 108 simplified bâtarde 96, 96 sizing up 146 skeleton versals 76, 76 sketches 191, 191, 197, 197, 200, 200 sloped decorated bâtarde 96, 96 sloped Roman capitals 40, 40 sloped sans serif versals 77, 77 sloped versals 77, 77 smoother bâtarde 96, 96 spacing 29, 31, 31 Spencer, Isabelle 154 spirals 171 spotting 172 square uncials 49, 49 squat gothic 85, 85 standard compressed uncials 48, 48 Stenstrom, Donna, One Year is Sufficient 243 striping 172 strokes borders 173, 173 clean-edged 22 curved 25 directions 21 first 22, 22 flourishes 168 height 23 horizontal 24 left-to-right diagonals 25 pen angle 23-4 ragged edge 22 right-to-left diagonals 25 sequence 37 serifs 28, 28 spacing 23 vertical 24 strong dots copperplate 120, 120 styles, combining 140, 140 Swann, Angela, The Most is Done 232 "swash" capitals italic 109, 109 swelling bâtarde 97, 97

tall and elegant Carolingian 64, 64 text, interpreting 154, 154, 155 textura prescissus gothic 84, 84 texture 150–1, 150, 151 *The Dance* 236 Thomson, George 243 Thornton, Peter 153 Tielens, Godelief 156 *To the Ends of the Earth* 238 tools and equipment 12, 13, 14, 16, 17 tracing 178–9, 207, 208, 212, 220 triangle 16, 17 troubleshooting guide 27 T-square 16, 17

uncials 8, 47, 141, 141, 234, 240 Celtic 210–11

combining styles 140 pen angle 46 strokes 46 variations 48-9 workbook 50-3 upright bâtarde 97, 97 Vanhentenriik, An 238, 245 versals 8-9, 75, 141, 141, 230, 234, 235, 239, 248.249 combining styles 140 nib-width 36 pen angle 74 strokes 74 variations 76-7, 76, 77 workbook 78-81 Vesanto, Paivi 239, 240 visual patterning 151 Walker, Brian 142, 157 watercolor 159 waves 171 wedding invitation 193, 193-4, 194, 195, 244 Werner, Michael 155 White, Mary 153 wider bâtarde 97, 97 wider copperplate 121, 121 Words-the ingredients of life 234 work surface, sloped 16, 17 workbook 34-7, 35, 36, 37 workspace 16

x-height 18, 18, 29, 31, 37

Yallop, Rachel 153

PICTURE CREDITS

All works of art are credited as they appear on the page, with the following exceptions: page 6, Shutterstock; page 138, Susan Richardson; page 166, Jenny Hunter; page 188 Janet Harper/George Thomson; page 228, Nadia Hlibka. Any uncredited works are anonymous.